street photography

street photography

from Atget to Cartier-Bresson

CLIVE SCOTT

I.B. TAURIS
LONDON · NEW YORK

Published in 2007 by I.B.Tauris & Co. Ltd
6 Salem Rd, London w2 4BU,
175 Fifth Avenue, New York NY 10010
www.ibtauris.com

In the United States and Canada distributed by Palgrave Macmillan,
a division of St. Martin's Press, 175 Fifth Avenue, New York, NY 10010

ISBN 978 1 84511 223 3 Pb
ISBN 978 1 84511 268 4 Hb

A full CIP record for this book is available from the British Library
A full CIP record for this book is available from the Library of Congress
Library of Congress catalog card: available

Typeset in ITC Bodoni Book by illuminati, Grosmont,
www.illuminatibooks.co.uk
Printed and bound in Great Britain by
TJ International Ltd, Padstow, Cornwall

contents

acknowledgements

I owe my sincere thanks to Kaye Baxter, for stepping into the task of tracking down images and permissions at short notice and for answering the challenge with such resilient efficiency and good-humoured resourcefulness. We have done our utmost to trace and acknowledge all sources, and we apologize for those few instances where our searches were unsuccessful. I am also extremely grateful to my editor, Susan Lawson, for her unfailingly wise advice and much-appreciated encouragement, and grateful, too, to Lucy Morton, who took the book through design and production so helpfully and with such flair.

illustrations

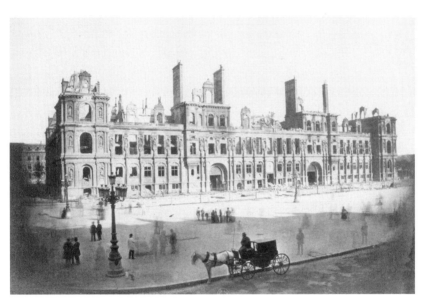

Hippolyte-Auguste Collard, *Hôtel de Ville, after the Fire* (1871)

introduction

In a recent book on Parisian street photography, *Paris Pictured* (2002), Julian Stallabrass throws down an implicit challenge:

> Paris, that great but compact cosmopolitan and imperial city, has a strong claim to be considered the cradle of street photography. The city helped form this genre of photography and, equally, photography contributed to the formation of the city, as Parisians saw first their buildings and then themselves reflected in the many photographic portraits constructed in magazines and books. (n.pag.)

The sense that Paris is the source of street photography, that Baudelaire and his 'painter of modern life', the ink-and-wash chronicler of wars and urban behaviour, Constantin Guys (1802–1892), are, or prefigure, the first street photographers, that Impressionist painters owed many of their subjects and compositional innovations to photography, and vice versa (see Westerbeck and Meyerowitz, 1994: 41-2, 44, 72), has floated freely around recent publications devoted to street photography. This book sets out to discover the ways in which these claims should be substantiated; but, more especially, it seeks to uncover the 'selfhood' of street photography, by exploring its relationship with documentary photography and with the aesthetics of photography more generally.

But I am interested, too, in street photography's emergence from, and contribution to, street painting, and I also want to suggest some of the ways in which urban writing of the period reflects both the street-photographic and the dialogue between the street-photographic and the documentary, and allows us better to understand these modes of perception.

My principal subject is, therefore, the street photography that has to do with Paris, although from time to time I cast an eye across to London, particularly a London seen through 'Parisianised' eyes. But mine is a West European affair; what is missing from my investigation is that so-called 'hard-boiled' strain of street photography – cynical, gritty, raw – of post-war American photographers such as Robert Frank, William Klein, Garry Winogrand (see Brougher and Ferguson, 2001). But one might just as pointedly ask why I have omitted reference to the street photography of Australia, or of Portugal, or of Greece, or of India. To feel bound to mention omissions in terms only of a certain photographic canon is tacitly to acknowledge our appalling visual illiteracy.

What kind of street photography, then, do we have to do with? A fairly clear idea can be garnered from *La Dame de Berlin* (*The Lady from Berlin*) (1987), the first novel in Dan Franck and Jean Vautrin's series, 'Les Aventures de Boro' (The Adventures of Boro). Each morning, in the early weeks of 1932, Blèmia Borowicz, the novel's photojournalist hero, is to be found slinging his Leica across his chest and setting out to harvest another selection of Parisian faces. His favoured subjects are the small traders who give such expressive performances of the everyday, whose humour is laced with feistiness, who use cheek to cheat the crassest misery. In these streets, the bistrot is a kingdom for grey cloth caps, and the accordion officiates at marriages and banquets. Boro is just as likely to find himself sharing a glass of red wine with a fairground wrestler as passing the time of day with a Sunday gardener:

> Ah, the people of Paris! They were certainly a motley crew to photograph! Boro, his eye glued to the viewfinder, stuffed himself with it all,

just as he pleased. ... Girls not niggardly with their charms, or crooks nasty-tempered with their fists. Spivs, errand girls, working women, *apaches*. But everywhere, life in the quick. Tender, fleshy. Characters with distinctive facial features, or get-ups, or habits, people he got to know – how could he fail to? – and who readily connived in his play-acting. He kept them company. Or rather, he grafted himself on to their lives. Donio,[1] the dog-trainer, Backless, the manager of the Villejuif ratodrome, or Weeny Bike, king of the Joinville pedal-boats – as many outings as happy days, as hours of learning. Boro had the knack of insinuating himself into people's intimacy or profiting from the decisive moment. His quick-acting intuition made him press the shutter release just at the right moment and gradually a certainty slipped into him, as warm as camaraderie, a voice whispering that his mission in life was to take on his contemporaries and that, instantaneous thief of their attitudes, of the faces they pulled, of the bared teeth of their joys and the cowardices of their solitudes, he was for ever destined to steal their truths. (1987: 114; unless otherwise attributed, translations are my own, and references are to the French source texts)

What does this passage tell us, in its writing, about street photography? We might select from this passage certain expressive tendencies which have implications for our further treatment of street photography. The language of street photography is not an amplified language – as that of documentary photography so easily can be (see Chapter 2) – and the opening exclamation marks reveal not an emotional intensity, but an ironic amusement, a simulated disbelief, an affectionate disownment. These are the equivocating, teasing kinds of motivation and response which both sustain and threaten to sentimentalise street photography: close by each street photograph a best-selling tourist postcard is waiting to bear that good-natured and flirtatious relationship with the street into the world of epistolary exchange.

Among other features to be picked out for future development are: the staccato, jotted style, which identifies street photography with perambulation and its peculiar world view (Chapter 1), with the speed of gesture, the glance, the haptic vision of Impressionism (Chapter 1), but also, occasionally, with the force lines of Expressionist and Futurist urban experience (Chapter 5); the use of nicknames and what they tell us about the 'redemption' of street types by eccentricity,

and the cultivation of the urban picturesque (Chapter 3); an easy collusion with duplicity, with peccadilloes, with the criminal fringes, those ambiguous relationships with the subject that the documentary photographer usually eschews (Chapter 5), and which make nocturnal activity an inevitable dimension of street photography (Chapter 5); the plurals – 'Girls not niggardly', 'Spivs, errand girls', 'Characters with distinctive facial features' – seem to present us, on the one hand, with a picture of the undifferentiated, of blurred lines between profession and character type and behavioural tic, and, on the other, with the heady promise of multiformity, of wonderfully random and changing lives, capable of flying off, anarchically, in all directions. Finally, we need to notice the way in which this passage first presents the photographer's raw materials and then goes on to establish the qualities necessary to turn this raw material into successful photography. In Boro's behaviour we find psychic and aesthetic resources which might have come straight from the writings of Cartier-Bresson: surreptitiousness, intuition – the street photographer also belongs to the criminal fringes – a feeling for the 'decisive moment', a sense of the instantaneous as the corridor into a certain kind of truth, the expression of one's whole organism in the photographic act, a creative temperament (audacity, generosity, enthusiasm, etc.), unstable, unprofessional, but responsive, versatile, where appropriateness of response depends directly upon that versatility (Chapter 1).

We have already begun to define street photography in contradistinction to documentary. How justified is this distinction? One looks in vain in the index of Olivier Lugon's recent *Le Style documentaire: D'August Sander à Walker Evans 1920–1945* (*Documentary Style: From August Sander to Walker Evans 1920–1945*) (2001) for the names of Marcel Bovis, Doisneau, Kertész, or René-Jacques; Brassaï has just three entries, Cartier-Bresson four. An exception is made for Atget. Lugon argues that in France, as in the USSR, 'we shall not find a documentary current in the sense that we understand it: images borrowing their neutrality from traditional documents, identity portraits, architectural archiving, etc.' (2001: 28). There is too much emphasis,

in French photography of the period, on elements of narrative, instantaneousness, peripheral angles of vision, for the documentary style properly to have taken root. And the Surrealists may have cultivated the document as a fragment of raw reality stripped of all cultural intentions, but only because it was thus available to free-associative mechanisms and to subjective interpretations geared to the deeper operations of the individual psyche (27).

This perception seems to run against that presented by Ian Walker in *City Gorged with Dreams: Surrealism and Documentary Photography in Interwar Paris* (2002).[2] Part of Walker's thesis is the proposition that Surrealist photography which exploits 'straightness' and 'realism', is more Surrealist, more disruptive of conventional norms, than its experimental, manipulative counterpart (solarisation, rayograph, superimposition of negatives, petrification, etc.). Walker's application of the term is as wary as it is inclusive; for him, 'documentary' is a generic term – with 'street photography' presumably as a sub-genre – whose very pluralism makes it complex and unsteady:

> Documentary is now a complex and multivalent genre that seeks to comment on issues of social and cultural importance without losing sight of the position from which that commentary is made. (2002: 4)

But I would not wish to call street photography a photography of commentary on issues of social and cultural importance, any more than I would wish to adopt Westerbeck and Meyerowitz's rather airy definition of street photography as 'candid pictures of everyday life in the street' (1994: 34).

In similar fashion, Gilles Mora (1998) includes street photography under the 'documentary' heading (85), but also has a separate entry for it, which makes no reference to documentary and offers the following definition: 'Street photographers pursue the fleeting instant, photographing their models either openly or surreptitiously, as casual passersby or as systematic observers' (186). This rather ambivalent definition reflects Mora's wish to see the street photographer as both *badaud* (the 'gawper' who happens to be in the right place at the right

time, without premeditation or motive) and *flâneur* (the serious amateur of other people's lives, in pursuit of quarry without quite knowing what it might be), as both casual reportage and as the potential vehicle of a new aesthetic (Rodchenko: Constructivism; Cartier-Bresson: the decisive moment). His entry on 'The City and Photography' (63–4) identifies a documentary of the street (architectural inventory, records of architectural change, preservational record of disappearing quarters, New Topographics), but also mentions those strains of street photography which treat the street as theatre, as witness to the intricate dynamics of life, as the trigger of many kinds of poetry.[3]

My approach treats street photography and documentary photography (a documentary photography of the street) as two genres on an equal footing, pulling in radically different directions. Of course, this approach entails processes of simplified binary thinking, a kind of ethnic cleansing of the terms which seems to deny their generical impurities or pluralistic capacity. But such a move is necessary if one is not to miss what seem to me to be their profoundly different overall orientations and ideologies. At the same time, it is necessary to remind ourselves that the reality is never as 'pure' as the theorised state, and to examine how the two modes, apparently inimical to each other, often manage to coexist in the same image.

One of the underlying assumptions of this book is therefore, inescapably, that generical definitions and parameters matter in photography, even though the whole thrust of the medium has been to underline the generical mobility of photographs, their ability to cross generic lines and adapt to new contexts. If anything, we might propose that the importance of genericism is a construct of the viewer rather than of photography itself, and that this may be a defence mechanism, a way of diminishing our vulnerability to photography's promiscuity. A vivid example of this phenomenon, an example close to our present concerns, was provided by a set of photographs taken by Michael Heffernan in 1995, and exhibited at the Coningsby Gallery in the autumn of 1996, under the title 'Streets: London's Young Homeless'. The photographs provoked some sharp indignation. Fellow-photographer of the mar-

ginalised Nick Danziger identifies them as fashion shots and taxes them with their lack of contextualisation: 'These pictures strike you because the young homeless people have been packaged, taken out of their environment (the street is removed so they appear as in a studio setting)' (1996: 8). In the same magazine (*The Big Issue*), Linda Grant pursues the same indictment of generical crossover (street fashion, grunge, real deprivation):

> The effect of this appropriation means that Heffernan's photographs look less like startling depictions of homeless people as we have never seen them, than rather vapid copies of what we have viewed already in other contexts. Attempting to take pictures without a realism which has itself become a style, one can only fall back on another style which does not show homeless people as they really are but how they might look if they were in a different, equally stylish context. (1996: 9)

These remarks are instructive. One of the arguments that we will be pursuing in Chapter 2 is that while documentary photography tends to imply – perhaps *needs* to imply, for its own dramatic effectiveness – that social predicaments are permanent, are evidence of powerlessness in the face of endemic social inequalities, street photography depicts predicaments as (hopefully) temporary, a glitch in a colourful and varied existence.[4] The life of the deprived in a documentary photograph is at best immobilised, and at worst, and more probably, in a downward spiral; deprivation in a street photograph occurs within a photographic mentality which is short-termist and addicted to a view of typicality as itself constituted by change. In this way, while both the documentary photograph and the street photograph can concern themselves with, say, tramps, the documentary is more likely to find the down-and-out, while the street photograph will give us the *clochard*, down on his luck, but weathering the storm.

At all events, in these criticisms of Heffernan's photographs, we might propose that Heffernan perceives the contemporary young homeless, for a variety of social and economic reasons, as a street-photographic subject rather than a documentary one. His critics feel that, in so doing, he is both betraying the *real* condition of the homeless

and, by the same token, absolving the viewer of moral responsibility. In short, either Heffernan has indeed opted for the wrong genre (an ethico-aesthetic mistake), or his critics want to force his work into what is essentially a nineteenth-century view of poverty, unmistakable in its evidential force, but dangerous perhaps in that the persuasive power of the evidence depends directly on the subject's being depicted as permanently condemned to his/her condition; transient misfortune is hardly likely to provoke public outcry. But more insidious still, and an important element in the argument of Linda Grant, is photography's own predicament: because the photograph is so weak in intentionality (Berger and Mohr, 1982: 90), in its ability to say what it means, so it must either outbid itself, make its case with the crassest obviousness, or it must fall back on language to make its case for it. More particularly, the photograph shaves context down to something wafer-thin. The photograph can never tell us enough of the story (see n4).

But if photography's implication in generical distinction has much to do with the perceptual anxieties of the viewer, with the strong pressures of visual expectation, photography has also itself to blame. As Walter Benjamin saw only too clearly, photography got off on the wrong foot by measuring itself, for much too long, against the principles and criteria of painting: 'Nevertheless, it was this fetishistic and fundamentally anti-technological concept of art with which the theoreticians of photography sought to grapple for almost a hundred years, naturally without the smallest success. For they undertook nothing less than to legitimise the photographer before the very tribunal he was in the process of overturning' (1999: 508). But even when 'New Vision' photography (Strand, Renger-Patzsch, Moholy-Nagy, Rodchenko, etc.) began to generate a peculiarly photographic seeing, genericism simply relocated itself. Thus, for all its ability to provide us with images of everything, to buck the generical constraints that continued to govern painting, the photography of the city seems simply to have become obsessively preoccupied with a new range of visual topics: people leaping puddles, empty chairs, road sweepers, markets, shop windows, café mirrors. One might argue that the very

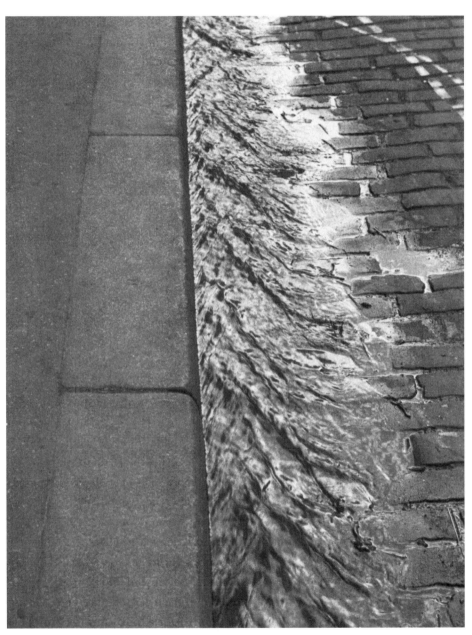

FIGURE 1 André Kertész, *Pavement* (1929)

FIGURE 2 Robert Doisneau, *Pavement* (1932)

reproducibility of the photograph made the proliferation of imitation, quotation and allusion inevitable; one might argue that we only see what other images have taught us to see. Looking at André Kertész's *Pavement* of 1929 (Figure 1), one cannot but think it the trigger of Robert Doisneau's 1932 pavement photograph (Figure 2) and Wols's of 1932–39 (Figure 3). In all of these images, the three protagonists – the paving stones of the roadway, the water in the gutter, the granite kerbstones – play out their dramas of colliding materials, timescales and textures. The paving stones of the roadway belong to the past, bear

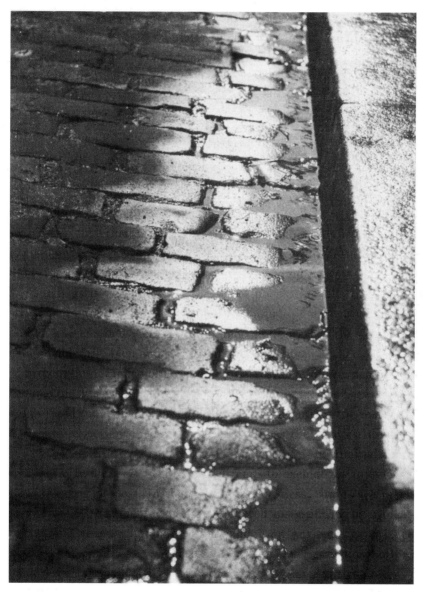

FIGURE 3 Wols, *Pavement* (1932-39)

the marks of time and use, painstakingly developing their legibility, their inimitable patterns of unevenness, their yielding softness that makes room for pools of water in crevices and troughs. The water,

the element of change, streaming in corrugated waves in the Kertész and the Doisneau, momentarily sunning itself in the Wols, leaves transitory designs on the paving stones and traces the trajectory of a tyre and is time itself, passing through the scene (Kertész, Doisneau), or evaporating out of it (Wols). And while the water is surrendered to by the paving stones, it is sternly resisted by the kerbstones, which, in the Kertész and the Doisneau, seem, indeed, to drive it on. In these kerbstones there is no forgiveness; as the buffer between the pavement and the roadway, they act out their impassive invulnerability to time, their refusal of any compromise about borders. And to these three images one might further add Pierre Boucher's *Ruisseau de Paris* and *Rue de Paris*, both of 1931, Brassaï's 'Le ruisseau serpente dans la rue vide' (The gutter snakes through the empty street) (no. 14 of the images in *Paris de nuit* [1933]), and René-Jacques's picture of a roadsweeper sweeping the gutter in the early morning sunlight, simply entitled *Paris 1933–1934*.

The pavement–roadway relationship is equally significant for the presentation of street trades. How far are street traders allowed to colonise that territory which represents safety, from traffic, from the dirt of the road, from the solicitations of the socially inferior? The poet W.E. Henley's 'Hawker' (1898) seems to be ever on the point of falling into the gutter:

> You shall behold him, edging with equal strides
> Along the kerb; hawking in either hand
> Some artful nothing made of twine and tin

And the sandwichmen, or boardmen, described by the journalist Adolphe Smith in 1877, certainly have no pavement rights: 'But few have escaped receiving ugly cuts from the whips of irate coachmen. If they walk on the pavement the policemen indignantly thrust them off into the gutter, where they become entangled in the wheels of carriages, and where cabs and omnibuses are ruthlessly driven against them' (Thomson and Smith, 1994: 91). Caught between the devil and the deep blue sea.

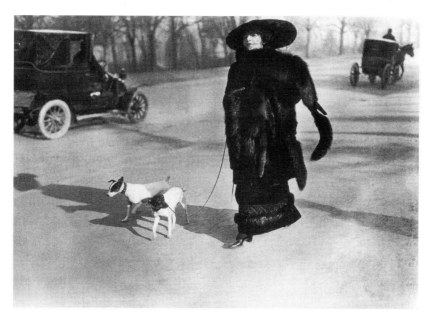

FIGURE 4 Jacques-Henri Lartigue, *Avenue du Bois de Boulogne* (1911)

But, curiously, when it comes to the relationship between the pave-
ment and fashion, or the chic of the Parisienne, then the pavement
is too confining and too 'safe', and becomes the 'roped-off' area of
spectation as the model takes to the roadway (e.g. Martine Franck,
Rue de Chaillot, 1972), with, sometimes, the traffic as if tumbling
over itself to bathe in her aura (e.g. Sergio Larrain, *Paris VIIIe ar-
rondissement*, 1959). This photographic thread perhaps has its origin
in Lartigue's celebrated *Avenue du Bois de Boulogne* (1911) (Figure
4), where the pavement has all but disappeared, leaving the fashion-
able, promenading woman to outdo the wheeled competitors (*fiacre*,
motorcar) in stylish transport. The woman is, in fact, walking against
the tide not only of alternative transport, but of history itself, since
the cab, preceding the motorcar but doubtless shortly to be overtaken
by it, acts out the unfolding progression from the horse-drawn to the
engine-powered. But this inexorable evolution, driving the cab into the
distance and out of the picture, does not impinge on the self-assured

FIGURE 5 Auguste Renoir, *Place Clichy* (*c.* 1880)

autonomy of the woman, gliding forward in a time of her own, in an instant of elegance, shaking itself free of history. But a forebear further back might be Renoir's *Place Clichy* (*c.* 1880) (Figure 5) where the foregrounded, cut-off figure of the *grisette* takes to the psychologically and existentially tempting empty spaces of the roadway, while the other passers-by, and even, seemingly, the horse-drawn omnibus, are

herded into an undifferentiated mass on the pavement. What moral taboos, what constraints of respectability, has she it in mind to break, with that step from the anonymous conformity of the pavement to the unannexed territory of the roadway?

Is there, then, a genre called 'street photography'? Street photography certainly puts us in a taxonomic quandary, not only because it stands at the crossroads between the tourist snap, the documentary photograph, the photojournalism of the *fait divers* (news in brief), but also because it asks to be treated as much as a vernacular photography as a high art one. This book certainly does not set out to provide a careful and comprehensive history of street photography; my concerns are more properly with the name and nature of the genre, and with a history which is more to do with the viewer's perceptual autobiography than with a chain of photographic events. Besides, elements of this history of photographic events are there to be garnered from other sources, from Deedes-Vincke (1992) and from Thézy and Nori (1992), from Westerbeck and Meyerowitz's large-scale 'first history of this tradition' (1994), from Seaborne's very useful critical directory of photographers of London (1995), from Hamilton (1997), from Stallabrass (2002), and, as this photographic current touches Surrealism, from Walker (2002).

My history of street photography, then, is necessarily selective and somewhat capricious, and is designed to serve the specific tasks I have set myself. The first of these tasks is the investigation of street photography from the perspective of its late-nineteenth-century origins, which necessarily entails its affiliations with painting. Street photography acts out, in a peculiarly intense way, the dialectical relationship between photography and painting. The street does not, as Westerbeck and Meyerowitz suggest (1994: 34), yield a type of picture 'that is idiosyncratic to photography', inasmuch as Impressionist painting is the first *thorough* exploration of the moments of the street, uninhibited by the constraints of exposure times. It is true that the stereoscopic images of Adolphe Braun, A. Houssin and Hippolyte Boivin date from the 1860s, but Impressionism colonised the events of the street and

café terrace with a freedom and adventure that photography took some time to match.

The second task is to isolate the street-photographic as a constellation of attitudes and stylistic features. In order to do this, I have to trace the interchanges between street photography and those genres lying closest to it (photojournalism, documentary photography). Here, from time to time, I enlist the support of a contemporaneous literature, to provide us with another way of defining the psycho-perceptual characteristics of the street-photographic mentality. But whatever assistance I might seek from painting and literature, this book is squarely about photography, and where it theorises, it does so about photography.

In my general reflections about photography, I have tried to restore a certain balance. As we have seen, Walter Benjamin lamented in 1931 that photography's credentials had too long been tied to its standing with the other visual arts. But photographic criticism continues to invest in the vocabulary of the visual arts – frame, modelling, perspective, composition, lighting, tones – and the medium's aesthetic claims continue to be a central preoccupation. These trends have located photography squarely among the arts of the image and have tended to interpret the invention of photography merely as a fixative process: the ability to fix the image which, for centuries, had appeared in the camera obscura as an aid to drawing. In his *Histoire de la découverte de la photographie* (*History of the Discovery of Photography*) (1925), Georges Potonniée defines photography in these terms: 'Photography is the art of making permanent the images perceived in the camera obscura, by means other than those of manual drawing' (quoted by Daval, 1982: 9).

But if one version of photography makes image-value paramount, another makes paramount sign-value. We have, quite rightly, to be warned against falling dupe to photography's protestations of innocence. We must be reminded that photographs do not provide us with unmediated access to reality, that they are ideologically loaded representations, instruments, voluntary or involuntary, of indoctrina-

tion and control, highly economical with the truth, and that the path of the photograph to the consumer is littered with significant choice. These warnings are certainly salutary, but they bring their own dangers with them, in that they tend to endorse the attitude of the aestheticians towards the photograph (photograph as constructed image, to be read for its meanings) and, correspondingly, they squeeze out the phenomenological (the psycho-perceptual, devoid of any conceptual construction), what the photograph provides in the way of a purely psycho-sensory contact with the world.

This phenomenological approach relates to photography as an involuntary (chemical) response to reflected light; in this version of photography, the camera refines a process to which it is, itself, not absolutely necessary. The case is economically put by László Moholy-Nagy:

> As a matter of fact, the main instrument of the photographic process is not the camera but the photosensitive layer; the specific rules and methods of photography accord with how the layer responds to lighting effects produced by different materials according to their light or dark, smooth or rough characteristics. ('Fotographie ist Lichtgestaltung', *Bauhaus* II/1 [1928]; quoted in Passuth, 1985: 302)

In this view, the photograph is not a likeness, not even an exact likeness; the photographed is directly perceived in the photograph. Phenomenological approaches concentrate on the photograph at the moment of its taking, rather than on its afterlife, on its subsequent contexts and uses. Phenomenological approaches concentrate on the photograph's indexicality (the photograph as product of the co-presence of subject and camera, subject and photosensitive layer) rather than on its iconicity (the photograph as a certain kind of representation or imitation of reality, which ultimately need not be imagined as present for the photograph to achieve its significance). Even when considering the socio-political implications of photography, Benjamin is fascinated by the phenomenology of photographic vision (e.g. the optical unconscious, the 'suppression' of the photographer by the subject) (1999 [1931]). Renouncing a semiology of the photograph

(*studium*), Roland Barthes re-engages with the viscerality of photo-perception (*punctum*) (1984). And more recent French photo-criticism continues to be preoccupied with the same issues (e.g. Pontremoli, 1996; Damisch, 2001).

Does this then mean that the most photographic of photographs are the ones that make the most of the *moment* of taking? Put another way, is photography more photographic the more it sets store by, or exploits, its instantaneousness? Do the still life, the architectural photo, the landscape even, disqualify themselves from the pantheon of the photographic through their relative imperviousness to time? A photograph is a combination of exact reproduction (or presence) and temporality (light). Does street photography serve this agenda better than documentary photography? And, further, inasmuch as the photography of the instant of taking is necessarily committed to the singular and unique, should we look askance at any photography which promotes the typical, the repeated, the taxonomic? Is it possible that realism and temporality can have conflicting interests? Is it possible that realism can only come into its own at temporality's expense? These and other questions will be unavoidable concerns in the pages that follow.

My overall itinerary is a relatively simple one. The first chapter concerns itself with the origins of street photography in Baudelaire's favoured illustrator Constantin Guys and the Impressionists. It examines what is entailed, particularly for memory and imagination, when painting/photography/literature abandon the studio/room for the street, and what the street-photographic owes to Impressionism's account of psycho-perceptual experience in the modern city. This latter involves consideration of the meanings of the instant and of instantaneousness, and of the interaction of the eye-frame and the support-frame as instigators of different understandings of visual composition. Chapter 2 offers an extended comparison of the documentary and the street-photographic, beginning with features they seem to share, and developing underlying differences on the basis of the readerly/writerly distinction and on a distinction between the

consumer or vendor, on the one hand, and the customer, on the other. The latter distinction is pursued through a study of Atget's photographs of stalls and shop windows, and of more recent examples. The chapter goes on to explore the relationship between the documentary and the street-photographic in photojournalism, and more particularly in the *fait divers*. The closing pages are devoted to the mutual interferences of the documentary and the street-photographic, and how these manifest themselves, stylistically, in literary texts of the street. The third chapter concerns itself with street traders, street entertainers and other street types. It looks first at processes of documentary decontextualisation and posing. It considers the feasibility and implications of differentiating between the instant captured and duration arrested, and how this differentiation bears on the notions of privileged instant and 'any-instant-whatevers' (Deleuze). It asks what kind of naming nicknames are, and what kinds of social commitment they presuppose. Paragraphs on the urban picturesque lead into renewed preoccupation with the frame, the frame of the 'New Vision' photograph, and the way in which the frame relates to photographic variants. A brief postscript on the street-photographic nude brings the chapter to an end. Chapter 4 is primarily concerned to debate the senses in which muteness might be a proper response to the street photograph, and, if language is deemed a necessary concomitant, what kind of language it should be. We are certainly used to the construction of the photographer through language, but if the photograph is self-authenticating, why should it need linguistic accreditation? The arguments for a mute response are reviewed, and then critical/interpretative discourse is weighed against the discourse of gossip. If mute response is justified above all by the intensity of visual contact, then the look that the subject gives is of considerable importance. Equally significant are the mechanisms of purely visual discovery, especially anamorphosis (visual 'double take'). But anamorphosis flirts dangerously with the shallow and short-lived. How is it to be given an experiential complexity? An answer is found in a literary example (Réda), through a cumulative anamorphosis of superimposition, created by involuntary memory/association and by

synaesthesia, generating a language of autobiography. These themes and issues are further examined in an example of a photographic/ literary 'collaboration', between Marcel Bovis and Pierre Mac Orlan. The fifth and final chapter uses Haussmann's reconstruction of Paris to activate the thematic threads of gender, remembering, forgetting, and fantasy which interweave in the topics that follow: demolition, darkness, prostitution. The chapter goes on to relate the city's buildings and fabric to different kinds of linguistic identification and self-expression – street names, the *poème-conversation* of café life and graffiti. The Conclusion reviews the different kinds of history that street photography is amenable to, and, in the process, reassesses assumptions about responses to photographs.

I

out of the studio into the street

At the heart of Baudelaire's conception of great art, as expressed in 'Le Peintre de la vie moderne' ('The Painter of Modern Life') (1863), is the ability to distil experience in gestures of synthesis and abbreviation, an ability he particularly attributes to the painter Camille Corot and to Constantin Guys, his 'painter of modern life'. Synthesis and abbreviation, gifts of memory and imagination, live in close company with the memory and imagination of the viewer, and stimulate these faculties in such a way that the viewer can reconstruct and participate in the originating experience.

Baudelaire allows that the foundation of an artist's work may well be sketches from the live model(s) (Raphael, Watteau, Daumier, Guys); but as the work proceeds to its completion, visual notes taken on the spot become an impediment to the artist's memory, which may become paralysed or confused by the multiplicity of detail; detail has an unfortunate habit of keeping the mind locked into the materiality of surface appearances and undermining the capacity to concentrate and essentialise. This concern anticipates the perennial debate in photography about the relative virtues of black-and-white, as against colour. Colour is often taxed with being preoccupied with appearances,

with distractive, superficialising 'glamour'; while black-and-white, for its part, has all the gravity of a perceptual asceticism, which, by dint of self-denial, is able to reveal and interpret underlying relationships. To translate colour into tonality is to synthesise detail, to draw detail into a unifying gamut, to make it speak in the language of the ensemble.

But to traffic in detail at all is, for Baudelaire, already to go too far, to espouse the wrong kind of aesthetic politics. This is how he describes artistic memory's hand-to-hand struggle with detail:

> Then begins a struggle between the determination to see everything, to forget nothing, and the faculty of memory, which has acquired the habit of registering in a flash the general tones and shape, the outline pattern. An artist with a perfect sense of form but particularly accustomed to the exercise of his memory and his imagination, then finds himself assailed, as it were, by a riot of details, all of them demanding justice, with the fury of a mob in love with absolute equality. Any form of justice is inevitably infringed; any harmony is destroyed, sacrificed; a multitude of trivialities are magnified; a multitude of little things become usurpers of attention. The more the artist pays impartial attention to detail, the greater does anarchy become. (1972: 407)

Detail, then, is the urban proletariat, demonstrating for their rights, for equality. Hierarchy and subordination are at an end; the justice of the multitude is no justice at all, if discrimination is what should lie at the heart of judgement. Anarchy is the price to be paid. This passage reiterates, to all intents and purposes, those charges that Baudelaire had already levelled against photography in the *Salon de 1859*. Photography is the art of the mob, obsessed with a progress which means progressive materialism and literalism, enamoured of a truth which means the undiscriminating and exact duplication of external reality.

Baudelaire's searing indictment of photography in the *Salon de 1859* is followed immediately by an apologia for the imagination. But where is the home of the imagination, and of memory? It is the poet's lamplit room and the draughtsman's/painter's studio:

And now, whilst others are sleeping, this man is leaning over his table, his steady gaze on a sheet of paper, exactly the same gaze as he directed just now at the things about him, brandishing his pencil, his pen, his brush, splashing water from the glass up to the ceiling, wiping his pen on his shirt, hurried, vigorous, active, as though he was afraid the images might escape him, quarrelsome though alone, and driving himself relentlessly on. ... All the materials, stored higgledy-piggledy by memory, are classified, ordered, harmonized, and undergo that deliberate idealization, which is the product of childlike perceptiveness. (1972, 402)

Guys delivers his distillation of closely observed reality in an environment in which objects, props, are a submissive reality, looking to be part of that dictionary of nature from which the artist makes his selection to suit his conception. The poet's room/artist's studio into which reality is admitted only on condition of its becoming malleable, classifiable, assimilable into ensembles, semanticisable, has enormous powers of magnetic attraction. And no doubt the apotheosis of this view is to be found in Gustave Courbet's *The Painter's Studio* (1855), subtitled 'A real allegory summing up seven years of my artistic and moral life'. This canvas depicts 'the whole world coming to me to be painted', including, of course, Napoleon III himself in the guise of a man with dogs (breeder? poacher? trainer? gamekeeper?) (see Toussaint, 1978: 249-80). This is, in effect, a studio which also contains the poet's room, for, on the far right of the picture, sits Baudelaire, on a table edge, deep in the perusal of a book, and in a pose based on an earlier Courbet portrait of 1847 (?). In the latter image, the poet sits in a dimly lit room, smoking his pipe, at a table, quill at the ready, acting out, it seems, that ritual of nocturnal isolation which figures the silent, lofty activity of the imagination and memory when the real is absent.

But, delivered from the tyranny of things seen, from the assault of detail, and liberated into the free spaces of imagining, what could the painter/poet achieve? For Pissarro, painting *sur le motif* allowed the registration of 'direct and instantaneous sensations' (letter to his son, Lucien, 13 May 1891), but it needed the studio to invest these

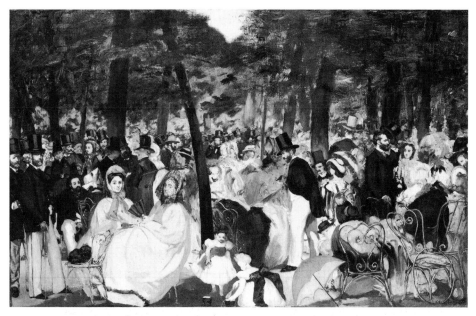

FIGURE 6 Édouard Manet, *Music in the Tuileries* (1862)

sensations with thought and aesthetic order: '[In studio paintings] there is a serenity, a unity, a certain something of the most artistic kind! What results from studio-painting is sometimes more severe, less eye-catching in colour, but, on the other hand, more artistic and more pondered' (letter to Lucien, 14 May 1891). And writing again to his son Lucien a few months later, he offered the following comparison: 'I think that these pictures [painted in the studio] have gained much in unity. How different they are from the studies [executed outdoors]! More than ever I am in favour of the impression filtered through memory; it is less the thing itself – vulgarity disappears to release truth glimpsed and felt' (letter to Lucien, 26 April 1892; all quoted in House, 1986: 25). 'The impression filtered through memory' takes us straight back to a Baudelairean position; the studio seems to safeguard the painter's capacity to extrapolate from the 'thing itself', to derive intuited concept from optical contact.

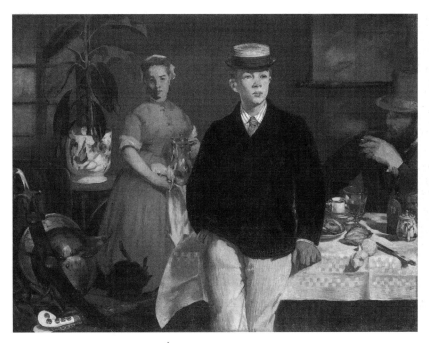

FIGURE 7 *Édouard Manet, Luncheon in the Studio* (1868)

During this particular period (1855-1890), the contrary pulls of studio/room and open air do not cease to exercise painters and writers, and I would like briefly to consider two instances. My first instance is a pair of paintings by Manet, *Music in the Tuileries* (1862) (Figure 6), and *Luncheon in the Studio* (1868) (Figure 7), both bisected by a central foreground feature (the 'Japanese' tree in the former, and the figure of Léon Leenhoff in the latter). In *Music in the Tuileries*, this tree, left-leaning, creates an intimate and remarkably taciturn space to the left, where a feeling of regimentation (similarity of dress, even in the two foreground women; composition by horizontals) and restrained respectability predominates. The figures in the immediate foreground pose for the artist (camera?) and the group portrait is the generical reference point (it has been suggested that these portraits, or several of them, were painted from photographs – Manet, Balleroy, Astruc, Baudelaire, Fantin-Latour, Champfleury, Mme Lejosne

and Mme Loubens or Mme Offenbach). Just to the right of the tree, in the centre of the picture, we pass through a patch of scumbled painting, undecipherable at first glance, into a space of animation, chatter, visual heterogeneity, positional fluidity. This is the space into which the two well-dressed, flamboyantly be-ribboned girls from the left foreground have wandered, where figures can still be identified (Eugène Manet, Offenbach, Charles Monginot), but where portraiture is no longer a motivation. And to set this mobile mass in relief is a right-foreground still life, of discarded parasol, ball, hoop and newly introduced wrought-iron chairs, which, haphazard, unoccupied, still reverberant with the life that has touched them, were to become one of the visual preoccupations of the street photographers (e.g. Kertész, Moholy-Nagy, Doisneau, Bovis [Figure 8]). But most important of all, perhaps, this canvas requires our eyes, as they move from left to right, literally to readjust, to look more fleetingly, less insistently, with more responsiveness. The eye does not stare or gaze, because such a perceptual mode is unproductive; the eye traverses, flickers, glimpses, intuits, guesses, constantly feeding itself into new patterns of circulation.

A rather similar distinction, with a slightly different orientation, is to be found in *Luncheon in the Studio*. Radiography indicates that this was, indeed, originally, a lunch in a studio: a glass-panelled wall, with seven uprights, ran along the canvas's background, behind the rubber plant on the left and the behatted diner on the right (some of these uprights were incorporated into the French windows on the left and the frame of the map on the right). In the picture as we now have it, the section to the left of the young Léon is a cross between a domestic interior with a servant, momentarily posing for her portrait, and a studio with warlike props (helmet, yataghan and sheath), while the right-hand section is a café interior, with its customer who has not bothered to remove his hat, reflectively smoking over the detritus of a finished meal. The separation of left from right is facilitated by the spatial discontinuity which has apparently been created by the position and scale of the maidservant: while the diner seems both closer

FIGURE 8 Marcel Bovis, *Champs-Elysées* (c. 1930)

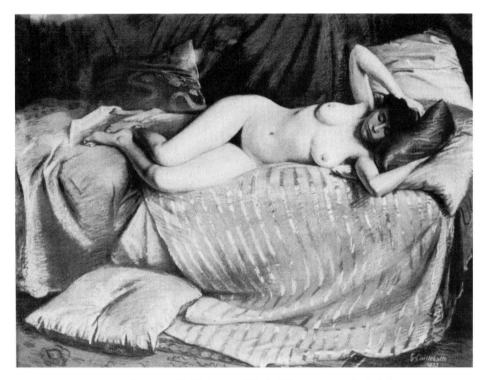

FIGURE 9 Gustave Caillebotte, *Nude Woman on a Sofa* (1873)

to us and closer to the wall behind him, the maidservant, conversely, is further both from the spectator and from the wall behind her; in other words, even though the French windows on the left make use of the same uprights from the original composition as the framed map on the right, they seem set much further back. Once again, the eye is compelled to adjust as it shifts from left to right: from a space immobilised around vertical axes, we move into a space criss-crossed by diagonal trajectories – the diner's eyeline, left forearm, right upper arm, knife, spiral of lemon peel, Léon's eyeline. These movements are surreptitiously installed by the yataghan and its sheath on the left of the picture. So it is that we move from a domestic interior, half lounge half studio, to a street interior, the café, to which Léon increasingly belongs, where time is accelerated, where compositional instability

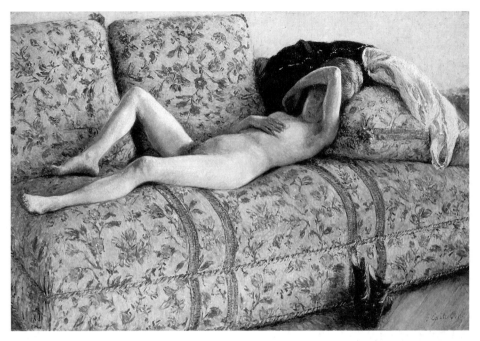

FIGURE 10 Gustave Caillebotte, *Nude on a Couch* (1880–82)

makes the scene pregnant with possible event, anecdote, and where the senses are very variously appealed to.

My second instance is a pair of paintings which between them also mark the shift from the studio to the street, but they do so with a subject both likely and unlikely – likely for the studio, unlikely for the street, the nude. Gustave Caillebotte's 1873 pastel *Nude Woman on a Sofa* (Figure 9) is a studio image in which props and accessories are arranged to act as metaphors for the model's body. The materials of the drapes and cushions (silk, satin), their colour (pink, beige, mauve) and their forms (languorously curved fold of striped underdrape, plumped up pneumatic bliss of cushions, suggestively shadowy creases) all archly refer us to the naked body. At the same time, a certain conventionality in this body – neat pubic hair, (improbable) symmetrical spreading open of the elbows of her upraised arms, the combination of pouting mouth and innocently closed eyes, of blushing self-consciousness

and the unconsciousness of sleep, of the immodest (light that falls on breasts and thighs) and the modest (the face in shadow) – gives this nude a certain abstractness or virtuality: the model acts out one of the known performances of nudity, is, at one and the same time, available, displayed to fantasy, and the vehicle of an idea, an ideal, a sublimate. The picture is without a narrative: it ends where it begins, in the nude.

In Caillebotte's oil of 1880–82, *Nude on a Couch* (Figure 10), we encounter a woman not transformed into a model by a studio, but starkly maintained in her own identity by the unamenable environment of a bourgeois sitting room. The couch, far from aiding and abetting the pose, helps to translate the physical into the psychological by dwarfing the woman's body and insisting on its own highly sprung refusal to yield to the body. The body itself is unenhanced: flesh that is too soft, pallid, marked by clothing, pubic hair which does not chime with the carefulness of the coiffure. The simplifications of the studio (unity, serenity) give way to the complexities and angularities of the street; as Varnedoe puts it: 'her gesture suggests, ambiguously and simultaneously, equal parts of auto-eroticism, somnolence and remorseful shame' (1987: 130). Just as the café diner sits smoking, with the street still in his clothes, animating his consciousness, accelerating the temporal space he occupies; just as Nadar's portraits of the mid-1850s (Gustave Doré, Baudelaire, Guys, Rossini) present his sitters, still in their topcoats, as having just dropped in from the street to take a pose for a moment, before re-immersing themselves in the turbulence outside, their expressions still alerted to an elsewhere; so Caillebotte's subject, her walking boots, shift and skirt still inhabited by the pavement, shows in her nudity, perhaps, a desire to throw off the street, to re-enter her selfhood, or, perhaps, an acknowledgement of a vulnerability that the street has exacerbated. We shall return briefly to the street-photographic nude at the end of Chapter 3.

The undermining of the significance of memory and imagination, these safeguards of processes of introspection, was connected with the dream of unmediated vision. Crary goes so far as to say:

The disengagement of perception from a model of interiority is an essential part of the work of Édouard Manet, and is decisively evident in his *The Balcony* from 1868.... The opening of the shutters, the moving out to the balcony from the shadows of the interior discloses the limpid freshness of a vision that might directly grasp the world; it is the claiming of a site from which the world, in its becoming modern, could be created anew to these three observers by virtue of its unmediated, unobstructed self-presence. (2001: 83)

It is difficult to put ourselves in the mindset of a pre-photographic world built on hearsay, dependent on the ability to imagine from scratch, or from maps, or from graphic images. But we can understand the shift from the imagination to the imaginary that Impressionism and photography entail. If the imagination is a faculty charged with processes of mental construction and reconstruction, the iconic need to create from an absence, so the imaginary is a state of fantasisation generated by a presence, a given, whose 'factuality' does not simply produce a confirmatory response, but rather an interrogative one, which activates mental 'gossip', the rumours of the viewer's reverie.

About the 'unmediated' factuality of the photograph we should say two things. First, it tells us nothing. Peculiarly, the longer the photograph exists, the more it empties itself of its initial meaning, the more it becomes an indexicality without a referent. What should we mean by indexicality without a referent? The photograph is indexical; that is to say a photograph cannot come into existence without the co-presence of the subject/referent and the camera, without the subject being in front of the lens. But as time passes, the referent falls away. The referent continues to exist, but now in a peculiarly incongruous relationship with the image; Florence Thompson continued to live long after Dorothea Lange had immortalised her in the Migrant Mother series of 1936. The image depends on the referent for its initial existence, but then can survive without the referent, indeed might be embarrassed by the referent's continued existence, because the referent could interfere with, jeopardise, the image's ability to acquire an aesthetic and semantic independence, and the value conferred on it by its

inimitable singularity, its uniqueness. And as the referent disappears, so the photograph becomes increasingly ahistorical. The photograph remains indexical, but lets drop its specific historical meaning (the reason for which it was taken). The photograph remains instantaneous, but ceases to be topical. The moment loses a significance assigned to it and is left with the freedom to assign its own significance. We are still aware of the photograph's immersion in pastness, but notice, in surprise, its inability to hang on to the particular past of its own taking. The subject/referent comes to exist entirely and only in the photograph.

So the photograph waits to be reinvested with sense, the warrant for this reinvestment deriving, ironically, from our very ignorance about it. Peculiarly, photography, this medium of real evidence and visual exactitude, this medium that brings us knowledge, depends, for its 'freedom of expression', for its ability to engage our fantasy, as much on the viewer's ignorance as on his/her knowledge. As time passes, it is probable that more people will know less about any particular photograph; and, as time passes, it will mean less to more people that the photograph was taken in 1864 rather than 1870, that it was taken in Dijon rather than Paris. The ambiguity of a photograph, as John Berger points out (Berger and Mohr, 1982: 85-92), derives less from the 'planted' presence of competing meanings, than from the discontinuity, the gap, between the moment of taking, and the moments of looking that stretch far forward into the photograph's future. What is additionally strange is that this cavalier attitude to knowledge and ignorance, as if they were merely accidents of the photograph's life (one *happens* to know or not to know, one is under no obligations), would not be a tenable position for the criticism of painting. It seems important that photographs should, as part of their real value to us, maintain their vivid relationship with the casual, the contingent, the accidental, the arbitrary.

We are left, then, with a photograph in which, as Jean Arrouye puts it, 'The [photographed] event remains without causality or finality other than that supplied by the photograph itself' (n.d. [1985]: 97). The

event in the photograph, however, cannot but have a future, although the photograph denies it one; this is the pretext for the activation of the spectator's 'imaginary'. François Soulages sums up:

> Photography is the art of the imaginary par excellence, much more than the cinema, perhaps because it is silent, motionless, cut off from the future, a pure piece of non-sense which requires an imaginary sense-giving on the part of the receiver. (1998: 67)

It is Soulages who supplies the second proviso about factuality. The process of framing is a process of *mise en scène*, because the photographer can make no claims about the truth of what appears in front of the lens (1998: 53-70). This unavoidable theatricalisation of reality suggests that our response to what the photograph shows us should not be Barthes's 'ça a été' ('that has been'), but 'ça a été joué' ('that has been performed'). Reality, whatever that is, will always escape the photographer, and this may be a further endorsement of the view that a photograph can only ever be self-reflexive. This does not, paradoxically, make the photograph any less indexical. At all events, the gap between a possible real and an actual theatricalisation (voluntary or involuntary) can only be filled by the imaginary.

But if the imagination shifts to the imaginary, where does memory go? We know that Impressionism enjoins forgetfulness upon us, wanting the eye to learn again from scratch, to get rid of received vision. Faced with the seascapes of his fictional Impressionist painter, Elstir, Proust has the narrator of *À la recherche du temps perdu*, Marcel, write:

> The names which designate things always correspond to a concept of the intelligence alien to our true impressions and which compels us to eliminate from them all that does not square with this concept. (1988: 191)

Marcel's meditations on Elstir's work are important for us, not only because Elstir's redesignation of the world, which makes it momentarily unrecognisable, relates closely to the street-photographic device of anamorphosis (visual 'double take'), which we will be exploring in

Chapter 4, but also because his reference to naming alerts us to the potential significance of photographic titles in their willingness, or unwillingness, to identify what the photograph puts before us. But we can already say that the entitlement which gravitates towards the photograph's indexicality, towards the *taking* of the photograph (time and place), is much more likely to renew vision, to maximise the interrogativeness of looking, than the title which expresses the photograph's iconicity (what it is an image of) or symbolism (what it means).

A further significance of Proust's text is the parallel it draws between Elstir's Impressionist techniques and photography. Photography has introduced into vision another pair of eyes, disrupts our habits of seeing, restores to us the optical illusions of our first visual encounters with things (1988: 194). But, more particularly, the photograph, like the Impressionist painting, even as it shakes us out of habit, 'makes us withdraw into ourselves, by recalling a personal impression' (1988: 194). This begins to suggest that the move from studio to street entails a move from a creative situation in which memory is the faculty that actively summons up the past, to one in which memory is triggered automatically, as an associative response to an external stimulus; in short, a shift from voluntary to involuntary memory.[1] The camera has no memory and, in that sense, creates no comfortable continuities between things; as Brassaï points out in his reflections about photography in Proust, photography might well have been the source of Proustian relativism (1997: 157–62). Paradoxically, the photograph, the ideal aide-memoire, spells – in its taking, in its promotion of temporal discontinuity – the death of memory. Between the there-and-then and the here-and-now, there is a crisis of continuity which the photograph is powerless to solve. The past is a past of moments without chronology; there is no continuous corridor of time along which we can look to see these images all in their allotted temporal niches, and because of this absence of chronology/continuity photographs enjoy a peculiarly 'free' relationship with the present; a photograph commemorates but does not remember, and so, in some fashion, it is always new and intact.

So the photograph can let us into a world of infinitely renewable sensory intensities, traumas, and by this renewability deliver us from the clinging burdens of regret and remorse. But in this existential limbo, how is the self to find a path to itself, to its own inimitable duration? How might photography serve involuntary memory and the beckonings of what Henri Bergson terms the 'deep self', the self of inner duration. Brassaï suggests one illuminating parallel: the passage of the latent image to the developed image is closely akin to the passage from a raw, sensory experience to the memory it conceals/reveals (1997: 173). And however much Barthes may seem to disavow a Proustian basis for *punctum*, that experience, too, involves tracing the same passage from the latent to the developed.[2] A photograph suddenly, unexpectedly, reaches into the depths of our past, even before memory has been triggered.

In closely related fashion, we might argue that street photography relates to involuntary memory through intertextual association. We might expect a photography which exploits instantaneousness in a way that documentary photography does not, and which, therefore, must make expressive capital out of the instant's singularity or un-repeatability, to fight shy of intertextual mechanisms. But intertextual endorsements are important both to street photography's generical stability and to its claims to everyday typicality (see Chapter 2). The practice of visual quotation is, however, one of those voluntary strategies which interest us less here than the involuntary intertextual connections made by a viewer. I see Paul Martin's *A Street Cab Accident in High Holborn. Overturned Cab* (1894), and cannot prevent the almost simultaneous eruption of Doisneau's *Fallen Horse* (1942) and Charles Nègre's *Fall or Death of a Horse, quai Bourbon* (1855-60). These images do not emerge as appropriate aids to interpretation, or to the tracing of an iconographic tradition; they emerge, unbidden, as elements in my perceptual autobiography, as elements which reveal my own duration and singularity to me. In my personal chronology, the dates of these images have no power to dictate a genealogy; in my spiritual life, Doisneau's image is the originating ancestor.

But whatever principles we may feel are shared by Impressionist painting and (street) photography, we know very little about the detailed particularities of their relationship (see Scharf, 1974: 165-209). Zola certainly found Caillebotte's work too photographic,[3] and the blurred notation of pedestrians in the city streets, figures cut off by the frame, the polarisation of near and far, high viewpoints, the 'atmospheric' series, monochromaticism (in Degas and Caillebotte) were shared by both painters and photographers of the 1860s and 1870s. Degas seems to have drawn on the findings (Muybridge's photographic enquiries into animal locomotion begun in the late 1870s) and compositional devices of contemporary photography (but see Varnedoe, 1989, for a sustained contestation of these avenues of influence), even though his own photographs of the 1890s favour the dramatic lighting of indoors; indeed, the only street photographs to have come from his camera are two from *c.* 1896, recording a gathering of people in the street of La Queue-en-Brie.

We can certainly see the converse influence in a variety of motifs which, given currency by Impressionist painters, continued to preoccupy photographers in the twentieth century. We have already had occasion to refer to empty park chairs, to which one might add empty street benches – both René-Jacques and Bovis have produced photographs of a bench in the boulevard Pasteur (1927, 1939) and Pierre Borhan describes benches as 'the shared seats of reverie' apropos of the photographs of Izis (Israël Biderman/Izraëlis Bidermanas) (1990: 172). We have also touched on the pavement/roadway relationship. We shall soon engage briefly with umbrellas and rainy days. We might equally make mention of cafés, music-hall performances, railway stations with smoke curling through the ironwork trellises, circuses, building sites, ballet scenes, crowded bridges, plunging views into streets and squares, 'flatiron' apartment blocks, markets, prostitutes. But it is perhaps not so much similarities of subject that should concern us – there is, after all, a natural limit to what a city can produce in the way of daily spectacle – but rather the psycho-perceptual inflexions of the subject. In Caillebotte's work, for example, it is not just that he

looks down into the street, but that he does so though the ironwork of a balcony (*View through a Balcony*, 1880; *A Balcony in Paris*, 1880-81), an angle of vision adopted, for instance, by Moholy-Nagy (*Marseilles*, 1928) and Willy Ronis (*Boulevard Richard-Lenoir*, 1946); or, it is not just that he looks down into the street, but that he does so from such steep angles, a practice explored by, among others, Coburn, Kertész, Rodchenko, Moholy-Nagy: 'The view from above is an emotional as well as spatial emblem of distance, detachment, and – certainly no view better embodies the word – estrangement' (Varnedoe, 1989: 242). It is to Impressionist/street-photographic psycho-perceptuality that I wish to devote the remaining pages of this chapter.

Impressionism installs the nervous, mobile spectator, whose relationship with the image is piecemeal, distracted, incomplete, ever-renewed. The potential double focus of the Impressionist painting (the raw, sensory encounter with the highly worked oil surface seen in close-up as against the synthesised and pacified 'scene', made coherent by distance) pulls the spectator both towards the canvas in its unsettled visual turmoil, and away from the canvas towards the haven of visual comprehension. Equally, compositional features like the diagonal, centrifugal eyelines or frieze-like arrangements have the effect of drawing the spectator laterally back and forth across the canvas and even beyond the frame.

Impressionism presents us with a speed of look, a glance, which not only guarantees a direct involvement with the thing seen but transfers itself directly to the hyper-active hand, producing the characteristic gestures – the *touche*, the *virgule* – only too visible in the painted surface. In his advice to the young painter Louis le Bail (1896/7), Pissarro outlines the following method:

> The motif should be observed more for shape and colour than for drawing. There is no need to tighten the form which can be obtained without that. Precise drawing is dry, and hampers the impression of the whole; it destroys all sensations.... When painting, make a choice of subject, see what is lying at the right and the left, then work on everything simultaneously. Don't work bit by bit, but paint

everything at once by placing tones everywhere, with brushstrokes of the right colour and value, while noticing what is alongside. Use small brushstrokes and try to put down your perceptions immediately. The eye should not be fixed on one spot, but should take in everything, while observing the reflections which the colours produce on their surroundings. (quoted in Denvir, 1987: 187)

In the studio the subject submits, in the pose, to the time of the painter, of the painter's observation and application of paint. The subject and the painter can thus operate on different temporal scales, need not be coincident with each other, just as the painter's hand need not be coincident with what his eye reveals to him. Outside, in the open air, the subject brings to bear on the painter the pressures of its own changingness, so that subject, artist's eye, artist's hand seek to converge in the same *real* time of their encounter. This real contact in real time means that the artist's hand does not so much describe what is in front of it (the time of describing is different from the time of perceiving), but *designates* it as it happens. In this sense, the painting of Impressionism is less a painting and more a performance of painting, or a performance of perception in paint. In this sense, *plein air* Impressionism is as indexical an art as photography, if not more so.

We might expect street photography equally to be the agent of the momentary glance, the slice of real time snapped in real time, the moment coincident with the shutter release. But it is not quite so simple. Street photography does take place in real time, but it harnesses the window aesthetic of Renaissance perspective and dispenses with the manipulations of the hand. In other words, it is, to use Bryson's term, 'erasive' (1983: 92); it erases the picture surface, the surface as evidence of real time. There is no performance of photography in photography, apart, perhaps, from the blur, or the gradualness of the impression in the photogram. Photography does not make the body of the photographer visible in the photographic act, although the photographer may be present in the image (as shadow cast, or reflection). One might conclude, then, that street photography is generated by a glance, but begets a gaze. Monocular perspectivalism threatens to set

at nought the visual improvisation that small cameras specialise in. And this conflict of interest between the product and the instrument is exacerbated by the fact that photography cannot make material – as signatory marks on the picture surface – its own techniques (the manipulators and gum splodgers of pictorialist photography have, precisely, to intervene in the photographic process in order to produce what is, essentially, a painterly form of manual visibility). What makes Impressionist painting both convergent with and divergent from photography is that it shares photography's indexical and unmediated engagement with reality, and yet the registering of the subject *en plein air, sur le vif, sur le motif,* does not entail the surrender of the glance to the gaze, of enunciation to the enunciated. So stubbornly manifest is the evidence of manual labour, of eye–hand communication and coordination, that both deixis and the duration of the creative act remain visible in the canvas's surface. We are, then, faced with the rather paradoxical declaration: 'You made this canvas with the subject in front of you, the subject was taken directly from reality, but the image produced does not represent what anyone else in front of the same subject would see.' We might say that photography averages vision out and that, while the photograph is unique because the moment will never return, the Impressionist moment is unique both because the moment will not return and because the physiology/neurology of the viewing eye will never be the same. But we might want to argue that Impressionist painting also combines the glance with the gaze, that the experience of the glance is to be found in the close-up encounter with the canvas, while the gaze gradually takes over as one moves back. The photograph collapses these two perceptions into one.

We now see that what is peculiar about Baudelaire's description of Guys at work at night in his room is the fact that, although he is in his 'studio', he is working with the feverish speed of the *plein air* artist. He does not need to. Baudelaire wishes to profess an aesthetic of distillation, harmony, 'deliberate idealisation', but he has, almost despite himself, allowed *plein air* principles to invade the meditative sanctuary of the artist's room. Indeed, quite explicitly he describes

Guys as 'darting on to the sheet of paper the same glance that a moment ago he was casting on the things around him'. Guys's art is clearly an art of the inquisitive, penetrating glance rather than the contemplative gaze.

What corresponding resources might a street-photographic writer use to convey the restless eye, roving nervously across, and into, its field of vision, adopting uneven rhythms of attention, selecting now one feature now another, often by chance, as if palpating appearances, feeling for the sensitive spot, the revealing visual lesion? How does the literature of the street introduce a sense of perceptual activity as the passage of real time, if not by ensuring that the reader's eye–inner ear coordination – corresponding to the painter's eye–hand coordination – negotiates the unfolding text as a variable duration, as ongoing sensory experience? As we think of the way in which the reader absorbs the text, so we can more fruitfully think of the way in which the photographer visually assimilates the spectacle in the viewfinder, or the spectator visually digests the photograph.

Rhythm is one resource which permits the writer to introduce physiological, perceptual real time into the text. Word-order, too, may trace out the sequence of perceptions as a passage through time. And intimately connected with both of these resources is punctuation, which, whatever its syntactical function, calibrates the correspondences between perception and respiration, the junctures between ocular saccades, and the varying speeds of the assimilative process of the senses. Édouard Dujardin's *Les Lauriers sont coupés* (*The Laurels Are Cut*) (1887) – a work credited with the 'invention' of interior monologue, which was to influence Arthur Schnitzler's 'Leutnant Gustl' (1900) and, by James Joyce's own acknowledgement, *Ulysses* (1922) – epitomises this time-filled, Impressionist street-writing.

In Dujardin's short novella, Daniel Prince, a 24-year-old law student, spends a Monday evening in April 1886 killing time in the streets of Paris before a sexually fruitless rendezvous with the actress Léa d'Arsay. The action takes place between 6.00 p.m. and midnight, and that action is no more than someone condemned to kick his heels for four hours, and

then pass unproductive time with his 'mistress'. This time, which the reader shares minute-by-minute with Daniel, weighs heavily, palpably, over the novella's length, in the very frequency and insistence of the punctuation, as it traces the movements of a mind intent on occupying itself as long as is necessary, a mind in conversation with itself.

The generator of interior monologue, as of street photography, is the act of walking, wandering without particular objective, so that mechanisms of reception, and the mind's readiness to associate, are at a maximum. Walking the streets releases the walker from the obligations of narrative, the need to get from here to there. Words and images are free to inhabit the mind, the eye, without their being appropriated to serve an ulterior purpose. The observations of the interior monologuist, like the images of the street photographer, have no debts to finality, can be made of pure contingency, are the point of intersection of the street's temporalities and the inner time of the monologuist/photographer. And significantly, too, we are not *addressed* by the monologuist's words or the street photographer's images: we are merely witnesses to them; the monologuist has no interlocutor. Could any of this be claimed of documentary photography, or of reportage? Surely not. These latter kinds of photography are clearly motivated, have a plot to pursue, a viewer to implicate, seek to make time single, a time shared by subject, photographer and viewer. On this basis, we could perhaps begin to claim that an image by Boubat, or Doisneau, is less a record of a referent in reality than an internal event, less the fixing of a given than the translation of a given into an idiomatic percept, into the construct of a certain sensory consciousness. Put another way, the monologuist/street photographer translates the given into something virtual or latent, something which has yet to realise itself in all its possibilities. Is this to say that the interior monologue and the street photograph reach further into the unconscious than realist narrative and the documentary photograph? Dujardin certainly thinks so:

> Interior monologue is, in the order of poetry, a discourse unheard, unspoken, through which a character expresses his most intimate thoughts, those that lie nearest to the unconscious, prior to any

logical organisation, that is to say, in their embryonic state, by means of direct speech reduced to a syntactical minimum, so as to give the impression of unsorted input. (1931: 59)

The sense of 'unsorted input' is what gives this 'walking art' its polyphonic nature: sensitive to all the solicitations of the environment, the street writer/photographer is equally subject to the multiple voices in his own psyche. As we finally come to an encounter with a short extract from Dujardin's novella, we may feel not only how polymorphous and multidimensional it is, but also how much like a photographic contact sheet, a series of swiftly notated images, which are all parts of a whole, parts of an evolving locality:

> The noises grow louder; it's the place Clichy; let's get a move on; without a break, long dismal walls; on the asphalt a denser shadow; now girls, three, talking amongst themselves; they don't notice me; one very young one, slightly built, brazen look, and what lips! in a bare room, dimly outlined, high-ceilinged, bare and grey, in a smoky candlelight, in the somnolence of the tumult of the crowded street. (2001: 84)

Here we cross the line between independent clauses and shorthand phrases, clauses with main verbs and verbless syntactic fragments, and between true notations of response ('on the asphalt a denser shadow', 'and what lips!') and descriptions, for the readers' benefit, of decor or event which, for the subject, would only be perceived, not expressed ('The noises grow louder', 'they don't notice me'). And in the final stages of this passage, Daniel launches into a sexual fantasy, in which the earlier semi-colons give way to commas; these commas imitate a projective, freewheeling consciousness rather than a receptive, self-protective one, in which barriers of articulation are reduced to a minimum, so that the mind can respond immediately to its drives in an accelerating pursuit of pleasure. The punctuation allows the accumulation of different perceptions and observations within a single existential field, all suspended, as it were, in the same psychic medium.

We find the same swift notation of urban phenomena in the rhythmically variable free verse of the Imagist poets (1913–17; e.g. Ezra Pound,

F.S. Flint, Richard Aldington, Amy Lowell). But the Imagists are not so much looking to accumulate a contact sheet of exposures as to capture an instant of transformation, when a snapshot turns into an instant of illumination, when the real supplies momentary epiphany. In these instances, the very speed of perception, the instantaneousness, is the agent of the transformation, the alchemical catalyst. When we shift from the first line of Ezra Pound's celebrated 'In a Station of the Metro'[4] to the second,

> The apparition of these faces in the crowd;
> Petals on a wet, black bough.

we pass through that 'precise instant' which, Pound tells us, this poem is all about, 'when a thing outward and objective transforms itself, or darts into a thing inward and subjective' (quoted in Ruthven, 1969: 153). It is as if the shutter of the street poet's eye, like that of the street photographer's camera, has the power to create a channel of communication between the literal and the figurative, the given and the possible, the seen and the hallucinated.

Street photography obliges a careful assessment of the meaning of the instant. Elsewhere (1999: 37–8), I made a distinction between the instant and the moment, based on the proposition that the instant is a 'digital' experience, seized only in itself, as the smallest division of psychological or perceptual time. In fact, it is so limited, both temporally and experientially, that it tends to exclude us, to evict us from ongoing process. In their instantaneousness, things are taken away from us, fall behind us, are rendered insignificant by a once-only-ness. The moment, on the other hand, is an 'analogue' experience of time and perception; we actively live moments in relation both to other, adjacent moments, and to other time. Because of this power of relation, the moment seems expandable, both spatially and tempo-rally; we feel able to inhabit it and be inhabited by it, have a greater sense of subjective presence. We are, in this momentary experience, susceptible to the beckoning of memory and feel a power to persist. I suggested that this distinction between instant and moment paralleled

Benjamin's distinction between *Erlebnis* and *Erfahrung*, between, on the one hand, the modern kind of shock experience, by which we are constantly beset and which we defend ourselves against, close ourselves off from, and, on the other, the kind of experience which is admitted, digested over time, becomes part of our developing inwardness and is accessible to memory. I would want to suggest that the taking of a photograph is an attempt to transform an instant into a moment, or, put another way, to extract from the instant the moment it has within it. The ability of the photograph to 'spread' the instant into the moment is much aided by the tendency of a photograph to shift from indexicality to iconicity, to shift from indexicality with a referent to indexicality without a referent.

This distinction is, I think, an important one, but we shall not be able to maintain it in the terminology we encounter, simply because so many of our subjects seem to treat 'instant' and 'moment' as synonyms. Most obviously, Cartier-Bresson's 'instant décisif' is translated as 'decisive moment'; and this crossover is further complicated by the fact that Cartier-Bresson's epigraph for his essay, a quotation from Cardinal de Retz, reads: 'There is nothing in this world which does not have a *decisive moment*' (my emphasis). In many senses, Cartier-Bresson is certainly the photographer of the instant that too quickly disappears:

> Of all the means of expression, photography is the only one that fixes for ever the precise and transitory instant. We photographers deal in things which are continually vanishing, and when they have vanished, there is no contrivance on earth which can make them come back again. (1952: 44)

And yet Cartier-Bresson still speaks the language of essence and distillation, and for all his commitment to the photographic series of reportage, he still dreams of the single satisfying image.[5] And his 'instant décisif' does sound like an instant transformed into a moment, transformed, that is, by an equilibration of forms and forces which creates a sense-giving dialogue between the scene's constituents:

In photography there is a new kind of plasticity, product of the instantaneous lines made by movement of the subject. We work in unison with movement as though it were a presentiment of the way in which life itself unfolds. But inside movement there is one moment at which the elements in motion are in balance. Photography must seize upon this moment and hold immobile the equilibrium of it. (1952: 47)

We shall run into terminological problems, too, if we want to pursue the already implied parallel between the Imagists' instant and the instant of street-photographic taking: we have already encountered Pound's 'precise instant' when 'a thing outward and objective transforms itself, or darts into a thing inward and subjective', and his more celebrated definition of the image, as 'that which presents an intellectual and emotional complex in an instant of time', has the more spiritually fruitful, the more temporally expanded, dimensions of the moment in view, as his further explanation makes clear:

It is the presentation of such a 'complex' instantaneously which gives that sense of sudden liberation; that sense of freedom from time limits and space limits; that sense of sudden growth, which we experience in the presence of the greatest works of art. (1960: 4)

We shall want to argue that the street-photographic epiphany is not quite as dramatic and existentially overwhelming as this; nonetheless, the general model of growth and expansion seems to be as apposite to photography as to poetry.[6]

We shall return periodically in the coming chapters to the issue of instantaneousness, but certain aspects of its complexity ought already to be addressed. The photo-instant is often looked upon as a fragment of time, of evidence, snatched from a continuum, which one can replace in that continuum, so that the continuum gives it back its meaning; alternatively, one can leave the photograph to find a new life for itself as an autonomous image, in which case the instant of taking will become increasingly arbitrary as an instant *in* time, and more significant as an instant *of* time, where the time itself – 1929 or 1957, say – matters less and less.

Our present question is really how the instant, deprived of the significance of the temporal sequence in which it takes place, engineers a new role for itself. Clearly, we need to imagine a photograph in which the instant is not a slice of some other temporality, outside it, but a momentary gathering together of its own spatiality and temporality. What we are suggesting is that the taking of a photograph should, in a sense, turn time inside out. The instant is not (any old) part of a temporal flow which subsumes it as time, or leaves it behind as a paper object; the instant is, rather, something of potentially infinite proportions, because it immobilises not only the totality of space but also the totality, not of time, but of available temporalities. What the photograph, the photographic frame, does is reduce the perceptible portion of these totalities. But notions of coincidence, convergence, confluence remain paramount. The instantaneous photograph performs the convergence of angles, spaces, lines, planes, figures, objects which we call composition, and of which we shall have more to say in a moment. But it also performs the coincidence of different temporalities, timescales, different speeds of perishability. A closed book is 'slower', more 'durable', than an open one, a knife set perpendicularly to the table-edge more stable, 'slower', than one set diagonally; a chair is slower than a fruit, a building than a cloud. As we look at the instant of an Impressionist painting or of a street photograph, we see it as, among other things, a weave of times, seen, for that instant, in cross-section. One of the poignancies of Kertész's photograph of the *Steps of Montmartre* (1925-27) (Figure 11) is the way in which the ubiquity of the instant of the photo's taking is expressed by the shadows, the signature of the light at a particular time. The shadows themselves endow each element – railings, trees, seated man, walking woman – with ostensibly the same temporality, which we know to be false: the railings are moving faster through existence than the trees, whose cyclical time is also more resilient than the linear time of the human figures; the male figure sitting at the base of the lamp post borrows some of the lamp post's immutability, while the walking woman is peculiarly alone in her transience. The Impressionist painters exploit

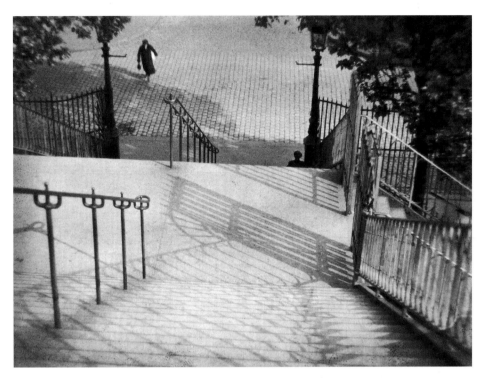

FIGURE 11 André Kertész, *Steps of Montmartre* (1925-27)

similar effects, but can counterpoint the different temporalities of objects with the different temporalities available in the manner of the paint's application. In Renoir's *The First Outing* (1875-76), for example, we might argue that the comparatively rough, sketchy painting of the audience members, visible beyond the young girl's box, casts them as part of the theatrical illusion; the young girl's excitement generates a vision of her co-spectators as insubstantial, transitory apparitions, no more lasting or material than the spectacle they are about to behold on stage.

The instant of the painting or photograph is the moment of the coincidence of different durations. The camera creates the instant by seeing instantaneously. We can perceive the instant, but we cannot see instantaneously, even though the eyelid seems so akin to the shutter: the muscular effort and concentration involved in rapidly

opening and closing the eyes prevents any effective perception. Impressionist painters can transfer this impossible instantaneousness of the eye to the hand, to the feverish speed of the brushstroke. In the photographer, if we are to go by Cartier-Bresson's description, this instantaneousness of the eye takes a slightly different form. Put briefly, the photographer calls upon the camera to perform this instantaneousness, while investing the release of the shutter with the full force of his existential presence. Sometimes, Cartier-Bresson speaks of the combined participation of intuition, sensibility and understanding, sometimes of the coordination of brain, eye and heart; and in his short essay 'L'Imaginaire d'après nature' ('The Imaginary Taken from the Life'), he writes:

> To take photographs is to hold one's breath when all faculties converge in the face of fleeing reality. It is at that moment that mastering an image becomes a great physical and intellectual joy. (1968: 4)

Instantaneousness, then, is this state of hypersensitive alertness, this tension of the whole self towards the temporal wave-crest, which the shutter will release. But Cartier-Bresson's prey is not the instant as coincidence of temporalities so much as the momentary harmonisation of structural components.

How, then, does composition relate to the instant? Looking at Cartier-Bresson's account, we might suppose that the instant is the point at which composition emerges, for a split second, from the surrounding plethora of percepts, bringing with it meaning, orchestratedness. But the sense of composition here is one that too much belongs to the photographer, as a preconceived aesthetic. However much Cartier-Bresson may insist that geometries can only be discovered after the fact, after developing and printing, however much he may deplore the day when we can buy cameras with compositional schemas built into the viewfinder, the compositional configurations intuited by the photographer are still the time-honoured ones: 'In applying the Golden Rule, the only pair of compasses at the photographer's disposal is his own pair of eyes' (1952: 47). But this observation should be qualified

by two further remarks. First, while composition for Cartier-Bresson is doubtless a value in itself, self-justifying, it is also a vital instrument in the *intensification of vision*: 'If a photograph is to communicate its subject in all its intensity, the relationship of form must be rigorously established' (1952: 46). In other words, it might be argued that composition principally serves not the integrity of the photo as image, but its immediacy as visual communication. Second, it is not far from Cartier-Bresson's preoccupation with composition as the coordination of visual elements, of surfaces, lines and values – 'In a photograph, composition is the result of a simultaneous coalition, the organic co-ordination of elements seen by the eye' (1952: 46) – to the notion that the 'instant of composition' is the means by which one opens a door in the complexity of the moving, a door into reality's unconscious (compare Benjamin's notion of the 'optical unconscious' (1999: 511-12)), a door into the Underworld, a door which leads from the chronometric time of the world into the Bergsonian duration of the observer. This takes us back to the Imagists' instant of transformation, of which we were speaking earlier. While documentary photography may well use composition as part of its rhetoric of intensity, it has no interest in instantaneousness as a corridor into what cannot be seen.

But there is a further twist in this argument about composition, to do with the bi-functionality of the photographic frame: in brief, the frame of the print is not the same as the frame of the viewfinder, and an awareness of this double being ambiguates the nature and role of a photograph's composition. The clue to this relationship between composition and the frame is to be found in Mallarmé's capital discussion of Impressionism, with particular reference to Manet's *The Washing* (1876), which appeared, in English, in the *Art Monthly Review* (September 1876) and whose French original has apparently been lost (Florence, 1986: 11-18). Before going on to discuss the frame, Mallarmé has this to say about Manet and composition:

> Then composition (to borrow once more the slang of the studio) must play a considerable part in the aesthetics of a master of the Impressionists? No; certainly not; as a rule the grouping of modern

persons does not suggest it, and for this reason our painter is pleased
to dispense with it, and at the same time to avoid both affectation and
style. (Florence, 1986: 15)

What, then, holds the picture together, establishes it, if only for a
moment, Mallarmé asks? The new science of framing is his answer.
This new science has to do with the shift of the frame from the sup-
port itself (page, canvas) to the eye (viewfinder): Mallarmé cites the
example of someone using their hands to frame a scene. The eye-frame
of photography is an act of *isolation*, of decisions about inclusion and
exclusion, in a way that the support-frame is not; in painting, the frame
itself is not an instrument of visual interrogation. In photography, the
eye-frame is not only what makes the viewfinder/camera an optical
prosthetic; it also invites processes of reframing, either as part of the
compilation of a contact sheet, or within the darkroom.[7] For Mallarmé,
the frame, as a result, has 'all the charm of a merely fanciful boundary'
(Florence, 1986: 15).

In adopting the eye-frame of the photographer, the Impression-
ist painter is making available to himself that option that seemed
peculiar to photography: the frame which *generates* composition, or,
more properly, registers the impulse to compose. But the fact that
elements of structure can be identified in a painting or a photograph
does not guarantee that it is composed; indeed Christian Phéline (n.d.
[1985]: 21–33) is of the view that structure within Cartier-Bresson's
photographs deconstructs as much as it constructs.

But equally, in its printed finality, the photograph also has a support-
frame, a frame that encourages us to believe that the picture was
composed in relation to that frame, *within* that frame, according to
the frame's formal dictates. We now think of composition as something
settled, as something to be identified rather than generated, and in
this way we are able to feed back into the image some of the (artistic)
intentionality that was missing in the manipulation of the eye-frame.
Clearly this discrepancy or ambiguity between eye-frame and support-
frame is not common to, or exploited by, all photographic genres: we
might propose that documentary and portraiture tend away from the

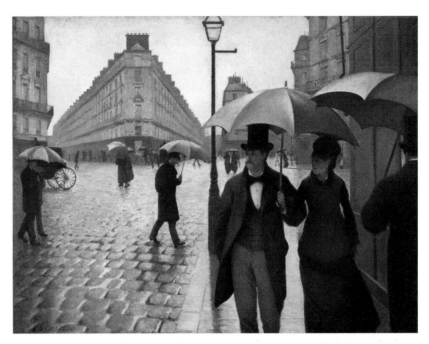

FIGURE 12 Gustave Caillebotte, *Paris Street, Rainy Weather* (1877)

eye-frame towards the support-frame; and the use of a fixed camera (tripod) is obviously an implicit request to be judged by the standards of the support-frame. Equally, we would need to propose that while, in photography, the two kinds of frame can be separated as between the moment of taking and the moment of printing, in Impressionist painting we have to think of them as combined in a single set of acts, the acts of painting.

What are the consequences of this ambiguity? Peter Galassi and Kirk Varnedoe (Varnedoe, 1987: 34–40, 88–90) are at pains to reveal Caillebotte's strenuous compositional planning in *Paris Street, Rainy Weather* (1877) (Figure 12): structured on a giant plus sign, the canvas places figures in positions plotted according to the perspectival plan and 'harmonic proportional divisions' (golden sections). But as Galassi points out: 'The presence of the golden section proportions tell us less about the viewer's experience of the picture than about Caillebotte's

experience of it and its making – that is, about his intention' (Varnedoe, 1987: 38). We might suggest that, in an order that reverses that of the photograph, Caillebotte wants the painter's support-frame to become the spectator's eye-frame, and accordingly for his own compositional intentions to be reformulated (as the same or something different) by the spectator. And that 'something different' may include the inability to make compositional sense, which, in turn, would reveal a possible meaning of the picture. Varnedoe draws attention to 'a subtle rhythm of regularity throughout'; but the repetitions of paving stones, chimneys, windows, umbrellas (a) are not rhythms in any 'cultivated' sense of coordinated *grouping* (repetition can be stultifying) and (b) create a set of jarring, mindless collisions. I also find the structural cacophony of overlapping street corners (top right) disorientating. I cannot reconcile images of alienation and isolation in space (left) with images of intimacy and enclosed space (right). In short, the picture-bisecting lamp post (and its reflection) dramatises the collision of two visions of the city, two cities.

But what is important in all this is not so much that I find incoherence in an apparently carefully planned view, or that planned structure actually serves incoherence; it is that the presence of the frame activates this structural interrogation, enjoins the spectator to 'read' the connections that the frame has brought into existence, without providing any guarantees of a visual resolution. The instant makes the frame which momentarily choreographs a field of forces. If that field of forces existed in a comfortable resolution, then in some senses (*pace* Cartier-Bresson) the whole point of instantaneousness would be lost; the very composedness of the picture would shake off the urgency of the instant. We want an instant transformed into a moment, but not because of some pre-emption of the instant by composition, not at the expense of the photograph's instantaneousness. We want a photograph in which the urgency of the instant repeatedly 'darts into' the duration of the moment, without ever installing a visual complacency.

Maurice Bucquet's pictorialist street photograph *Rainy Day in Paris* (*c.* 1898) (Figure 13) looks, in many respects, like a lateral reversal of

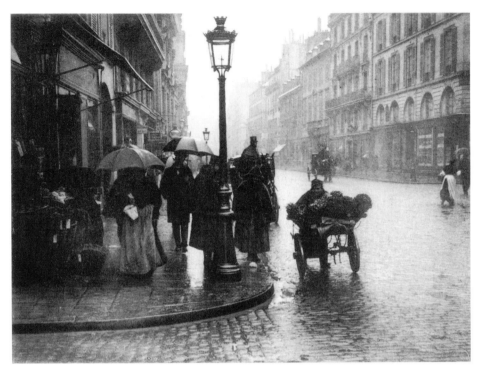

FIGURE 13 Maurice Bucquet, *Rainy Day in Paris* (*c.* 1898)

Caillebotte's picture;[8] the scene-bisecting lamp post places the human proximities of the pavement on the left, while the individual cabs, traders, pedestrians negotiate the unmapped spaces of the street on the right. The singleness of the central vanishing point makes the image more emphatically symmetrical, but the foregroundedness of the left side, set against the relative backgroundedness of the right, with some leakage of left foreground across to the right, upsets this balance, and leaves the eye as if swivelling on itself. And Renoir's unfinished *The Umbrellas* (Figure 14), painted at two different times, in different styles (right-hand side *c.* 1881, left-hand side *c.* 1885) seems to be have been left uncompleted because he could not (bring himself to) find a structural way out; that is, in resuming the painting of the picture in 1885, Renoir, as it were, reframed the scene, looked at it from another angle, so that, as it is, the woman to the left vies with the girl to the right

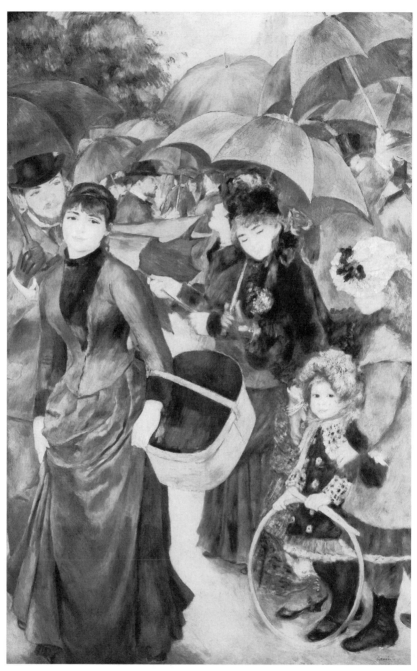

FIGURE 14 Auguste Renoir, *The Umbrellas* (1881/1885)

for the spectator's attention, while the swarming umbrellas behind create a turbulence of half-glimpsed vignettes, of faces, torsos, hands, that refuse to let even these posed foreground figures settle. And the blues scattered across the canvas in various hues and densities, while providing cohesion, help, paradoxically, to undermine coherence. So we have images in which the eye-frame, with its nervous readiness to reframe, or to select arrangements which invite and frustrate, rather than satisfy, compositional urges, maintains the dynamic, the fluidity, the changeability, of the street scene. The street becomes a place in which our eyes are not led to a targeted sight, so much as activated, made restive, left endlessly to reformulate the imaginary.

It is possible to observe the same framing habits in written street photography. The Goncourt brothers, Edmond and Jules, kept a journal from December 1851. When Jules died in June 1870, Edmond did not resist for long the temptation to maintain the journal, up to his own death in July 1896. In its early years, the journal constituted a kind of prototype of the Impressionist urban text, as Edmond makes clear in his 1872 'Preface':

> We have portrayed these men and women as we saw them on a given day and at a given hour, reverting to them in the course of our journal, displaying them later in a different light, according to the changes and modifications they had undergone, and doing our best not to emulate those compilers of memoirs who present their historic figures all of a piece or paint them in colours grown chill and damp with the recession into the past of their meeting. In a word, our ambition has been to show changing humanity in its *momentary reality*. (Baldick, 1984: xix)

And in their efforts to preserve the living immediacy of this 'momentary reality', the Goncourts remain true to habits of eye-framing. This is their somewhat salacious portrait of a peasant girl, encountered on an omnibus in Paris on 1 April 1869:

> Sitting in an omnibus next to a little peasant girl who looks as if she has just arrived in Paris to go into service. She finds it impossible to sit still. Try as she might to strike serene attitudes, to keep her

arms folded without moving, she seems to feel, in this huge and overwhelming Paris, a kind of restless embarrassment, a shy and agitated anxiety, but full of curiosity at the same time and constantly turning her head to the window-opening behind her. A little dumpling, in a white bonnet. Like a goat rubbing itself or as if she were infested with fleas from her native province, she keeps straightening her back and the small of her back, already soft and lascivious and ready to assume the shapelessness of the Parisian streetwalker, against the back of her seat. Alarmed like an animal in a wagon, biting her nails, absent-minded, happy, somewhat frightened, mumbling, muttering things to herself, then yawning with fatigue. (1956: 213)

This passage is guided by a present tense of commentary. Notations are jotted down, it seems, as they occur. We do not know who this girl is: this is a portrait of appearances. Her main characteristic is her fidgeting. In some senses, the peasant girl personifies the kind of self-making and self-undoing structure we are talking about. This piece of writing has a frame: it is a separate entry in a journal, and has certain features of cohesiveness, for example, the part played by animals – surprise, surprise – in this description of a peasant ('goat', 'fleas', 'animal'). But her actions, her changes of posture and expression, tumble over each other in such quick succession that the Goncourts cannot quite seem to identify structures beyond a certain limited point; and, if anything, these incipient structures, far from confirming each other, throw each other into question, so that the text continually threatens to unravel. The frame leaves the composition still to find. The composition is, in fact, a collection of glimpsed structures, as mobile as the reality from which they seem to have been snatched.

From time to time throughout this chapter, and not least in these final paragraphs about the distinction between the eye-frame and the support-frame, we have been tempted to differentiate between street-photographic and documentary practice. It is the plausibility of this differentiation that we will now go on to explore more systematically.

2

the street-photographic
and the documentary

In an article of 1942, Berenice Abbott appeals to those who wish to document the city to use cameras of as large a format as possible. This appeal begins to suggest that documentary photography was an essentially retrospective photography, a photography, indeed, prepared to court anachronism. Technologically, street photography was wedded to the development of the small format camera – Ermanox from 1924, Leica from 1925, Contax from 1932 – and to the concomitant mobility of point of view, and speed both of use and of exposure. August Sander and Albert Renger-Patzsch used large-format cameras throughout their photographic careers; Abbott and Walker Evans turned to large format around 1930, precisely at the time when the small format had come fully into its own (see Lugon, 2001: 128-9). Their change of technology was no doubt a polemical gesture. Yet this wilful self-marginalisation also points to other expressive intentions: the documentary photographer, as it were, accepts a vocation in which temporality moves at another pace, in which vision is steady and undistractable, in which posing is not so much the choice of the subject or of the photographer as a requirement of the *camera's desire to see* – in this sense the subject both makes demands on the viewer by the returned look, and submits

to the interrogation of the camera in a way which may risk victimising the subject, but which at the same time authenticates the subject and guarantees the reliability of the evidence. In short, the camera bestows on the subject his/her credentials as a witness.

But more troublingly perhaps, this technological choice implies the choice of an 'archival' or 'archivalising' approach, to which we might attribute two meanings: first, a bending of the documentary photograph to the photograph as document; that is to say, the quality of the print, its account of detail, texture, and so on, endow it with a substitute status: no longer an aide-memoire or representation of the thing seen, it becomes the thing seen itself, the very source material of a particular collection of visual facts. Second, it may seem to take the photograph out of the world, establish it as a permanent record, as part of a series of specimens whose fate has already been sealed, about which nothing further is to be done other than, precisely, to make a record. Just as Charles Marville compiled an archive of images of a Paris about to disappear, so Sander, say, or Abbott, consign their subjects, with all the respectful pomp of an interment, to an extinction which leaves the photograph, once again, as the substitute source.

What is it that documentary photography and street photography might be said to share? First, a long-time devotion to black-and-white, as the guarantor of authenticity (strangely), as that which 'reads' reality, reaches through colour to underlying truths, as that which organises the world and gives it coherence through the careful gradations of tone, as that which ensures a certain austerity, a denial of self-indulgence, a non-glamorising steadiness of vision, as that which allows greater technical control. These virtues may have been defended in absolute terms, and still might be; but we must remember that even by the 1950s, colour photography was still a complex and unstable process. As Cartier-Bresson puts it in 1952:

> Colour photography brings with it a number of problems which are hard to resolve today, and some of which are difficult even to foresee, owing to its complexity and its relative immaturity. ... Personally, I am half afraid that this complex new element may tend to prejudice

the achievement of the life and movement which is often caught by
black and white. (48)

Marc Riboud, for his part, is of the view that 'Colour adds to the
problems, the risk of wrong notes. ... We also depend a great deal on
the conditions of reproduction. Still more one must beware of the
"pretty", the "spectacular"' (Borhan, 1980: 78).[1]

If there is one crucial difference between street-photographic black-
and-white and documentary black-and-white, it is the nature of that
underlying something that black-and-white is able to penetrate. For
the documentarist, we might simply define this something as the
human condition. For the street photographer, it is the adventures
that lie dormant in a street, at a crossroads, in a market, adventures
generated by the secret forces at work just below the surface of things.
Colour mingles uninquisitively with life itself; black-and-white has the
capacity to isolate the mystery which swirls unseen around us. This is
an argument particularly pursued by Pierre Mac Orlan:

> Adventure is inscribed in black and white. Black and white are purely
> cerebral colours. They are efficient conductors of all the secret forces
> that govern the universe for the sole and definitive benefit of lyrical
> invention which alone carries its own explanation within itself: an
> explanation based on the seductive mysteries of the five senses. (1965:
> 302)

A further point of contact between the two photographies lies in
their shared pursuit of the typical. Willy Ronis tells us: 'I have never
pursued the unusual, the never-before-seen, the extraordinary, but
rather what is most typical in our everyday life' (Hamilton, 1995a: 7).
Brassaï seems to express himself in similar vein (1951): 'But contrary
to the trend in American photography, I do not search out exceptional
subjects, I avoid them. Because I think that it is daily life which is
the great event, genuine "real life"' (2000: 58). I say 'seems' because
Brassaï's remarks also reveal a critical difference. He further expresses
his conviction that it is the photographer's mission in contemporary
life 'to seize those rare and moving instants in his surroundings'

(2000: 58), and to make of these an 'imagiary' (as in 'bestiairy'), a set of mirror images in which man would recognise himself. The rare in the banal? The new in the known? The moving in the conventional? How we explain these apparent paradoxes will vary. The space in which we move is full of photographs that we never see. And it only requires a small change of position for that collection of photos all to be different. We might say the same about time and the multitude of ways it rearranges our space. We might just say that it is the camera which introduces the new and rare and moving, simply because it sees differently (focus, flattening of space, rereading of scale, black-and-white, etc.). But what we fundamentally return to is the frame, and two crucial effects.

First, the process of *exclusion* involved in the eye-frame creates an ignorance (of context, narrative). This installation of ignorance is vital because (a) it reactivates the blind field not as known or know-able, but as a space of the imaginary, and, relatedly, (b) it renders the banal, conventional, etc. suddenly enigmatic and *renewable as reality.* Kertész's de Chirican *Meudon* (1928) (Figure 15) is a picture of traversals – train on viaduct, man with package in foreground – pulling in opposite directions, but put in contact with each other by the central pillar of the viaduct. What secrets do they share? What fatal object or image is wrapped in the newspaper? This man begins to assume the lineaments of the newly arrived passenger in W.H. Auden's 'Gare du Midi':

> ...Clutching a little case,
> He walks out briskly to infect a city
> Whose terrible future may have just arrived.

And this is not so much because the air is full of foreboding: quite the opposite – it is the unsuspectingness of this street, of its passers-by, that makes it vulnerable, that creates the gap in purpose and attention which a crime or disaster is only too ready to exploit. Longitudinally, we discover in this picture a similar tension of trajectories, this time gendered, between a trio of men moving *down* the street towards the

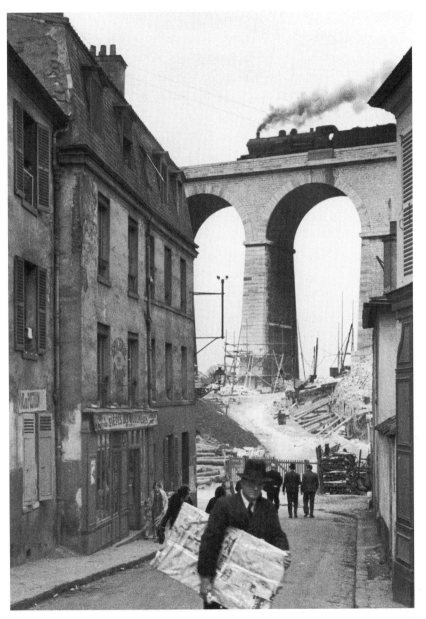

FIGURE 15 André Kertész, *Meudon* (1928)

viaduct's construction site, and women, a girl, making their way *up* the street, effortlessly, past the dilapidated houses. The frame confronts us with an everyday, familiar picture, but imposes an unusual scrutiny, challenges us to make sense, even as it removes the reference points which might facilitate such sense-making. Something is happening on the street, something is happening in the eye, but the image itself withholds its motivations. The 'invisibility' that the documentary photograph brings to light, on the other hand, is not the invisibility of what we cannot see but, precisely, the invisibility of what we usually refuse to isolate, to treat as a special case.

Second, in the case of street photography, the implementation of a potentially peripheral point of view (oblique, plunging, asymmetrical, close-up, disseminated) throws into question what the subject is. This ambiguation clearly frees the eye to explore, without prejudice, to find its way by glancing, to continually recycle the process of looking. Heiko Lanio's recent photograph of the doorway of the Plaza-Athénée hotel in the avenue Montaigne (2002), by contrast, adopts a documentary frame, inasmuch as, although not frontal, it centres up its subject: the doorkeeper, imperturbable, self-assured in a context of art-nouveau luxury and tidiness, the Cerberus of privilege, the defender of laws of class and of plutocratic identity, in a Paris street which takes little account of such things. If documentary photography is a restabilisation of *being*, however fortunate or unfortunate, street photography is about *eventfulness*, either in the subject or in the eye. Arthur Symons, following in the footsteps of Degas's and Zola's (*Nana*, 1880) exploitation of unusual views of the stage, makes clear what renewal of vision the peripheral angles of street-photographic seeing might bring:

> To watch a ballet from the wings is to lose all sense of proportion, all knowledge of the piece as a whole; but, in return, it is fruitful in happy accidents, in momentary points of view, in chance felicities of light and shade and movement. It is almost to be in the performance oneself, and yet passive, as spectator, with the leisure to look about one. (1896; quoted in Ledger and Luckhurst, 2000: 68)

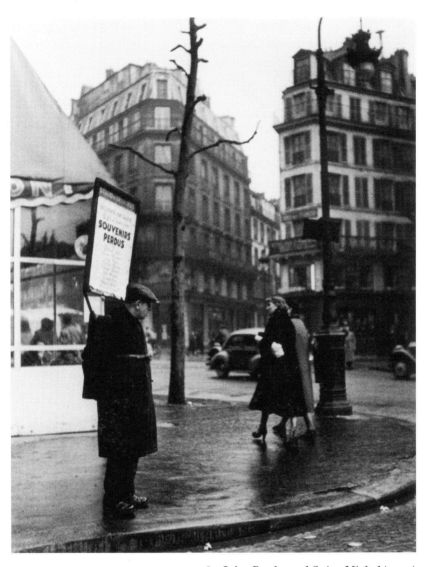

FIGURE 16 Izis, *Boulevard Saint-Michel* (1949)

If documentary photography justifies its transfixation of the subject through implict affirmations of destiny, street photography maintains its transformative capacity through a lively relationship with chance. If documentary photography draws us towards confrontation, looks to exert a moral pressure, street photography affects detachment and courts communal irresponsibility in the name of uncontrolled individual responses. If documentary photography looks to turn the relative into the absolute, street photography looks to do the reverse. If documentary photography looks to espouse Barthes's notion of the *lisible* (readerly), street photography is more at home with the *scriptible* (writerly) (see below). If documentary photography suggests a world that is ever funnelling down to a restricted range of predicaments, street photography makes its home in variety and proliferation. If the documentary photographer presents himself as the public servant, the street photographer gets by as the unattached *flâneur*.

In summary we might ask why it is that Izis's photograph of a boardman in the boulevard Saint-Michel (1949) (Figure 16) is a street photograph rather than a documentary one. If this photograph were documentary, we would expect it to imply that the boardman's condition was inescapable and long term. (How can he represent a type, if the condition has not had time to seep into his appearance, to motivate his gestures and actions?) We would expect the contingencies of the particular scene to act merely as the *parole*, or surface structure, which the *langue*, or deep structure, of 'boardmanness' is able to generate without itself undergoing change: these are the transformations of a performance which changes nothing, which, paradoxically, only serves to confirm the governing principles of the deep structure. We might expect, too, a 'rhetoric' of context which would confirm the unequivocality of the meaning, as here the bare tree which has nothing to show for itself, or the lamp post cropped of its lamp. The 'readerly' text is the text which it is only possible to consume, passively, where, to use Barthes's own terms, 'reading is no more than a *referendum*' (1974: 4), the ability to accept or reject. The readerly text is the text which makes a virtue of self-confirm-

ing wholeness, which institutionalises itself, in the sense of existing beyond interferences from the present. One might think that focus here also helps to underline the documentary value of the image: it isolates the boardman in a shallow foreground and seemingly denies him access to the slightly out-of-focus street context (café, pavement, roadway). His interest in the passers-by is not returned; his concern for appearance (his shining shoes) opens no doors to respectability. The place of his social immobilisation is the pavement's edge.

But, as spectators, we find that all this potential tendentiousness and moral pressure dissipates before our very eyes. We quite literally make this picture writerly for ourselves, by picking up the name of the cinema, 'Studio des Ursulines' (are these two passing women potential nuns?), and the title of the advertised film, 'Souvenirs perdus' ('Lost Memories') (is the whole scene a memory we have lost, or will lose? are these women the lost memories of the boardman? is it just the out-of-focus café and street which are drifting into a past and which have no more substance than a memory on the brink of extinction?). If we think of the viewer less as a 'yes or no?' consumer and more as a 'which one?' customer, then we see how the writerly works: it never loses its presentness, because it is always being different, a perpetual present 'upon which', again to quote Barthes, 'no *consequent* language (which would inevitably make it past) can be superimposed; the writerly text is *ourselves writing*, before the infinite play of the world ... is traversed, intersected, stopped, plasticized by some regular system (Ideology, Genus, Criticism) which reduces the plurality of entrances, the opening of networks, the infinity of languages' (1974: 5). This proliferative trend is acted out in the collection of photographs to be seen framed in the café windows, the topmost of which is a fragmentary reflection of the tree. All that which is not the boardman is suffused with instantaneousness; in fact, to return to our linguistic analogy, derived from the terms of Saussure and Chomsky, this is an image in which *langue*, or deep structure, cannot hold its own against *parole*, or surface structure: the performance of any street is greater, at any one time, than the sum of its components, to which it cannot be reduced.

And, besides, the surface structure is never still. The documentary is always looking for the right classification, the founding type, a grammatical syntax of relationships. The *parole* of the street, on the other hand, is generated by, and generates, chance, and its syntax is so loose that we can never quite know what should connect with what, nor on what understandings. But a street photograph does not require a consensuality among its viewers. Each viewer, according to their own 'take' on the image, will find their own particular kinds of visual fruitfulness.

This photograph sets the documentary against the street-photographic and seems to allow the latter to absorb the former; and we will find other instances where the reverse is true. And as the process of absorption takes place, so our ethical and social personae as viewers will also change. Most commentators on the documentary photograph would agree that the viewer must belong to the charitable classes. For that reason, as Rosler points out (1992: 304), 'documentary photography has been much more comfortable in the company of moralism than wedded to a rhetoric or program of revolutionary politics.' Only if such photography were addressed to the social equals of the subjects within the photograph would a revolutionary rhetoric be appropriate. Furthermore, it is in the interests of the photographer-spectator contract that any ills presented should be seen to be socially inbred rather than adopted by the subject and tolerated by the viewer. The viewer of street photographs, on the other hand, is the detached, classless (but with left-wing sympathies) *flâneur*, for whom each photograph is a chance encounter, designed to trigger an unselfconscious spontaneity of response, free, shifting, made of insight, amusement, sentiment, but uninsistent, and of uncertain duration. If the posed, 'frontal', 'centred up' compositions of the documentary tend to victimise the subject, or at least to render the subject docile to a photographic intention, street photography's predominant commitment to operating unobserved – hence the fostering of peripheral angles of vision – does not serve candour so much as indocility, the untamed.

We have, on Barthes's instigation, introduced a distinction be-
tween a readerly consumer and a writerly customer. This seems an
appropriate moment to essay a distinction between the ways in which
the documentarist and the street photographer present consumable
goods, and to suggest not only that, in Atget's photographic work,
there is a gradual shift from readerly consumer to writerly customer,
but also that a distinction between *vendor* and customer might better
serve our purposes.

The images Atget offers us in the late 1890s and early 1900s are
frequently open-air displays: the fowl, fish and meat stalls of Les
Halles, or the displays of street fruiterers – even as late as 1910 we
find a *Fruit Shop, rue Mouffetard*. These images promote a view of
trade as social cementing, as the evidence of a concert of resources
and resourcefulness, as the map of the seasons and of a culture, as a
celebration of that which can be put to use. Price tags tell us directly
about economic conditions, costs of production, relative scarcity, and
at the same time strike an ironic note: stalls and shop windows have
always had a cornucopian dimension which is never far from being
a taunting derision of customers in straitened circumstances; and
the open-air accessibility of these stalls only serves to heighten the
cruelty.

In these images, we might be lucky enough to see stallholders but not
customers. These photographs are consumable objects which already
have a *raison d'être* and about which, therefore, questions relating to
waste, turnover, distribution, customer satisfaction, may be asked.
The documentarist wishes to instigate critical thinking from a reliable
base, a base into which change could be introduced but which is itself
unchanging – this is how the meliorist agenda works, propelled by a
central paradox: the viewer is the agent of change, and in order to
validate that role the viewed must be shown to be mired in a position
made doubly inescapable by the intricacy of the deterministic network
in which he/she is caught. Photography itself is a documentary medium
precisely because it is an instrument of immobilisation, of the fait
accompli, that from which nothing new can ever emerge. And the

absence of personnel in Atget's images only serves to underline the unmalleability of the situation: the wares are not the source of *social* exchange, of moments at which different classes make contact and a new system of dependencies comes momentarily into existence. In Atget's work, the stall is presented as the terrain across which age-old socio-economic struggles have been waged.

If we looked at Pissarro's treatment of market stalls, on the other hand – the two Parisian market scenes in black chalk and watercolour of 1889, *A Corner of Les Halles* (Figure 17) and *The St Honoré Market* – we would find ourselves directly among the shoppers and stallholders, invited to glance and duck, to disseminate our attention as an incorporative and communal activity. Thomson (1990: 73) is of the opinion that, in these pictures, 'we literally side with the stallholders, facing the bonneted bourgeoises across the produce, the means of exchange'. But this is to imagine the encounter rather too abruptly. It is easy to imagine these stalls as festive tables, as structures which make it difficult to determine who is selling and who buying, as opportunities to throw the etiquette and hierarchies of communicative exchange back into the melting pot. Once again, the 'street-photographic' works to turn away from confirmation towards opportunity, invites the viewer to engage in fruitful fictions (possibilities).

If Pissarro's work shows one direction out of the documentary into the street-photographic, we find another adumbrated in Atget's early *Dealer in Second-hand Goods, boulevard Edgar-Quinet* of 1898 (Figure 18). The trade itself (bric-a-brac) is a crossover point between the documentary (recycling of goods, extension of the pawnshop, abbreviated cross section of domestic histories, the culture of making do) and the street-photographic (objects looking to find new uses, unpredictable and suggestive juxtapositions of objects, chance discoveries). The second-hand dealer is the kin of the Surrealist flea-marketeer, the source of 'objective chance' (about which we shall have more to say in Chapter 5). But equally important for our purpose is the fact that Atget's image contains a single prospective customer, balanced on the kerb, looking over the goods. The customer is the street photographer.

FIGURE 17 Camille Pissarro, *A Corner of Les Halles* (1889)

While the documentary photographer seeks to transfer a subjectivity into the image (usually by *knowledge* of the subject, compassion felt, respect shown), for the street photographer, subjectivity is all in the choice of the moment of taking, a choice which is intimately bound

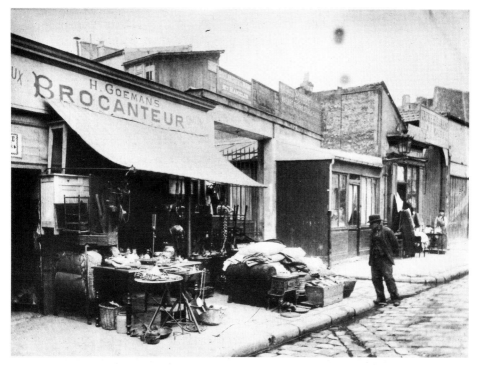

FIGURE 18 Eugène Atget, *Dealer in Second-hand Goods,*
boulevard Edgar-Quinet (1898)

up with an (exactly) when (which is of smaller concern to the docu-
mentarist). Berger reminds us that, 'unlike the story-teller or painter
or actor, the photographer only makes, in any one photograph, *a
single constitutive choice*: the choice of the instant to be photographed'
(Berger and Mohr, 1982: 89–90). But as Buisine suggests (1994: 14),
because the camera is 'objective' and 'mechanical', this single constitu-
tive choice is all the more absolutely subjective. In the taking of the
photograph, the photographer is peculiarly free from reality, while the
image itself is peculiarly subject to reality. It is in the documentarist's
interest to minimise (the viewers' awareness of) this subjectivity of
taking, and to imply that the (exactly) when does not matter, precisely
because subjectivity has been evacuated from that act and has come

to suffuse the picture space itself, and will continue to suffuse it until the photograph is taken. Our metaphor then leads us to propose that the street photographer operates in relation to reality as a customer, while the documentarist acts as vendor (the high standards of the vendor suffuse his goods).

Looking at Atget's *Dealer in Second-hand Goods*, we may reckon that it hangs between (1) an act of selling, where the photographer wants us to feel, in the motley display of wares, the condition of a community, a pattern of reutilisation driven by need and economy, a heterogeneity which bears the marks of life's unfortunate vicissitudes, a condemnation to the second-hand and down-at-heel, permanent socio-economic shipwreck in which salvage has become the only available form of existence; and (2) an act of consuming, where this flotsam and jetsam is a potential treasure-house of the psycho-physical 'find', the trigger of involuntary memory and unconscious desire, the engineer of small-scale epiphany. If we had to opt one way or the other, then it would probably be for the former, if only because the customer's rather disreputable appearance puts his custom in the realm of unavoidable necessity rather than free-associative prospecting.

Even in 1898, then, we find what might be considered Atget's first flirtations with the street-photographic, albeit within a firmly docu-mentary habit. Other photographs of the 1900s and early 1910s further install that curiosity that takes us towards the shop windows of the mid-1920s. *At the Marché des Carmes, place Maubert* (1910-11) (Figure 19), for example, introduces us to the repeated (with slight variation) product (shoes), where number outdoes function, so exceeds it that the shoes are in a sense addressed to no one, recover their 'thinginess' by not envisaging use, are not the display of a stock but instead a collec-tion, dead mens' shoes still haunted by the feet and lives that occupied them. One does not have to look for long to sense the infiltrations of the uncanny, the tremors of that anxiety which for Mac Orlan is an identifying feature of the 'social fantastic' (of which we shall more to say in Chapter 5). The shoemaker (?) is visible through the frame of the window, the image of a manufacturer receding from his products,

his recession proportional to the increasing autonomy, the regimented purposefulness, of the shoes themselves. Below them, on the ground, are the displaced sabots of another generation, a peasant relic caught in the irresistible tide of the urban.

But if the street-photographic eye is drawn to these moments of eerie encounter, wills a 'poetry' into existence, where the documentary wishes to be a laying bare, it is because its motivation is not investigative clear-sightedness, but curiosity. Not only had Baudelaire drawn attention, as early as his 1846 Salon, to the 'marvellous' hidden in urban banality,[2] but curiosity is central to the aesthetic of his painter of modern life: 'Thus to begin to understand M. G[uys], the first thing to note is this: that curiosity may be considered the starting point of his genius' (1972: 397). And in his prefatory essay on Atget, Mac Orlan sums up the interwar mentality in these terms: 'The world has been subject, since the great European war, to the great joys and the no less considerable disappointments of curiosity' (1965: 301).

John House (1998: 33–57) has traced the ideological conflicts at the heart of this notion in the 1860s. Critics of curiosity identified it as a symptom of a society over-preoccupied with superficial appearances, novelty, trivia. Gustave Merlet attacks curiosity in 1865 for preferring 'ruins to monuments, anecdotes to lessons, sketches to finished paintings, the study of individuals to that of their works, the sketches of physiognomies and customs to principles and doctrines' (37–8). There is much here that is suggestive for our differentiation between the street-photographic and the documentary: 'anecdotes to lessons'; 'sketches to finished paintings' (the documentarist pursues a rhetoric of completeness, so that evidence can become proof; the street photographer wants recurrent potentiality); individuals to works (we might argue that the documentarist is concerned with the conditions created by, or reflected in, individuals rather than with human agency itself); customs to principles (the street photographer pursues behavioural characteristics in action rather than underlying moral abstractions). But we should remember that indiscriminate looking, the procedures of the dilettante and *flâneur*, not only involve reassessments of accepted

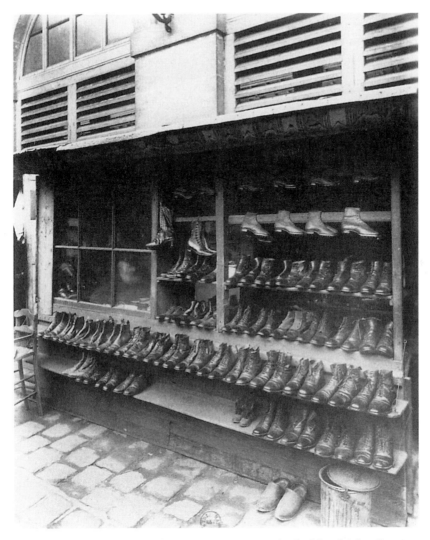

FIGURE 19 Eugène Atget, *At the Marché des Carmes,*
place Maubert (1910-11)

classifications – the idea, for example, that the legibility of cities is to
be found not in political institutions, social hierarchy, topographical
segmentations, but in pavements, empty chairs, rain and umbrellas,
stalls and shop windows – but are forms of ocular invocation, the
teasing out of transitory revelation by the glance.

If *At the Marché des Carmes, place Maubert* gives us a foretaste of Atget's shop windows of the mid-1920s, then the celebrated *Corsets, boulevard de Strasbourg* (1912) and *Hairdresser, boulevard de Strasbourg* (1912) take us even closer. The corsets are still a display of stock rather than a spectacle, still physically acquirable, thanks to the examples hanging outside the shop. But the repetitiveness of the object, and the insistent solicitations of the headless mannequins, pressed up close to the window glass, invite us to think *out of* the photo, in a way which would be irresponsible for the documentarist. And the blurred petticoat, caught in a draught of air (?), begins to take the photograph towards the theory of spectres:[3] what the photograph captures is a spectral emanation of the petticoat's soul, a kind of sublimated form of the camera's desire to unclothe its subject. The *Hairdresser*, on the other hand, pathfinding for the *Hairdresser, avenue de l'Observatoire* (1926) and *Hairdresser, Palais Royal* (1926–27), presents the shop window as that which authorizes the imaginary, precisely by putting the wares out of reach, by iconising them, in both senses of the word. And at one and the same time, the mannequins not only become images with that glazed look which is the look of the camera itself – the look that does not see, but stares through you – not only cross and recross the line between the real and the unreal, the thing seen and the hallucination, but also go through processes of fragmentation and dismemberment, which do nothing to lessen the quiet confidence of their smiles.

But it is the shop windows dating from 1925 that fully live out the supersession of the small shop by the department store, the display by the spectacle, the self-presentation of the stall by the mini-theatre of the shop window.[4] In these later shop windows, reflections finally come into their own, superimposing images as in a multiple exposure or sandwich print, creating metaphors, blurring the distinction between inside and outside, and in doing so reducing each other to the imaginary. The paradox of this juxtaposition – the invasion of the inside by the outside, the unbreakable barrier of the shop window – tells us of that transformation of the tangible display of wares into publicity, advertisement, the narcissistic mirror; as Mac Orlan puts it:

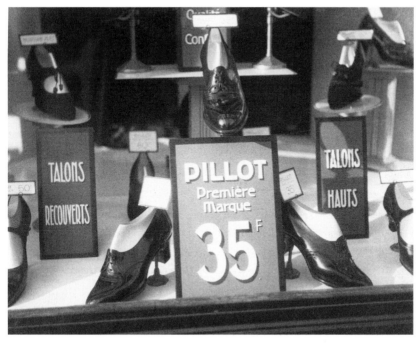

FIGURE 20 Germaine Krull, *Pillot Shoes* (n.d.)

> Direct publicity is the publicity which arrests passers-by and groups in
> front of a poster, an illuminated sign, a shop window. This last, which
> belongs to the aesthetics of the street, reveals the taste of the crowd,
> and, more curiously, the education of public taste. (1995: 19)

Alongside those displays that continue, unnervingly, to repeat the
product, there are social tableaux (e.g. *Bon Marché Shops*, 1926–27);
alongside the mannequins with the frozen look are the headless ones
(e.g. *Shop, avenue des Gobelins*, 1925).[5] Mac Orlan goes on to speak of
the secret lyricism of industry and commerce that these shop windows
express, and further asserts: 'The eye accepts without further explana-
tion the beauty of this spectacle, which often resembles an illustration
from a tale of the supernatural' (1995: 20). Germaine Krull, several
of whose shop window photographs appeared alongside Atget's in the
Surrealist art magazine *Variétés* (see Sichel, 1999: 326), goes further

still in the exploration of theatrical transformations: the shop window devoted to Pillot ladies' shoes (n.d.) (Figure 20) is a cross between a religious service (shoes as religious objects, shoes as officiants in a carefully hierarchised rite) and an immobilised choreography, the shop window itself a photograph of a dance routine as complex as anything out of Busby Berkeley; or the photograph of a doll repair shop, specialising in natural-hair wigs, presents its row of dolls' heads as a chorus line, looking out at the audience across the footlights, their highly rouged faces managing a whole variety of bemused expressions.

It would be unwise to propose that, just as the small shop was superseded by the department store, so documentary photography was superseded by street photography. Documentary photography continues to enjoy robust health, thanks to its capacity to diversify. But it is perhaps worth suggesting that documentary is more at home in a supply-and-demand economy than it is in an economy of customer seduction, of the irresistibility of the unnecessary. Ultimately, we imagine the customer/street photographer as having two roads open to him, both deriving from a position of *choice* (not need): to reduce choice to something imaginary, something that requires no purchase; or to accede to a purchase, not because it is a *sine qua non* of brute life, but because it promises to take existence in new directions – this is to use old goods for new purposes (see the notion of *détournement*, Chapter 5). The former of these kinds of choice relates to metamorphosis, the capacity of images to beget images in a never-ending proliferation of spiritual opportunity; the instantaneousness of the street-photographic image is, then, precisely this window of opportunity, this moment when fantasy can take reality across other territories, far out into the blind field. The latter of these kinds of choice relates to anamorphosis, to a redefinition of the visual, a reuse of what is before the eye by the adoption of another angle of vision; the object itself does not change, the eye stays within the frame – it is the mode of perception that changes. In both instances, objects, figures present themselves as signs waiting to be remotivated by an interpretative subjectivity, shifters waiting to be equipped with new points of reference, new

experiential coordinates. The documentary object or figure has its meaning indwelling, has no need of sense-giving encounters with the customer/dilettante/*flâneur*. In the documentary object, meaning has steadily accumulated, acquired an incontrovertible density; the street-photographic object is an initiation of meaning.

Hitherto, we have made strenuous distinctions between the documentary mentality and the street-photographic one, while noting some areas where their practice overlaps. We have discovered a general shift from one to the other in Atget's work, but there are individual images in which the decision could go either way. And there are piquant anomalies, too. In his 1910 photograph of a *Newspaper Kiosk*, for instance, we find an example of the new Haussmannian street furniture made possible by the width of the pavements. But this commercial innovation has all the look of a nomadic costermonger's roadside cart, the vendor imprisoned in the exiguous interior, the wares displayed pell-mell in the open air. We seem to cross and recross generic boundaries, always likely to bump into photographic hybrids; and nowhere is this more apparent than in the world of photojournalism and reportage.

The dictionary defines reportage as '1. the act or process of reporting news or other events of general interest. 2. a journalist's style of reporting. 3. a technique of documentary film or photojournalism that tells a story entirely through pictures' (*Collins English Dictionary*, 2000: 1306). What such a set of definitions does not capture, nor indeed seeks to, is the distinction between a reportage that investigates an ongoing situation or condition (feature), a reportage that pursues an ongoing item of significant news (news story), and a reportage that captures a brief and transitory piece of news with a high curiosity value (*fait divers*).

In January 1910, an exceptional rise in the Seine's water level flooded the centre of Paris, despite the defence measures which had been put in place by Eugène Belgrand, the Second Empire director 'des eaux et égouts de Paris'. The water reached as far north as the Gare St Lazare, which was turned into a large lake, as were the Champ de Mars and the Gare d'Orsay. The Séeberger brothers (Henri, Louis and Jules) took photographs of these floods, which had transformed Paris into a Venice

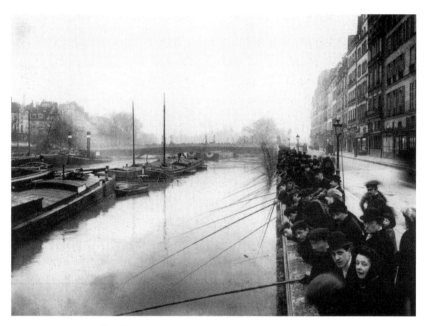

FIGURE 21 The Séebergers, *Floods, quai des Orfèvres* (1910)

and suddenly made fishing its principal pastime (Figure 21). This was
a genuine news item, an ongoing situation, but the Séebergers did not
forsake the street photographic to become documentary photojournal-
ists. The photographs they produced are not full of events – rescues,
drowned domestic animals, hardships caused by the absence of basic
services – which enlarge our knowledge of the situation's progress.
Their photographs have something of the arbitrariness of the *fait divers*
(which always raises the question, 'Why this piece of news and not
that?', just as the eye-frame might raise questions about inclusion and
exclusion), something of the *fait divers*'s self-sufficiency, its bending of
newsworthiness in strange directions, the direction of the quirky, the
bizarre, the beside-the-point. What is odd is when the river is no longer a
river, because it is surrounded by water of its own making, is the author
of its own anonymisation; when water levels are so high that you can
fish over any pavement parapet; when the notion of streets and traffic
disappears, and occasional boats, filled with unlikely bowler-hatted

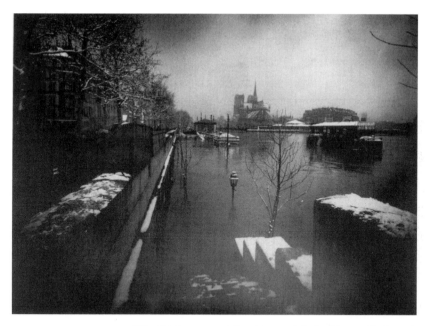

FIGURE 22 The Séebergers, *Floods, quai de la Tournelle* (1910)

occupants, move off randomly, in any direction; when chivalry reappears, as men carry women across the shallows of water-filled public places; when pedestrians no longer need pavements to protect them, but walk along the middle of streets on elaborately constructed wooden walkways. And there are photographs without even this degree of physical event, photographs of *visual* event: a city which exists entirely in reflections; juxtapositions of snow, water, deserted misty spaces, the submerged ghost city; and the tops of street lamps emerging from the water, alongside the tops of trees and various masts, like an exotic species of aquatic plant (Figure 22). These photographs were published as postcards by the Staerck brothers; that is, not as news photographs, not as images made urgent by their topicality, or made sense of by contextual knowledge, but as visual curios, stand-alone puns and incongruities and coincidences, whose meanings are still waiting to be made (but need not be made yet) and whose surfaces are filled with competing autonomies, a floating cardboard box, a sign advertising chocolate, a cameo reflection.

The *fait divers* thus seems to be the point at which photojournalism diverges from the documentary towards the street-photographic. The *fait divers* deals in (marginal) news that cannot easily be classified, news not quite sure of its function, news that could easily become a shaggy-dog story, news that connects with nothing else. 'Real news' comes to us as daily episodes, or fragments, and can afford to do so, because we know that they are parts of a larger whole, an ongoing story, a serial, from which they effortlessly draw their significance. The *fait divers*, on the other hand, is self-contained and immanent (Barthes, 1964: 189), carrying its causality and consequences within its own frame. The newsworthiness of the *fait divers* lies not so much in the news itself as in the mechanisms which produce newsworthiness, the disparity between causes and effects, small causes generating large effects, or the reverse. Frequently, coincidence is the central justification.[6] In fact, coincidence and disproportions of causality are intimately related to each other:

> Aleatory causality, ordered coincidence, it is at the junction of these two movements that the *fait divers* is constituted: ultimately both encompass an ambiguous zone *in which event is fully experienced as a sign whose content is, however, uncertain.* (Barthes, 1964: 196–7)

In the photography of reportage, therefore, we are likely to find a similar crossing of documentary and street-photographic wires, as news not only happens, but stops to ask itself how it became news, stops to note how inventive it is, stops to smile at its own arbitrary eruptions.

As we move into the closing pages of this chapter, I would like to look back over the road we have travelled through the eyes of the writer, once again to gauge how literature can help us better to understand the perceptual modes connected with documentary and street-photographic seeing, and to trace how, in literature also, these modes collide and mingle.

Atget's shop windows of the mid-1920s may well cast our minds back to a passage in the opening pages of Zola's department-store novel *Au Bonheur des Dames* (*The Ladies' Paradise*) (1883), when Denise Baudu,

newly arrived in Paris from Cherbourg, is dazed by the splendour of
the store's window dressing:

> At the back, a long scarf worked in Bruges lace, and costing a con-
> siderable amount, was spread out like an altar cloth, its two reddish-
> white wings unfurled; flounces of Alençon lace were strewn like
> garlands; then there was a cascade of every kind of lace – Mechlin,
> Valenciennes, Brussels appliqué, Venetian rose-point – streaming
> down like a snowfall. To the right and left, rolls of cloth formed dark
> columns, which made the distant tabernacle seem even further away.
> And there in this chapel built for the worship of woman's beauty and
> grace were the clothes: in the centre was a most striking item, a velvet
> coat trimmed with silver fox; on one side was a silk cloak lined with
> Siberian squirrel; on the other side was a cloth overcoat edged with
> cock's feathers; and finally some evening wraps in white cashmere
> and white quilting, decorated with swansdown or chenille. There was
> something for every whim, from evening wraps at twenty-nine francs
> to the velvet coat priced at eighteen hundred francs. The dummies'
> round bosoms swelled out the material, their wide hips exaggerated
> the narrow waists, and their missing heads were replaced by large
> price tags with pins stuck through them into the red bunting round the
> collars, while mirrors on either side of the windows had been skilfully
> arranged to reflect the dummies, multiplying them endlessly, seeming
> to fill the street with these beautiful women for sale with huge price
> tags where their heads should have been. (Zola, 1995: 6)

In this passage, a first section (up to 'chenille') belongs to the (prospec-
tive) customer, Denise, a section characterised by a certain optical
febrility, a cataloguing of phenomena which resorts, for its ordering,
to minimal spatial indications and the equally minimal control of
commas and semi-colons. What syntax there is is highly episodic, fol-
lowing the saccades, or jerky readjustments of fixation, of the feasting
eye. The second section, by contrast, is driven by the voice of the
alerted commentator, whose evaluative role is traceable in odd words
and phrases ('exaggerated', 'skilfully arranged') and in the rhetorical
flourish of the close.

The close of the passage makes two broad points. First, just as
window reflections absorb the outside into the inside, so mirrors project
the inside into the outside, and, in this way, the dream is realised in

mirages, the imaginary reaches out in anticipation. Second, the price-tagged heads are an unmistakable reference to goods as prostitution, solicitation, sexual gratification, anonymous relationship. If we associate the street photographer with an availability to solicitation of the senses, with the experiential kerb-crawler, we must also take into account that solicitation is itself a simulacrum, that no contract of exchanged pleasure is guaranteed. It is not just that it all depends on the price, but that the mannequin personifies the imaginary. Just as in a fashion magazine, the price is the key to the acquisition not of a particular garment but of Fashion itself, unidentified and unidentifiable, so street photography promises access not to a lovers' kiss or an empty chair, but to the lyricism of the street. Documentary photography looks on and is not impressed.

But we cannot conveniently say that Denise has a street-photographic perspective, while the narrator has a documentary one. True, the street-photographic, as we have already argued, is the customer, the Impressionist, the undiscriminating look, ready to capitalise on the accidents of the eye, but that ability to capitalise depends on the instinct of shrewd realisation, which gives value, which invests the shifter, the emptied sign, with meaning. For his part, the documentarist (Naturalist?) must also have knowledge; not a knowledge come to in the revelation of the instant, but a knowledge which is a point of departure, the knowledge with which a scene can be invested from the outset, the available knowledge of consensual engagement (*studium*). Besides, this is a passage in which the fluid, fusional, feminine (street-photographic) view is, in a sense, embraced by the masculinist, narratorial (documentary) view, by the device of free indirect speech. We shall find a rather similar strategy, and an even more complex interpenetration of the street-photographic and the documentary, in a passage from George Moore's *Esther Waters* (1894).

Esther is tramping the streets of London, looking desperately for the £18-a-year situation which will allow her to survive and have her illegitimate son, Jack, properly cared for. She has just been sexually accosted by a young man and has emerged from a bout of dizziness:

Here, as in Piccadilly, she could pick out the servant-girls; but here their service was yesterday's lodging-house – poor and dissipated girls, dressed in vague clothes fixed with hazardous pins. Two young women came out of an eating-house, hanging on each other's arms, talking lazily. The skirt on the outside was a soiled mauve, and the bodice that went with it was a soiled chocolate. A broken yellow plume hung out of a battered hat. The skirt on the inside was a dim green, and little was left of the cotton-velvet jacket but the cotton. A girl of sixteen walking sturdily, like a little man, crossed the road, her left hand thrust deep into the pocket of her red cashmere dress. She wore on her shoulders a strip of beaded mantle; her hair was plaited and tied with a red ribbon. Elderly women passed, their eyes liquid with invitation; and the huge bar-loafer, the man of fifty, the hooked nose and the waxed moustache, stood at the door of a restaurant, passing the women in review.

Three strata of consciousness – that of a woman, that of a woman who is an illiterate maidservant, that of an illiterate maidservant who is at the limits of fatigue and hunger – potentially intervene between us and the scene described. But what might add up to the screen of an individuality generalises itself into the available corridor of a subjectivity. We soon no longer distinguish between Esther's perception and that of the narrator.

There are two large, 'indicative' differentiations that I would like to make, which may help both to underline essential differences between the street-photographic and the documentary, and to show how intimately they intermingle. The first of these is between the present participle and the past participle. When the two young women emerge from the eating-house, the mood is comfortable and projective: 'hanging on each other's arms, talking lazily'. The present participles here ('hanging', 'talking') give these women a future, as in a photogram, or film still. These present participles interweave with each other, construct a togetherness, of pleasure, animation, continuity; the participle is not a tense but a way of suspending tense, either increasing its duration or creating a space of respite from time. This, one might argue, is the peculiar force of the street photograph: to arrest movement, yes, but *in its very duration,* to suspend motion *in its promise*

– in short to turn the instant, once again, into the moment. A future is declared, a future which radiates out into possibility.

But almost immediately, and almost without our noticing it, this nascent togetherness turns into a togetherness of destitution, in the repeated adjective 'soiled' (past participle). This subjection to the past participle is then underlined by two further past-participle adjectives, 'broken' and 'battered', which pull us up abruptly with two realisations: first, that the adjectives applied to the clothing of one of them are directly transferable to the women themselves, abused, soiled goods, branded victims. Second, that the film still has shifted to the still photograph, to an arrestation of motion which is not a moment on the brink, but a moment of consignment to a past. These young women are not in a position to reinvent themselves, must sacrifice their unpredictable freedom of being to their exemplarity, to their symptomatic or evidential value. This 'too-late' draws the spectator away into the safety of his own spectatoriality.

Already we begin to sense the complex interrelatedness of the street-photographic and documentary modes. It only requires the slightest adjustment of vision, the slightest shift of emphasis, for us to tumble from one into the other, and that in the space of a sentence. But we can only affirm the significance of these shifts by referring to the generic distinctions we have made. And the significance of these shifts relates to a coming to consciousness of our own moral and perceptual shiftingness, the way we justify to ourselves a loss of interest, a need to turn away or sign off, or to summarise to ourselves what we have seen. In this sense, one would want to argue perhaps that, paradoxically, documentary photography may seek to engage us precisely by giving us the desire to disengage ourselves; in other words, either our reason for having compassion (civically, socially) is the same reason for our withdrawing (psychologically, existentially), or our sense of having the visual right to turn away is what pricks us into turning back, or at least into excusing our turning away by some personal act of charity. Street photography, on the other hand, attempts to bring to us something which we have become bound to by our invention of futures, by our

sense of an ongoingness, by a refusal to reveal secrets. Peculiarly, then, although we look at something which is manifestly past, we cannot acknowledge that it is no longer worth thinking about.

I want to develop the complexity of this generical interchange in relation to another linguistic feature of the passage, the shifts between the definite article ('the') and the indefinite article ('a'/'an'). Broadly speaking, we would want to attach the definite article to the documentary on the grounds that it is the article of taxonomy, of the specimen, of the typical or the representative (it justifies the removal of the proper name), that it appeals to the already known, that it fixes its noun in the web of destiny. The indefinite article, on the other hand, belongs to the street-photographic inasmuch as it registers and affirms the random, the uncontrolled, the unknown (and perhaps unknowable), something whose autonomy is proportional to its anonymity, or whose eccentricity deserves a sobriquet. In the passage we have before us, the striking recovery of the street-photographic is to be found in 'a girl of sixteen'. What a powerful and unexpected image this is! Apparently she is un-constrained by the social and sartorial inhibitions which afflict Esther and the other servant girls, and no doubt her very 'virility' is conducive to her being released into herself. But important for our purposes is the connection between the indefinite articles ('A girl of sixteen', 'a little man', 'a strip of beaded mantle', 'a red ribbon') and the insistent posses-sive adjective ('her left hand', 'her red cashmere dress', 'her shoulders', 'her hair'): quite literally she is a free spirit, unforeseen, haphazard, in total possession of herself. This is the spirit of the street-photographic: at the heart of urban anonymity, stray stars cross the firmament and light up the apparent disorder with their self-possession, itself signalled by the reclamation of the present participle ('walking sturdily'). Against her is set a classic documentary presentation: the bar-loafer, the man of fifty, the hooked nose, the waxed moustache. These latter features are thoroughly predicted, the image more photo-fit than photo. And yet, in this particular environment, the documentary, in masculine hands, in the hands of the spectator/narrator ('passing the women in review' – has Esther herself become one of these women?) is, as in the

Zola passage, making room for free feminine consciousness, while endowing it, as we have seen, with masculinist traits ('sturdily, like a little man', 'thrust deep').

As a caution against using the definite and indefinite articles as automatic indicators of the documentary and street-photographic modes, we should signal instances here, where the indefinite article has lost its efficacy as a guarantee of the street-photographic and falls into the hands of the documentary. In the sentence 'A broken yellow plume hung out of a battered hat', we may wonder why it is not '*her* battered hat'. Suddenly, the indefinite article is not the index of individual autonomy, but an insinuation about social circumstances: the indefinite article suggests (a) that the hat does not belong to her (has it been borrowed, stolen?); or (b) that the hat does belong to her technically, but in her world nothing really belongs to anyone (thanks to the second-hand dealer and the pawnshop); or (c) that the hat does belong to her, but her state of consciousness is such that she does not perceive it as hers; or (d) that the narrator holds these people in such low esteem that he does not care who the hat belongs to; or (e) that the pathos of the women's condition is such that nothing can be connected with anything anymore.

A later instance of the collisions and mixtures of the street-photographic and the documentary are to be found in George Orwell's *Down and Out in Paris and London* (1933). This work has its autobiographical sources in Orwell's travels between 1927 and 1929, during which time he took up with tramps in the East End of London, and thereafter sought to make a living as a writer in Paris, managing for some eighteen months to survive on savings before being compelled to take a job as a dishwasher (*plongeur*), first in a hotel and then in a Russian restaurant. *Down and Out* is often referred to as one of his book-length documentaries, along with *The Road to Wigan Pier* (1937) and *Homage to Catalonia* (1938), but critics note a radical difference of attitude between the Paris and London halves:

> The Parisian episodes are written with such enthusiasm and light-heartedness as to give the impression that Orwell was, on the whole,

happy during his stay. The London chapters, by contrast, are marked
by a drabness and tedium which, despite the liveliness of the writing,
suffuses the final portion of the book with a grey quality. (Hammond,
1982: 84)

From some points of view, it does seem that he has a documentary
purpose; 'Poverty is what I am writing about', he remarks at the end
of Chapter 1, and in the Introduction to the French edition he reiter-
ates: 'my theme is poverty'. And, in the same Introduction, Orwell
confides: 'All the characters I have described in both parts of the book
are intended more as representative types of the Parisian or Londoner
of the class to which they belong than as individuals.' But this latter
is highly questionable, not least on account of a statement made in
his general discussion of tramps, where he deplores the prejudices
which are rooted in 'a sort of ideal or typical tramp – a repulsive,
rather than dangerous creature, who would die rather than work or
wash, and wants nothing but to beg, drink and rob hen-houses' (ch.
36); and the centrality of Orwell's concern with poverty is undermined
not only by the anecdotalism of his character sketches, but also by
the casual nature of the book's structure,[7] and the apologetic way in
which he introduces his meditative asides on linguistic habits, or the
predicaments of particular professions or classes of people: 'For what
they are worth, I want to give my opinions about the life of a Paris
plongeur' (ch. 22); 'I want to put in some notes, as short as possible, on
London slang and swearing' (ch. 32); 'I want to set down some general
remarks about tramps. When one comes to think of it, tramps are a
queer product and worth thinking over' (ch. 36); 'A word about the
sleeping accommodation open to a homeless person in London' (ch.
37). Orwell may insist that poverty is what he is writing about, but
his retrospective view of what he has written sounds less like a case
study and more like social tourism: 'It is a fairly trivial story, and I
can only hope that it has been interesting in the same way as a travel
diary is interesting' (ch. 38).

The inconsistencies to be found in Orwell's approach to his subjects
are sometimes attributed to the fact that this is his first significant work;

that his own social position made involuntary hypocrisy inevitable; that he is by nature a multi-vocal writer (see, e.g., Davison, 1996: 38-45). But we must also remember that the depiction of social issues in capital cities had been driven in conflicting directions since the end of the nineteenth century. Alex Zwerdling (1974: 164) argues that *Down and Out* 'seems to be an attempt to write the genre [documentary] by the rules. There is a curious impersonality about it, even though it is written in the first person and records experiences that are generally taken to be autobiographical in their main outline.' We may feel that this is a misjudgement. Orwell writes not so much with impersonality (majestic, self-righteous restraint; implicit sympathy), as subjective detachment, governed by customer-consciousness (the reader's point of view) rather than by vendor-consciousness (writer/subject complicity).

Two words which appear in passages from Orwell already quoted – 'queer' and 'interesting' – Zwerdling's own 'curious', and others ('amusing', 'instructive', 'strange'), tell us something about Orwell's relationship with his subjects. These are words with a low temperature of involvement. Indeed, they are words which have as much power to exclude as to intrigue. They are a point at which analysis decides to stop, to suspend enquiry, deems itself adequate, particularly as these words presuppose a normality, an even, featureless, clean-lived existence, from which these are unremarkable deviations.

These are words which are not so much features of the subject as modalities of the reader, anticipations or models of a response to Orwell's text: 'as interesting (queer, strange, curious, amusing, instructive) as a travel diary'. Once more we are reminded that where documentary assumes continuity (a continuity requiring change), the street-photographic thrives on discontinuity (moments of the bizarre, strange, intriguing). This discontinuity can, we now see, be a discontinuity of response, as in 'It was amusing to look round the filthy little scullery' (ch. 12). How do we reconcile 'amusing' and 'filthy'? Is 'little' enough to smooth out the clash? And how, more generally, do we reconcile Orwell's tendency to qualify and play down ('rather proud', 'rather worse than', 'none too warm') with statements that are

punishingly direct: 'There was, clearly, no future for him but beggary and a death in the workhouse' (ch. 30; this about his friend Bozo); 'He had the regular character of a tramp – abject, envious, a jackal's character' (ch. 28; this about his friend Paddy).

Orwell seems to be caught between the contrary tugs of liberalism and socialism, between a tolerance of idiosyncrasy which is loath to put a label on things, which looks to demystify labels, and a socialism which needs to think of society as driven by the interests of social groups, themselves understood tribally. But even within the liberalism, there is another potential conflict, between, on the one hand, the impulse to let live and let be, and, on the other, the liberty to be disgusted by what one sees. One of the differences between the Paris and London sections of the book is that while Orwell, in Paris, is within the circle of filth, sweat and unscrupulous opportunism as a fully paid-up participant, untraumatised by his discoveries, in England, among the tramps, his sensitivity to distasteful details, his urge to recoil, constantly push him outside the circle: 'Someone was coughing in a loathsome manner in one corner' (ch. 24); 'The sheets stank so horribly of sweat that I could not bear them near my nose' (ch. 24); 'Seen in the mass, lounging there, they were a disgusting sight; nothing villainous or dangerous, but a graceless, mangy crew' (ch. 27); 'I shall never forget the reek of dirty feet' (ch. 27); 'It was so different from the ordinary demeanour of tramps – from the abject worm-like gratitude with which they normally accept charity' (ch. 33). These feelings of guilt and remorse which encourage a penitential readiness to put up with revulsion and disgust, are, I would argue, typical of confrontational kinds of documentary. The opportunism of the street photographer, the brevity of contacts, the distractedness, make adverse conditions easier to envisage as elements in life's rich pattern.

3

street arts and street métiers

The Manet of Baudelaire's poem in prose 'La Corde' ('The Rope') prides himself, as would many another nineteenth-century artist or social commentator, on his abilities as a physiognomist:

> My profession as a painter drives me to cast an attentive eye at the faces and physiognomies that I come across, and you know what pleasure we extract from this gift, which makes life appear to us more lively and significant than to other people. (1991: 78)

Mary Cowling (1989) shows how the same skills are deployed by William Powell Frith in his *Derby Day* (1856-58) and *The Railway Station* (Paddington) (1862), in the confident expectation that the public would look for, and read, the signs as he intended them. Physiognomy, in the wake, principally, of Johann Kaspar Lavater's four-volume *Physiognomische Fragmente zur Beförderung der Menschenkenntnis und Menschenliebe* (1775-78) (published in French 1806–09 as *L'Art de connaitre les hommes par la physionomie*), had become a science, confirming and fossilising social distinctions and the belief that inequality was an unavoidable fact of life. This craze for physiognomy and physiology, aside from its sociological and anthropological ambitions, and its being an inevitable concomitant of the gradual development of positivistic

and deterministic thinking over the course of the nineteenth century – of which Balzac's part-retrospective *Avant-propos* (*Preface*) (1842) for *La Comédie humaine* is perhaps the first literary testament – is also attributed to a presiding urban anxiety: the explosive growth of urban populations left citizens with a pressing need to make the human environment legible and to re-establish the psychological security provided by acts of confident social recognition. But the whole enterprise was under constant threat: the scientific approach was undermined both by the competing interests of the journalistic, the essayistic and the fictional, and by its own parodisation in extravagant references to the zoological and botanical classification systems of Buffon, Linnaeus or Cuvier (see Sieburth, 1985: 45-6); graphic representation ran the gamut from caricature (see Wechsler, 1982) to photography; the classification of physical features was complicated by the classifications of habits and behaviour; nature (the inborn) was complicated by nurture (the acquired and acquirable); social species ramified into myriad subspecies, so that the more exact the science, the less reliable and controllable it became. John Thomson's complaint about the 'London Nomades' he photographed is typical:

> These people, who neither follow a regular pursuit, nor have a permanent place of abode, form a section of urban and suburban street folks so divided and subdivided, and yet so mingled into one confused whole, as to render abortive any attempt at systematic classification. (Thomson and Smith [1877], 1994: 1)

Not surprisingly, as we shall see, different sign systems merely interfered with each other's transparency, and the thrust of the new consumerism (arcades, department stores, advertisement) was to equalise consumer opportunity and thus efface, in both goods and the activity of purchase, the signs of social differentiation.

The situation we have just described is one in which, as we have intimated, the need to document, to elaborate that documentation, and to update it as necessary, springs as much from neurosis as from beliefs in socio-economic determinism. At the same time as physiognomy and physiology publicise scientific advances, they look to act deceleratively

on social change, to put a brake on social proliferation. But such gestures seem futile: physiognomy loses its graphic incontrovertibility in the photograph; anecdote and personal testimony come to undo and prejudice third-person scientific impartiality; lives cross boundaries and embrace the unpredictable. Once again, street-photographic way-wardness parks itself corrosively beside the sober decorums and stern purposiveness of the documentary.

In several of his portraits of street traders, street entertainers and other types – for example, *The Absinthe Drinker* (1858-59), *The Old Musician* (1862), *The Philosopher(-Beggar) (with a beret)* (1865), *The Philosopher(-Beggar)* (1865-6), *The Ragpicker* (1869) – Manet isolates his character against a featureless or peculiarly inappropriate, dissociative background. This is characteristic of many of the contemporary popular prints devoted to street types, which played as active a part in Manet's visual formation as the Spanish masters (see Hanson, 1972). The woodcuts based on daguerreotypes (by Richard Beard) used by Henry Mayhew in his *London Labour and the London Poor* (1851-62) frequently have a similar 'vignetted' appearance, as do John Thomson's photographs for *Street Life in London* (1877); and in the early 1890s Paul Martin produced a series of photographs of street traders in which he blocked out the setting and presented the figures 'sculpturally', on a painted-in artificial base. Likewise, many of Atget's photographs of the *petits métiers*, though taken in the street, have a very shallow depth of field, so that the figures are detached from a background whose fuzziness makes another world of it.

Atget's images follow in the wake of Charles Nègre's *scènes de genre* of the early 1850s, the street musicians, the navvies, the stonemason, the tiler, the chimney sweeps. In all of these images, pose, too, is of central significance: the subject has the opportunity to give an account of himself, to create his chosen persona. In a sense, posing spells the solicitude, the fair play, of the photographer. At the same time, the photograph makes visible the subject's pretensions, or indeed the lack of them. Posing draws the self unwillingly out, as much as it encourages

the self to settle within. Posing is at once the challenge to make your case and the invitation to give yourself away.

These visual strategies, which are, of course, as much symptoms of easel painting, slow emulsions, cumbersomeness of equipment – the physically decelerative aids and abets the socially decelerative – serve the interests of documentary. The documentary isolates the individual in his predicament/plight/professional persona/routine, while the street photographer promotes an assimilative agenda. In the documentary view, life gradually pushes us into a socio-economic corner without immediate prospect of deliverance, and at the same time removes the claims of our psychological presence. A photograph which might have seemed to start out as a portrait, indeed still looks like a portrait, has deviated towards something else, a sociological mugshot; a selfhood built on an accretion of personal experience, a bundle of memories, associations and ambitions, designed to produce an inimitability, has become a selfhood surrendered to a lower common denominator. Photographic indexicality works now as an agent of confirmation of something known or knowable, etching in the precise lineaments not of psychic or emotional activity, but of external pressures, of living conditions and working practices.

Isolation transfixes the character in the space of his own condition. Space itself acts as a quintessentialiser, as if it measured an act of withdrawal into a social station. This isolation has other important, negative effects. It removes from the subject any possibility of social interaction. This does not necessarily spell pariahdom, but it removes the socio-political threat of association, solidarity, conspiracy: these are individuals whose withdrawal into the existential singularity of their type seals them into their taxonomic slot. Deprived of inter-personal communication or social intercourse, the street type has access only to self-translation and self-substitution: he can either be interpreted into another order of perception, as an exemplum of, say, honest industry or feckless vagrancy, or he can simply be replaced by another of his kind. Concomitantly, isolation removes the subject from

the possibility of narrative, where narrative has the power to restore a life, a mobility, and, above all, a protagonism.

But the truth of the matter is that street types usually came with anecdote attached to them, as in social surveys such as Léon Curmer's nine-volume *Les Français peints par eux-mêmes* (*The French Depicted by Themselves*) (1840–42), or Henry Mayhew's four-volume *London Labour and the London Poor*. This may have been part of a need to generate a touristic interest in street trades as much as a sociological one, but it encouraged strollers to *imagine* the lives of these people and restored to them a certain psychological interest and a certain freedom of self-construction. It takes very little to achieve this shift of emphasis. The result of an actual street encounter, but painted in the studio with his model Victorine Meurent, Manet's *Street Singer* (c. 1862), alone, emerging from a *cabaret*, resists, by the elegance of her dress, the masculinity of her headgear, her suggestive toying with cherries, any desire we might have to attribute to her an exemplarity. Just as the painting derives not from the seeking out of the type but from an accidental encounter, so the image restores that accidentality, that refusal to be visually convenient. And Manet's last great work, *A Bar at the Folies-Bergère* (1881–82) juxtaposes, on the one hand, the documentary barmaid, held prisoner in the narrow space behind the bar, her lack of animation both aped and enforced by the objects on the counter, passive commodities, like her, awaiting purchase, and, on the other, the street-photographic barmaid, in the mirror's reflection, losing definition in the flux of her activity, in her problematic stance, in her unreadable exchange with the customer, all this in tune with the misty dynamic of the reflected auditorium at large.

Looking forward to Nigel Henderson's photograph entitled *Street Vendor near the 'Salmon and Ball', Bethnal Green Road* (1951) (Figure 23), we find similarly shifting perspectives. The street vendor appears to be selling items of haberdashery (buttons, hanks of wool, reels of cotton), but, unaccountably, also has a clutch of plastic windmills. His extravagant home-made turn-ups, his invisible hands, his challenging, if involuntary, promotion of Labour's case (he almost doubles as a

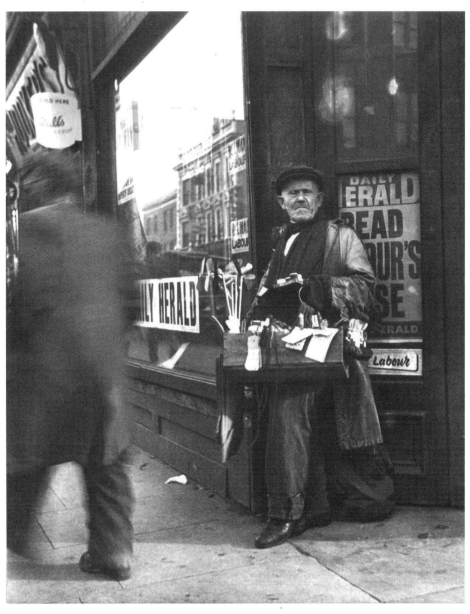

FIGURE 23 Nigel Henderson, *Street Vendor near the 'Salmon and Bull', Bethnal Green Road* (1951)

sandwichman), the transformations undergone by the posters, as one sees now one part, now another, as if imitating, in their croppings and elisions, the local vernacular, the reflection of the neo-classical building, a shadowy memory of right-wing imperialism – all these things make of this street vendor a centre of radiating meanings, social nuances, anecdotal possibilities, a nub of self-liberating dispersal. If anything, street photography resists the socialisation of the subject and restrains the lure of the personal psyche, in the name of larger anthropological interests and an emphasis on the behavioural and situational. The world of the street photograph is a world held open, caught in an unending process of self-definition, in which chance and change constantly revise the givens and introduce unexpected transformations.

René-Jacques's *Newsvendor, Paris* (1936) (Figure 24) looks at first sight to be an image of casual servility: a homburg-hatted motorist has drawn up alongside the kerb to purchase a newspaper without leaving his car; the payment looks as much like a tip as a payment, and the downcast eyes and slightly inclined head of the newsvendor, his cupped hand, bespeak a grateful humility. But the more we look, the more this socio-economic relationship reverses itself. As cars and pedestrians go about their anonymous business (the frame exerts a peculiar pressure, cropping the head of the passer-by, not giving him a place in the picture, and creating a low ceiling for the background cars, pushing them on their way), the vendor finds his island of tranquillity on the pavement's edge. While others have time only to purchase or carry their newspapers, he has time to read his, and his customers are necessary, but rather irritating, interruptions of his repose. He may be wearing a workman's cap and ankle-length boots, but he is the man of leisure. Indeed, he is so much at home – the lamp-post his umbrella stand, the newspaper stand his desk – that those who would benefit from his services must visit *him*. The relaxed posture of his body, his comfortably crossed legs, the very stillness of his hanging jacket-flap, tell of someone not really prepared to budge for anybody. He is the nomad who can instantly appropriate any patch of urban land. And the

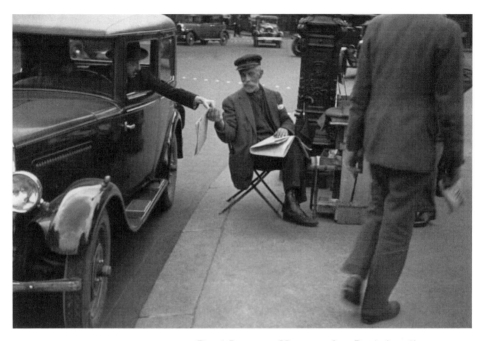

FIGURE 24 René-Jacques, *Newsvendor, Paris* (1936)

line of road-studs which passes behind the vendor's neck – in parallel
with the motorist's arm – makes him both a visual and a social linchpin
between the worlds of roadway and pavement.

This photograph brings us, through its frame, back to the question
of instantaneousness, and to a distinction not, in my view, sufficiently
insisted upon, a distinction between arrestation and instantaneousness.
This distinction is not very visible because we may lazily think that
a photograph arrests an instant. In fact, the camera arrests duration,
in order to produce an instant – unless it actively photographs the
instantaneous. This latter can be quickly disposed of: something which
lasts only a split second (a runner crossing the line, a pole-vaulter
clears the bar, Bichonnade jumps down the steps (Lartigue, 1905),
Oléo jumps off a wall (Lartigue, 1908)) is caught in a split second by
the camera. The danger is that a split second is all that is required to
read such a photograph:

the interest that we feel for these images does not exceed the time-span of an instantaneous reading: there is no resonance, no inner disturbance, our receptivity closes down too soon on what is pure sign. (Barthes, 1957: 106)

A puff of visual smoke and it is gone. The true instantaneous does not *record* an instant, but creates one, the decisive moment, the moment of coincidence, convergence, suggestive association, and so on. Time itself seems to proceed by setting itself target-instants which the camera hits. These target-instants/photographs are animate time; unphotographed time is dead time. The difficulty is this: the privilege of scrutinising the instant is bought at the price of the instant's instantaneousness; snapshot become icon.

If we adopt the language of Gilles Deleuze's second thesis on movement (deriving from his commentary on Bergson) (1992: 3–8), then we might argue that the photographed instant is inevitably a privileged instant and can never be any-instant-whatever. Photography's 'antique' sense of temporal movement would be a movement between 'poses', a 'dialectic' of forms ever again projected towards an instant of synthesis, of movement's self-transcendence. The frame is the sign of that transcendence, of an instant being taken out of time (both 'extracted from time' and 'put in timelessness'), of index becoming icon, of individual becoming type or exemplum, of behaviour becoming moral concept. What photographs cannot do, unless they imitate the chrono-photographic exploits of a Marey or Muybridge, is communicate the transitions between privileged instants, the immanent ongoingness, the uninterrupted equidistant progression of any-instant-whatevers, the very stuff of cinema. In the cinema, no instant is brought to completion; in photography, every photographic instant is fulfilled by the frame, the blind field constituting the projective play of the spectator's 'imaginary', rather than the *real* imminence of a continuation. Looking at our analysis of René-Jacques's newsvendor, we might suppose that we have found in it a privileged instant, deriving from a dialectic of forms, a synthesis which recasts the newsvendor as independent householder, himself generating significant dependencies, a nomadic trader relieved

of modern pressures. Anamorphosis – look once and see one thing, look again and see another – is the movement of that dialectic.

But here we equally want to argue that the frame is not what takes this photograph out of time, but what, precisely, reinstalls it *in* time. Here, the camera has arrested duration not to create a privileged instant, but to record an any-instant-whatever, not to discontinue, but to affirm continuity (a chair sits there imperturbably and will continue to do so; I snap it in order to become part of, to make contact with, its continuity). If much photographic commentary tends to move the photograph on from its indexicality (moment of taking) towards iconicity (persistence as image), it is partly because critical discourse itself necessitates this move. Iconicity makes photography available to a wider audience and, in so doing, builds ignorance into the interpretative equation: we no longer need to know the identities of the subjects, or the exact occasion of the photograph. And the act of interpretation itself clearly aims at completeness and finality through a process of generalisation, through recourse to the already known (the pre-photographic or the extra-photographic, the cultural interest that is Barthes's *studium*). Phenomenological criticism has tried to restore the photograph to its indexicality, to the miracle of a contact, to the corridors which focus opens up in history, endowing the past with a future in our perception, an animate posthumousness, making it press on our consciousness as unfinished business. In his reflections on the relation between instants and movement, Deleuze observes:

> In fact, to recompose movement with *eternal poses* or with *immobile sections* comes to the same thing: in both cases, one misses the movement because one constructs a Whole, one assumes that 'all is given', whilst movement only occurs if the whole is neither given nor giveable.
> (1992: 7)

Clearly only the indexical can properly safeguard what is neither given nor giveable, but this indexical only remains beyond the reach of manipulability and interpretative exploitation if, equally, it remains immersed in its own duration. René-Jacques's photograph might be viewed as the record of an instant-action, the purchase of a newspaper,

but (a) this action need not be privileged, and (b) it may be seen not as the culmination, the objective, of temporal transition, but as itself transitional. In saying this, I am not suggesting that we should imagine what has happened prior to this image and what will happen afterwards (precious little in both cases). What we should imagine is that this instant of arrest is not a sudden conjuncture, but an accumulated and accumulating process interrupted by a shutter.

We are not told where this photograph was taken, but if it had for title not *Newsvendor, Paris* (1936), but rather, say, *Rue de Rivoli* (1936), we might better understand how this newsvendor could be part of the street's duration, how the street, like the photographic frame, holds time in, absorbs all moments, all any-instant-whatevers, so that the newsvendor is a stratum in the street's temporal sedimentation, or one of the common nouns which, as a proper noun, the street can encompass and make constitutive of itself. Even without the aid of a name, other than 'Paris', we can still perceive the photograph in this way – that is, as duration arrested and held in by the identifiable space of the blind field.

The complexity of a street, which we shall explore further in Chapter 5, derives from the interplay between its own immobility as architecture, the relative stability of its 'inhabitants' and the unpredictable comings and goings of its birds of passage. The street trader, nameless specimen for the documentarist, is often enlisted into the street photographer's assimilative agenda, into the street's powers of synthesis, by the bestowal of a nickname.

We introduced ourselves very early to the idea that the street photographer relates to those around him through the nickname (see above p. 3): Blèmia Borowicz ('Boro') knows Donio, the dog-trainer, 'Backless', the manager of the Villejuif ratodrome, and 'Teeny-Bike', king of the Joinville pedal-boats. We expect nicknames to derive from some distortion of a real name, or to reflect some feature of profession, or character, or anatomy. It is a token, but perhaps only a token, of familiarity (affection or, indeed, contempt), which smacks of initiation into a group and a certain group solidarity. But it detaches from identity

as much as it bestows identity: it turns x into 'x', a 'character' who is thus endowed with a greater degree of manipulability – because the nickname erases civic status and affirms no genealogy – has greater susceptibility to anecdote, and can more easily perform himself. The individual concerned now has the *ability* to be himself, to live up to his name. At the same time, he is cut off from routes to rights, social respect, rootedness. Nicknames remove from the nicknamer the need to pursue relationships by means of judgements constantly under review, because they presuppose that people are always true, or equal, to themselves. In this sense, the nickname is a way of constantly excusing the nicknamed. It has close connections with caricature, but tends to let the satirical pointedness of caricature slip into the picturesque. The nickname almost invariably depoliticises; it humours any justified anger and diminishes the political effectiveness of the one it labels; the nickname distracts (detracts) from the person.

The camera cannot nickname, of course, but captions can, and so can accompanying commentaries. We meet 'Jean l'Américain', 'Le père "La Purée"' and 'Nini-la-Frisée' among Germaine Krull's photographs of tramps (1928), and 'Bijou', 'Le Grand Albert', 'Dédé' and 'Doudou' in the pages of Brassaï's *Le Paris secret des années 30* (*The Secret Paris of the 30's*) (1976). Even Thomson and Smith's *Street Life in London* (1877), caught between the need 'to present true types of the London Poor' and to depict 'street characters', frequently indulges in the colour of nicknames. Thomson and Smith hope that the camera will hold the mean between conflicting impulses –

> The unquestionable accuracy of this testimony will enable us to present true types *of the London Poor* and shield us from the accusation of either underrating or exaggerating individual peculiarities of appearance. (1994: n.pag.)

– and themselves look to strike a balance between exonerating determinism, sympathy and justified reprobation. But the nickname – 'Tickets', the card dealer; 'Cast-iron Billy', the omnibus driver; 'Caney', the chair-caner – is itself an act of reclamation, an acknowledgement of

the subject's community membership. And inasmuch as the nickname does absolve the photographer from moral judgement, from the role of public spokesman,[1] so it warrants fraternisation with the unsavoury and the street photographer's partial criminalisation, so well expressed in Cartier-Bresson's title *Images à la sauvette* (*Images on the Sly*) (1952), images snatched surreptitiously by an unlicensed street trader who has no sooner made a catch than he is legging it round the corner, careful not to be spotted. In this sense, street photography is a form of visual pickpocketing.

What the nickname also represents is the escape from socialism into liberalism. For the liberal, it is important that the destitute can be individualised, anecdotalised, rendered colourful, for, in that way, class consciousness is minimised and, instead, the condition of, say, poverty, is fragmented into the individual destinies of men and women, who, without abandoning their characters or their potentialities for redemption, have fallen, by a whole variety of quirks of circumstance, on hard times. So the threateningly widespread needs of a group condemned by birth to an intolerable condition are dispersed in a collection of idiosyncratic destinies, all of which can be salvaged by the right turn of luck, fully deserved. The liberal, on this reading, is not required to commit himself to a political position, or revolution, but can go on looking forward to the possibility of numerous upturns of fate, fuelled perhaps by his own comprehending sympathy. Like his colleague Doisneau,[2] Willy Ronis joined the French Communist Party in 1945, certainly not as a political activist, but as someone who, in more impalpable ways, identified with a cause or a class:

> At the end of the war there was a great feeling of friendship towards the Russians. But I was never a true militant. I felt incompetent in politics, I didn't have that sort of mind. The daily political battle was difficult to follow. I went to meetings. I sold *l'Humanité* at the Metro exits. But I was never at my ease. Yet fundamentally I was on that side: it was a philosophical, sentimental attachment. I felt attracted to the struggle, especially for the workers. Sometimes I was outside factories at five in the morning to distribute tracts with the comrades. (Hamilton, 1995a: 29)

Just as liberalism breaks open the prison-house of the species to liberate as many subspecies as there are individuals in the social or professional group, so the kinds of non-political, intuitive affiliation described by Doisneau and Ronis blur the rules of belonging and the motives for socio-political affiliation.

Significantly, then, several of the subgenres of street photography – the circus, the funfair, the flea market – seem to share the values of the menagerie, as against documentary photography's adoption of zoo practices (see Bouissac, 1976: 108-22). The zoo means the place of differentiation, the place of the taxonomy of the species, of the segregations of the human and the animal. In the zoo, species are artificially maintained as a hoped-for mirror of a corresponding order in the animal kingdom. Habitats are constructed in such a way as to dupe the animals into feeling comfortably at home. To liberate the animals is to subject them to outlawry and the slow death of non-assimilation. The zoo is where people come to find animals locked into the absolute authority of a Latin name, performing according to their own genetically programmed behaviour. Do not feed the animals; it will give them the wrong idea about themselves; we will feed them on your behalf, and on the right diet. Yet for all this doing justice to the animals' quiddity, you do not put Thomson's gazelle in the lion's cage. Natural animalistic interaction would upset the exhibitionary quietude, the image, almost abstract, of an order that stays safely within the frame.

The menagerie, on the other hand, is a place where humans and animals of all kinds, from pony to camel, from tiger to sea lion, promiscuously inhabit a continuous world, where things need not make a great deal of zoological sense, and where performance is always out of character, or creates absolutely unheard-of modes of cohabitation. The lines of animal socialisation and self-definition are constantly being redrawn. The camels munch hay, tethered on a convenient piece of waste land, as a preamble to acting the unamused straight man to the antics of the clown, or to taking children for a ride. Alain Lanavère's account of the funfair explores the further reaches of the menagerie principle:[3]

a miracle, because the fair manages to blur and blend in itself a thousand and one contradictions. It is well-known: the fair makes no distinction between rich and poor, great and small, it combines immemorial traditions and modernist inventions, it unites ritual and spontaneity, folly and gravity, conformity and transgression, innocence and monstrosity, so much so that if anyone who goes to the fair throws himself into having a wild time [*faire la fête*], it will be impossible to tell him apart from the platform percussionist or the clown, and so that the show will be found somewhere other than you might expect. (1995: 11)

The menagerie is, in many senses, a democratisation of the zoo. Reptiles are no longer necessarily assigned to the reptile house and might indeed be mistaken for a relative of the amphibious mammal. One of W.E. Henley's poems about London types, "'Lady'", is symptomatic of that removal of reliable social indices, exploited and fostered by the street photographer, which allows free migration across class borders, here imagined as a promiscuous mixing of London boroughs and landmarks:

So this fair creature, pictured in *The Row*,
As one of that 'gay adulterous world' whose round
Is by the *Serpentine*, as well would show,
And might, I deem, as readily be found
 On *Streatham's Hill*, or *Wimbledon's*, or where
 Brixtonian kitchens lard the late-dining air.

A strong sense of locality permeates the urban picturesque. Sir George Lawrence Gomme recommends in 1900 that '[a] ride on the top of an omnibus through any of the great routes ... reveals, to those who have the feeling for the picturesque, beauties in London streets which are wholly local in character' (quoted in Andrews, 1994: 284). A vision of cottage industries, of itinerant workers plying their trades within particular neighbourhoods, is pursued, in which a multiplicity of distinguishing features, textural differentiations, inimitable colours create that circumscribed variegation to which the picturesque traveller is so susceptible. It is naturally assumed that the lower down the social orders one descends, the more pronounced will be physical and behavioural idiosyncrasies.[4]

Clearly cosmopolitanism generates only tourists, the *collectors* of the picturesque, rather than the object of their quest. This particular emphasis makes the urban picturesque as spatially confining/confined as it is temporally. It is characteristic that Apollinaire, in *Le Flâneur des deux rives* (*The Stroller of the Two Banks*) (1918), should twice use the word 'picturesque' and, on both occasions, in conjunction with 'corner': the rue Berton is described as 'one of the most picturesque corners of Paris' (1996: 10), while Ambroise Vollard's 'cellar of la rue Lafitte' (closed) is referred to as 'this picturesque corner of Paris' (1996: 113). The picturesque nourishes unfocused nostalgias for the old *quartiers* (quaint), local artisans and crooks, and, before we know where we are, becomes a measure of the authenticity of place and custom. But it is an authenticity without the risks of real otherness, an authenticity already certified, an authenticity without the dynamic of relationship, already a picture.

In Brassaï's introduction to *The Secret Paris of the 30's*, 'picturesque' occurs only once, in a quotation from one of Brassaï's literary mentors, Mac Orlan: 'The almost complete disappearance of every trace of the picturesque, ... which formed the most touching part of life in 1900, is a fact' (1976: n.pag.). Mac Orlan associates the 'picturesque' with the lifestyle of a particular period, 'la belle époque' ('Parisian nights have gained in luxury what they have lost in picturesqueness', 1965: 74). Brassaï himself seems to have little fondness for the word, and when he speaks of his own engagement with Parisian life, resorts to notions of 'wonderment', 'fascination', 'inborn fondness', 'necessary infatuation'.

There is probably little to be gained from trying to use 'picturesque' as a term of critical discrimination, partly because of its loss of aesthetic coherence –

> To pursue the picturesque into the Victorian period is to watch it lose coherence as a theory, manifest itself in ways that seemed entirely unrelated, and finally saturate every domain of cultural production. (Armstrong, 1999: 56)

– partly, and consequently, because it has different implications and weight for different commentators. Certainly, it would be foolhardy to

erect some fundamental distinction between the documentary and the street-photographic on the strength of it. More usefully, perhaps, we might claim that the picturesque helps us to understand the paradox of photography itself. As Nancy Armstrong points out (1999: 32–74), William Gilpin's three essays on the picturesque of 1792 had the effect (i) of democratizing aesthetic values in the picturesque (the beginning of middlebrow cultural values); (ii) of commodifying landscape and the environment; (iii) of fixing on 'sight as the only sensation to be received from an object classified as picturesque' (36); (iv) of shifting the locus of reality from the object to the image (in fact it is the image which begins to give value to the object). In 1869, Henry Peach Robinson confirmed that photography was the chosen medium of the picturesque: 'By its nature photography can make no pretensions to represent the sublime, but beauty can be represented by its means and picturesqueness has never had so perfect an interpreter' (*Pictorial Effect in Photography*, 1869; quoted in Harker, 1979: 27). There would, of course, be other assessments of photography's underlying affinities (e.g. Mac Orlan: 'Photography, which I look upon as the greatest expressionist art of our time...', 1965: 28), but Robinson's view, based on his own 'aesthetic realism', would not have been seriously contested in the closing decades of the nineteenth century, even by P.H. Emerson. Important for us is the implicit understanding that the picturesque, like the photographic, sits astride the indexical and iconic. The cultivation of the eccentric, the singular, the authentic, 'local colour', goes hand in hand with the commodification of the visual, the photographic record of what is already a picture, a touristic aesthetics. Both documentary and street photography, in pursuit of the picturesque, are likely to fall foul of their own paradoxicality.

This paradoxicality expresses itself, as we have already seen, in the ambiguity of the frame. For the street photographer, the mobile frame of the viewfinder is the instrument of illumination, an illumination which is not as intense, as life-focusing, as an epiphany, but is, rather, a relishable distraction, snatched out of the play of other less relishable distractions. But the frame carries with it the ever-present threat of

condescension, of a momentary complicity and exuberance condoned by an established and self-confirming aesthetic establishment. In experimental, post-Pictorialist photography, often loosely referred to as 'New Vision' photography, we do, however, find the frame used to create and explore subjective continuities and interchange between subject and spectator. When we speak of 'New Vision' techniques in the context of street photography, we are speaking of a visual practice which is still relatively restrained. But the photographs of tramps by Germaine Krull of 1928 often, by their use of framing, ask us to reassess our relationship with the tramp in ways which are not morally confrontational, which ask us not to inspect our feelings of guilt or hostility, but rather to experiment with our ways of imagining that relationship.

In order to understand this difference of frame-effect, we might call upon the distinction made by Jonathan Friday between the causality of photography and the intentionality of manugraphy (painting, drawing, engraving and collage):

> photographs are causally dependent on the world they depict, but manugraphs have an intentional relation to the world in that the beliefs, thoughts and skills of the manugrapher are the sole determinant of the world depicted in a manugraph. (2002, 39)

The very causality of the photographic process – the real world is the inescapable cause of the photograph – can easily communicate itself to the photograph's subject: things could not be other than how we see them, the more so since the camera is a disinterested third party/third person. But we have already examined the extent to which, in making us more aware of the eye-frame of the viewfinder rather than the support-frame of the photograph, photography can make its pictures composable, *scriptible*, reframable. A closely related consequence of the activation of the eye-frame is the greater sense we have of the frame's first-personness, of its being intentional in the sense that it responds to, or colours, the real world, rather than merely recording it. We might look at a documentary photograph of a tramp – for example, Don Mc-Cullin's *The Voice of Liquor / Destitute Men. London / Down-and-out*

shouting confused political obscenities, Spitalfield Market, London (1973) – and think what he is *reduced to* (coat held around him with string); forced into vagrancy, what little he has is his *by necessity.* The view that Krull's photographs promote is quite different and squarely street-photographic: her tramps have not only chosen to be tramps, but their straitened circumstances and makeshift belongings have not diminished the pride they have in their property. Furthermore, their gestures, bearing and habits remind us that tramping is more way of life than nemesis, that they are really bourgeois in *clochard*'s clothing. In one image, a female tramp sits along a bench with her slippers (?) off, reading a newspaper article about Goya; in another, a female tramp has the posture of a society woman taking a picnic. In the article in *Vu* on tramps (17 October 1928), written by Henri Danjou and illustrated with ten of Krull's photographs, we are told that one of the tramps is the niece of a government minister, another (the Goya fan) a countess, and another (deceased), called 'Trompe-la-Mort' ('Cheat-Death') became a millionaire and bought a chateau, but returned once a week to his old tramping haunts, ultimately at the cost of his life. All these people have colourful stories, but lead ordered lives, as Krull herself remarks.[5]

These photographs, then, seem to contribute to a nineteenth-century-style idealisation of vagabondage as an act of self-dissociation from the work ethic and from the charitable government agencies which take its place, and of vagabonds as self-reliant, carefree, eccentric, peace-loving and often cultured characters doing their best to get on with their lives unhindered. If the poet could associate himself with the ragpicker, living on the city's detritus, putting it to use, operating on the social margins and at the experiential extremities, it was equally easy to claim spiritual affinities with the tramp. More particularly, the frame of the New Vision was able to provide a visual affirmation of contact and perceptual transformation. An aerial view of a tramp (Figure 25), looking straight down from the *quai* (riverbank) to the *berge* (riverside), positions the tramp at the top of the image, as if attached to some vertical wall. The figure resists gravity, as if made weightless

FIGURE 25 Germaine Krull, *Tramp (Under the Bridges)* (1928)

by sleep, surrounded by floating scraps of rubbish – his galaxy – and attached to the earth only by the mooring ring at the bottom right of the image. Visual disorientation like this alerts the spectator to the camera's position not only because that position has to be constructed – that is to say, enforces a journey towards first-personness, towards the eye of an engaged beholder – but also because it encourages that process of 'as if', of imagining the subject into a new relation with the world, which liberates a host of metaphorical possibilities.

Our return to concerns of the frame, and, more particularly, to the frame's ability not only to negotiate a place for the photograph's subject in a world of established structures, borders and dividing lines, but also to adjust and control both the subject's input and that of the photographer/viewer, makes most apt some exploration of the ambiguities of proximity and distance to be found in the work of Brassaï, who perhaps came closest to balancing ambitions as a street photographer with those of a street-photographic writer.

When Brassaï turned to writing his 'portraits' of Parisian types and situations towards the end of the Second World War – 'Le Bistrot-Tabac' ('The Café-Newsagent's') (dated 20 August 1943), 'Le Chauffeur de taxi' ('The Taxi-driver') (dated 25 December 1946), 'Soliloque à la fermeture' ('Soliloquy at Closing Time') (undated), *Histoire de Marie* (*Marie's Story*) (published separately in 1949, with an introduction by Henry Miller) – there was no question of interposing conventional poetic frames between these free-rhythmic, self-improvising dialogues and monologues, and the reading public. But these are instances not of *recorded* direct speech, but of *reported* direct speech. In *Histoire de Marie*, made up of 44 sections and divided into two parts ('Propos de Marie' [Marie's Observations]; 'Le Procès de Marie' [Marie's Trial]),[6] we find sallies of the following kind:

Chateau Life

When I was young, me, too, I lived in Chateaux.
What did I do in those Chateaux?
Well, the Lavs if you must know!
You can get fond of the Lavs!
Then, after that, I did the Stairs.
But Stairs, well, that's not my kind of thing.
I could never get fond of my Stairs.
At the age I've got to, Washing's what I prefer.
No one nowadays wants to do Washing.
So, that brings in the Needful. (1949: 33)

Brassaï uses capital letters, because, he tells us, Marie thinks in capital letters, and these capitalised words form the constellation of her worldly

concerns. The same device can be found in 'Le Chauffeur de taxi'. But despite this, despite the elisions, the simple syntax, the redundancies, the quaint possessive ('my Stairs'), this is not the unmediated spoken language of someone barely literate. Where are the hesitations, the false starts, the mumbles, the fillers? Warehime sums up Brassaï's equivocal position:

> Significantly, while Brassaï's photographic practice and his approach to style embody the contradictions of photography's position in the transition from modernism to mass-media culture, his writings repeat these same contradictions. He attempts to resolve them by elaborating a form of literary art 'in the spirit of photography', which takes conversation as its model. (1996: 173)

Brassaï himself addresses these contradictions, without managing to resolve them, in his introduction to *Paroles en l'air* (*Empty Words*) (1977), in which the hitherto unpublished poems and *Histoire de Marie* are collected. Brassaï places himself in the lineage of Diderot, Proust, Joyce and Max Jacob, those obsessive collectors of 'verbal snapshots' which may be the key to a character or give us access to the intimacy of being. But Brassaï is no tape recorder, most importantly because it debases the quality of attention of the human listener (who erroneously thinks that the job of listening will be undertaken by the machine) and because transcription of the taped conversation is not true to the memory of that same conversation: like the eye, the ear is selective, picking out those words which *animate* speech (mark it as comic, stupid, original, poetic) and letting all others fall away; the ear is, in effect, like the agent of the written.[7]

This process of selection is the creative activity of memory: in the space between listening and transcribing, memory makes its crucial discriminations. The tape recorder does not listen, it merely hears; the tape recorder does not remember, it merely repeats. And this process of remembering, selecting, is the process whereby all elements in the work become 'consubstantialised' (Brassaï's term), or inseparably coexistent, and the work becomes consubstantial with the artist. Yet Brassaï equally seems to concede that, in the last resort, the raw truth,

the ability to espouse alterity, to enter other manners of thought, feeling, expression, are preferable to a homogeneous style. Indeed, he states quite explicitly that his *Paroles en l'air* are written in the spirit of his photographs, and that the characters are left 'in their own lighting': without commentary, explanation, psychological analysis or elaborated context:

> In this kind of literature, humility, self-effacement in favour of the object, disinterestedness become the author's major virtues. (1977: 24)

Brassaï seeks to extricate himself from this self-contradiction by proposing a bifurcation in literature, similar to that between painting and photography fifty years earlier. He aligns himself not with those who deal in poetic invention, fantasy, the imaginary, but with those who harvest surprise and the unforeseen in everyday reality. This latter is what Brassaï calls a literature *'in the spirit of photography'* (1977: 27), a spirit which predates photography, but which photography has made peculiarly visible and intelligible (1977: 27). And yet, even here, Brassaï seems to veer back again to an earlier position: he suggests that Claude Roy's definition of literature 'in the spirit of photography' is valid for the photographic image itself: a form of expression *'in which nothing is created by the author, but in which, however, the author is everything'*. This sounds suspiciously like the convenient paradox of the absent but consubstantial author, a suspicion not dispelled by his own dictum: *'I invent nothing, I imagine everything* (where 'imagine' means not *invent* but represent *reality* by thought)' (1977: 27–8). These affirmations have two kinds of consequence for our case.

First, this suggests that, with Brassaï, we have returned to the artist-in-transition, the street artist still with the strong loyalties to memory and imagination that Baudelaire's Constantin Guys has. It is hardly surprising, then, that Brassaï insists on acknowledging, as his true forebear, Guys, and, precisely, Guys as described by Baudelaire. But, while Brassaï picks out those passages which describe Guys as the streetwise man of the crowd and man of the world, as the convalescent

and child, with their acute perceptual sensitivity, he makes no mention of processes of memory and distillation. And when he goes on to develop his ancestry – Rembrandt, Goya, Daumier, Hokusai, Degas, Toulouse-Lautrec – his yardstick is how much they were taught by the sights in the streets around them. More surprisingly, perhaps, he identifies Guys as the pioneer of 'eye witness reporting in the modern sense' (Sayag and Lionel-Marie, 2000: 282). But there is a clear undertow of Baudelairean distillation thinking in his later description of Rembrandt's method:

> And because, in the excitement of seeing, every superfluous detail would be a waste of time, he is obliged not only to seize the impression quickly, but to reduce it to its barest essentials, extracting from it just that significant detail which indicates and suggests human beings and inanimate objects. (Sayag and Lionel-Marie, 2000: 283)

Second, the issues raised here relate to our causality/intentionality concerns. Can memory be involved in the taking of photographs and, if so, what kind of intentionality does it make manifest? There are perhaps three ways in which one might wish to speak of memory in relation to Brassaï. The first relates to Brassaï's suggestion that his photographs are inner images remembered. The latency of the photographic image itself mirrors the latency of perception which wishes to establish itself as an image. Brassaï's photographs of Paris are the actualisation of things seen in his early, pre-photographic days (1924–29), images in pursuit of him: 'This man is sometimes said to hunt for pictures. But he hunts nothing at all. He is the quarry, rather, hunted by his pictures' (Sayag and Lionel-Marie, 2000: 280). We have already had cause to refer to the parallel Brassaï draws between Proustian memory and the development of film: 'No memory, no latent image either, can be delivered from this purgatory without the intervention of the *deus ex machina* which the developer is, as the word clearly indicates' (1997: 173). And this, in turn, may relate to what Lartigue and Cartier-Bresson have to say about the pressure of the whole self looking for an outlet in the release of the shutter.[8]

The second sense also has a Proustian connection. Marcel, Proust's narrator in *À la recherche du temps perdu*, discovers himself, remembers himself, understands his artistic vocation, through the intertextual support of, among others, Chateaubriand, Balzac, Nerval, Wagner. In similar fashion, intertextuality, remembered literature and painting, is the way in which Brassaï invests his own seeing with experiential depth, cultural embeddedness, expressive validity. It is because literature, or painting, is not photography, because writing is not seeing, that it contributes to, but does not interfere with, supports but does not displace, personal optical contact. There is here the implication that we can see not only more richly, but in a more indelibly self-expressive way, if the past of our reading and seeing can infiltrate the eye. Intertextuality intentionalises indexicality.

Third, Brassaï remembers his own photographs. It may seem that *The Secret Paris of the 30's* (1976) is a regathering of photographs of the early 1930s which had already appeared in *Paris by Night* (1932) and the disowned *Voluptés de Paris* (*Parisian Pleasures*) (1935); and to a large extent this is true. But we must go carefully. At first sight, *Paris by Night* and *The Secret Paris* share nine photographs; in fact, they share none. The camera may be in the same position, but time has moved on a moment or two; or the camera angle is reversed; or the subject, although occupying the same position, is dressed differently. This may well be the result of necessity: Sayag points out that, after the publication of *Paris by Night*, Brassaï lost access to his negatives, which remained in the archives of the publisher (Sayag and Lionel-Marie, 2000: 20); but necessity of circumstance may here coincide with a necessity of being, causality with intentionality. Despite the apparent fixity of the photographic print, the visual relationship with the image remains fluid, unfixed, with memory itself acting as a supplier of variants.[9]

But repetitions/variations of the image itself are not all. With each new publication, the photographs undergo changes of tonal range and contrast, changes in cropping, changes of paper – the matt textures of *Paris by Night* make the blacks more deeply embedded, more diffuse,

FIGURE 26 Brassaï, *Two Girls Looking for Tricks,*
boulevard Montparnasse (*c.* 1931)

both softer and more louring. The paratextual materials also apply
different pressures: the caption for the Byrrh urinal in *Paris by Night*
runs: 'The night and the interior lighting, the silence emphasized
by the soft hiss of the gaslamp and the discrete sluicing of running

water, all conspire to make of the awful urinal a strange and delicate monument', while the corresponding caption in *The Secret Paris* baldly tells us: 'A urinal in the Boulevard Saint-Jacques (*c.* 1932)'. *The Secret Paris*, it is true, has a full textual accompaniment, but it, like the photographs, with their punctilious dates, is in the past tense, a long step away from the present of *Paris by Night*. In one sense, this is simply an effect of history: from the perspective of 1976 these are images of a world long lost: 'Everything changes in a few years, and in a half-century everything has become far away, unrecognizable' (1976: n.pag.).

But, in another sense, in the sense of the self's duration, of the self's self-multiplication and yet underlying continuities, this loss is a retrieval: 'For me too, or rather, for that other me of forty years ago, this infatuation for low places and shady young men was doubtless necessary' (1976: n.pag.). Brassaï's account of prostitutes ('Les Filles de joie') tells of prostitution in the early 1930s and of the changes that the profession has undergone. But the impression given by the photographs, that they depict a past which we are now cut off from, that they isolate these women, as visual documents, in the stationariness of their lamplit soliciting, needs to be corrected; these are not women who have undergone photography's funereal 'mortification', but women who embody history's own duration: 'The half-dressed girl strutting along the Rue des Lombards, picking up passers-by, murmurs the same "Want to come with me?" as the streetwalkers murmured to the rakes of the fourteenth century' (1976: n.pag.) (here Brassaï's present tense, precisely, runs against the grain). This effect seems to me to be perfectly captured in the photograph captioned 'Two girls looking for tricks, boulevard Montparnasse' (*c.* 1931) (Figure 26). The long exposure means that the (now absent) cars have left trails of light; alongside this persisting trace of time's unending passage, two woman stand in the pool of light from a shop window. These women are both within the duration that has been arrested and encompass it; they are an element of an instant, and, at the same time, something much slower-moving than the instant, history itself.

Furthermore, judging by the way in which the photographs are presented, we are encouraged to see Brassaï's prostitutes as interactive facets, a kaleidoscopic constellation, with something cinematic about them, reminiscent of Degas's grouped ballet dancers. This is no documentary photo-essay or photo-story, but a collection of shots which we should treat more as a collage, inclusively, suspending these images in our perception so that we can, as it were, see them all at once. This almost cubist way of looking, which develops different angles of vision – plunging views from hotel windows, shots from across the street, shots round the corner, a front and a back view of the same woman – looks to cohere as an ensemble, not to make sense as it goes along. Thus, the very business of looking necessitates remembering, holding in the mind. It is an exploration without edges, expanding, absorbing more material. The final photograph is the only one that makes an explicit visual point: viewed from an upper-floor window, a prostitute stands by a lamp post, in the rue des Lombards, looking down the street, with a sign above her announcing 'Changement de propriétaire' (Change of owner).

Brassaï's way of looking is also Brassaï's way of writing. His commentary on 'Les Filles de joie' moves associatively, unpredictably, without much sequential cohesion. In one section, for example, we proceed from the routines of prostitutes to the fact that Boccaccio was born in the rue des Lombards, and that the financier John Law had his bank in the rue Quincampoix, and then are told that, in the 1930s, the rue Quincampoix specialised in 'fat girls'. In another, after making observations about the mixture of solidarity and rivalry to be found among prostitutes, Brassaï remarks that his hotel – a *hôtel de passe* – is surprisingly comfortable (with a reference to Douanier Rousseau), touches on further prostitutional habits, and then turns to a specific event: the triumphal return from Saint-Lazare (prison/hospital) of Éliane, one of the prostitutes. This is a prose which moves like the perambulations of the *flâneur*, 'adrift on his bewitched moods' (Pierre Borhan's description of the perambulating Izis; 1990: 174), or like the Baudelairean prose poem, adapting itself to 'the lyrical movements of

our souls, the undulating movement of our reveries, and the convulsive movements of our consciences [consciousnesses?]' (Baudelaire, 1991: 30).

In many ways, Brassaï looks like a throwback, a photographer too deeply imbued with Baudelaire and Proust, struggling against the current of many of the ideas we outlined in Chapter 1. But consideration of Brassaï allows us to imagine a street photography which looks different, and makes different kinds of claim on us, when we release ourselves from the twin tyrannies, of the decisive moment, and of an approach which has overvalued authorship and the authority of the single image, and which has closed our eyes somewhat to the vagaries of creative and perceptual intentionalism and associative open-endedness. Our justifiable desire to distinguish between photographic genres once again needs to be qualified, not only by a sense of their reciprocal interferences, but also by a flexibility of response, able to incorporate significant variations and idiosyncrasies of practice and ideology.

the street-photographic nude: a short postscript

One might argue that the nude has very little to do with street photography. The nude is predominantly a product of the studio and when she ventures outside it tends to be by water, in marine or rural settings, where nudity has a natural justification and where it can be assimilated to mythological allusion. Alternatively one might suppose that if it exists at all, it is a very recent phenomenon, invented by Marc Rivière in *Up & Down* (2000). Aside from women sunbathing by the Seine, this collection is made up of encounters with women who have agreed to bare their breasts in the streets and parks of Paris. The blurb, a peculiar piece of prurient, sexually anachronistic writing by Eléonore van der Bogart, explains:

> A woman goes by. 'Would you mind, Miss...?' The voluptuous bliss of a gesture, the limpid stirring of a breast, a strong temptation is this stranger, to penetrate her mystery by all means possible. To unmask this bosom this symbol. Camera in hand, he approaches. Marc Rivière

captures the moment in all its beauty, in all its intensity. Like love, this is a game that two can play. Every picture proclaims the triumph of a sweet and sensual love.

This is evidently an often awkward translation – what is 'the limpid stirring of a breast'? – of the French parallel text.

But, as is evident from the blurb, this photographic venture perpetuates a view of the *flâneur* as penetrator of the city's secrets; a (photographic) glance is enough to unveil 'this bosom', symbol not only of the privileged instant itself – 'Le temps d'un sein nu/ Entre deux chemises' (The time of a bare breast/ Between two chemises) (Valéry: 'Le Sylphe') – but of the urban erotic, and its momentary eruptions from the crowd. For Rivière, it seems, the photographic act is not an act of theft, reification, domination, but of mutually satisfying complicity.

The most obvious candidate for the original street-photographic nude is, of course, the prostitute, the one who sells a nudity in the street which the customer collects in the *maison/hôtel de passe*. It is not surprising that Brassaï counts Degas and Toulouse-Lautrec among his forebears. But there is another Degasian nudity, the nudity of the so-called 'keyhole' nudes, women at their toilette. This is a private world made eloquent by the degree to which it presupposes the pressures of a public world. Or, rather, it is a world neither public nor domestic, but a limbo, on the rack between the two, where basic bodily tasks – washing, drying, combing the hair – demanded by the world beyond the door, seem to allow no opportunity for self-collection or self-regeneration. The room itself, with its exiguous spaces, becomes the presiding taskmaster, not the source of a spiritual security, but the timekeeper whose meagre allowance of respites is always running out. Nudity here is a piquant mixture of desire and punishment: the desire for self-possession expressed in auto-erotic possibility, and the punishment of exploitation and self-alienation. This paradox is nowhere more visible than in the sequence of oils and pastels of 1896 entitled *After the Bath*, based on Degas's photograph of the same name and same year.

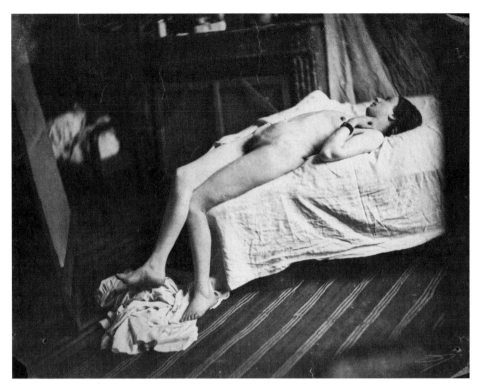

FIGURE 27 Charles Nègre, *Nude Lying on a Bed* (*c.* 1850)

Caillebotte's *Nude on a Couch* (1880-2), explored in Chapter 1, belongs to this strain of imagery, and its closest spiritual ancestor is, aptly enough, a photograph: Charles Nègre's *Nude Lying on a Bed* of about 1850 (Figure 27). Nègre's model, as Denis Roche points out, has neither 'the classic pose of the nude (curves and highlights...), nor the voluptuousness which is its usual accompaniment, nor their framing' (1999: 26). This uncentred body, legs awkwardly crossed, tries to maintain, in her upper torso and head, a reflective serenity. But the tilt of the bed and room, and the dizzying play of intersecting diagonals, drive away any thought of comfortably indulged sensualism. One can hardly identify this room as a studio: a mirror or screen to the left, trampled clothing or sheet underfoot, a covered fireplace and

mantel – none of these speaks of anatomical metaphor or fantasised substitution. This is a space of passage, barely inhabited, difficult to negotiate with. It is only *technically* an interior, and it seems actively to prohibit the sought-for interiority of the model. In short, if the setting is metaphor at all, it is a metaphor of a psychological rather than a physical nature: a psyche that cannot put itself together, that slides away in awkward, dissociated geometries, full of shadows and intrusions, a psyche that cannot properly frame itself. This is an un-domesticated domestic space, a port of call, a space through which the street all but passes. These ports of call provide only snatched moments of selfhood, as quickly snatched away.[10]

The strain continues up through the nudes of Walter Sickert, to culminate photographically, perhaps, in Bill Brandt's 'empty-room' nudes (1945-59, 1977-79). More completely than ever these images take place in the psychic spaces of dream and existential interrogation, spaces into which his wide-angle lens introduces perceptual warping and the onset of hallucination. This ballooning of volumes, allied to the low angles and the model's proximity, makes the image reach out to us from the picture plane. We are almost sucked into these rooms; and yet, appropriately perhaps, we learn that Brandt's turn-of-the-century mahogany plate camera had been used by the police (Hiley, 1982: 8), to record accidents, crime, etc. (Roegiers, 1990: 130). These images, made stranger by Surrealist interventions, tell of guilts and anxieties, of the instability of self, of phantasies of the self, of lonelinesses, of incommunicable desperations; these are expressionless nudes who can only speak the language of posture and gesture, of the objects by which they are surrounded, the language, too, of ceilings, doors and windows though which we may glimpse the worlds of Hampstead, or Belgravia, or Campden Hill. In a sense it is, precisely, their nudity which communicates with us and communicates itself to us, a nudity produced by the city in its manifold acts of dispossession, accusation, manipulation, indifference. These nudes cannot really inhabit their rooms, which permit nudity, but only to prey on it. It is as if the city itself has de-domesticated habitations, sent in bailiffs or removal

men to make rooms themselves agents of spiritual discomfort and desolation.

Brandt's nudes betray some debt to André Kertész's 200 *Distortions* (Figure 28), photographs of the multiple reflections of two models in two fairground distorting mirrors. Kertész's images may have a touch of winking salaciousness – they were initially produced in 1933 for the magazine *Le Sourire* (*The Smile*) – and belong to a Surrealist tradition of liquefied forms in processes of permanent metamorphosis, forms becoming metaphors of themselves and exploring the limits of anatomical potentiality. But their importance for us lies in their introduction of the nude into the heart of a street-photographic venue, the funfair. As Patrick Roegiers points out (1990: 152), these *Distortions* are images of dream and desire. But, as he also points out, they are images of images. In an urban setting, they are reminders of what we do to ourselves to please a mirror or a shop window, and how these same mirrors and shop windows reflect back, or project, parodic and caricatural versions of the daily quest for beauty or fashionability through fetishisation or self-mutilation; the headless or limbless mannequin, the disembodied torso, the bald bust, are close kin of these *Distortions*. Pierre Borhan (1994: 200) suggests that Kertész's method places 'these startling nudes in suspension, outside the world and outside time'. But one might argue the opposite: the fairground is a place of carnival, where normality plays with abnormality, with violence, with the monstrous, with uncharacteristic self-indulgence; these amusements thrust us back into our own world, into time, into our drives and impulses, into self-confrontation, just as surely as they invite us to forget ourselves.

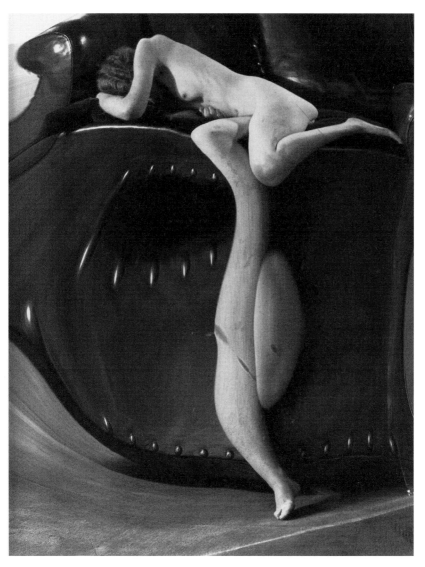

FIGURE 28 André Kertész, *Distortion No. 60* (1933)

4

street photography: the appropriateness of language and an appropriate language

One of photography's peculiarities is that, although it has a history or histories (relating to technological advances, uses, styles), there is really no history of individual photographs (as there are, for example, histories of individual literary texts or paintings) – no history of accumulating knowledge about photographs and no history of the developing interpretation of photographs. It is as if each time we make the acquaintance of a photograph, we must start again from scratch; we must not pre-empt the effects of the photograph's pure visibility with imported, ready-made linguistic meanings; we must find our own way from the relatively unmediated perceptual encounter, from the awareness of our ignorance, towards our own way of absorbing the image into, and making it significant in, our individual lives, without recourse to a prejudicial vocabulary or available critical discourses. Others argue that, since its invention, photography has been exploring different symbiotic relations with language, that language is not merely a constant companion of photographic images, but indelibly implicated in the very process of looking:

> But the influence of language goes beyond the fact of the physical presence of writing as a *deliberate* addition to the image. Even the

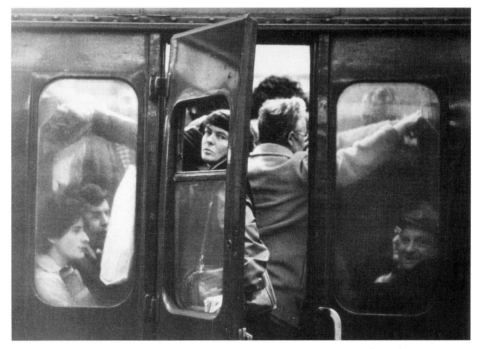

FIGURE 29 Barry Lewis, *Charing Cross Station, 5.30 pm* (1978)

uncaptioned photograph, framed and isolated on a gallery wall, is
invaded by language when it is looked at: in memory, in association,
snatches of words and images continually intermingle and exchange
one for the other; what significant elements the subject recognizes
'in' the photograph are inescapably supplemented from elsewhere.
(Burgin, 1982a: 192)

In what senses, then, should our relationship with the photograph be
(relatively) mute and/or (unashamedly) verbal?

A first argument for the primacy of a mute relationship with the
photograph is simple, but perhaps not sufficiently emphasised: photo-
graphs are not just moments snatched *out of* time, they are moments
of contact *with* reality, even though that reality is past and may be
geographically distant. The woman who looks at the camera, through
the half-open carriage window, in Barry Lewis's *Charing Cross Station,
5.30 pm, 1978* (Figure 29) is somehow still looking at us, as we at her.

Somehow, across time and space, a visual dialogue is possible; somehow this figure, with this look, is not disqualified by her pastness, is not transformed into human specimen or historical document. It is the very pastness of the image which makes the magic of the contact. We travel back, through the image, to the time of its taking, and this journey, registered by the title, makes words inadequate, because, while they may do some justice to the image, they cannot do justice to the magic, because that magic is what makes words inadequate to her clenched fingers on the sill, pulling the door closed, to the folds in her coat, to the clarity of her image as compared with those of the faces seen through the misted glass, in another world, out of reach – but a world she is about to become part of – to the light catching the door hinges, and so on. Our surprised discovery of these things, our wish to look at them again, to visually palpate them without mediation, drives language away. It is the intervention of language that would assign this image to another time and another place, disabuse us of the mirage, interrupt the visual dialogue, transform the woman into a social identity. The eye, left to its own devices, lets its curiosity become a fascination, which explanation and interpretation would put an end to. Titles are crucial in this; they either whisper discreetly and withdraw, set up the magic, or bellow uninterruptedly so that the magic can never establish itself. But here, indexicality, the confirmation of a distance in time and space, which the title confirms with its careful notations, *5.30 pm, 1978* and *Charing Cross Station*, at the same time rebuts the title by investing what has become iconic with an urgent presence.

The second argument for a mute relationship is closely connected with the first and is to do with the sheer quality of the image, where by quality I mean what the quality of the print can only enhance, the sharpness and selectiveness of focus, the sensitivity and expressivity of tonal gradation, and the silence or 'coolness' that these things are able to communicate. The mute would then be proportional to the degree to which the photograph realised its own photographicity, where, by the 'photographic', we mean a new ocular physiology, a reconfiguration of the perceptual possibilities of the eye. Photography

pursues its own kinds of visual 'accuracy', in sharpness of focus, in the black-and-white photograph's ability to map light on to its subject with such care, to trace the subtlest gradations of tone, to demarcate objects, and different zones of the subject, with such clarity that these things come to exist with an uncanny vividness, seem to have very powerful reasons for being there. These qualities of photographicity can be referred to by language but not inhabited by it, because language is geared to *human* perception. Just as avant-garde music may seek to rejuvenate the ear by asking sound to project timbre – how describable is timbre? – rather than the other way round, so photography, seeking to refresh vision, asks the image to project perception, rather than the other way round. Photographic vision, perhaps again under the influence of painting, was domesticated before it was properly under-stood, treated as no more than an extension of the camera obscura (not *seeing* images, but fixing them); language has merely perpetuated that condition. To argue for the muteness of the photograph is, if nothing else, necessary as a polemical gesture on behalf of the medium against the non-recuperability of the 'innocent' picture, against a social institutionalisation (by function, genre, etc.) which semiologises the photograph before it has had chance to assert its photographicity, not as code but as sensory experience.

My third reason relates, appropriately, to the closely intertwined Barthesian concepts of the third meaning, the obtuse meaning, and *punctum*. These terms refer to pictorial elements by which the viewer is inexplicably pierced, wounded, affected, and whose value or power seems to be directly proportional to language's inability to anticipate or translate them. One facet of the third meaning relates to our second reason above: it is a manifestation of the quiddity of the medium in question, the filmic of the film, the photographic of the photograph, which, in the case of the latter, Barthes further defines as the 'that-has-been'. But the third meaning is also a signifier without a signi-fied, hence the difficulty of naming it. 'My reading', Barthes goes on, 'remains suspended between the image and its description, between definition and approximation ... obtuse meaning is discontinuous,

indifferent to the story and to the obvious meaning (as signification of the story)' (1977: 61). So the third/obtuse meaning, or *punctum*, is supplementary, probably disruptive, opens up the image into a blind field, is subversive. Although the trigger of the third meaning is in the image, it belongs more to the viewer lacerated by it than to the image itself. What in *Charing Cross, 5.30pm, 1978* might constitute the *punctum*, what item, for me, and for reasons I may not be able to plumb, falls outside, or disrupts, its unitariness, its coherence, its readability? What, for me, may be the repository of forgotten memories, unnamed fantasies, psychophysiological associations? It is the profiled face of the woman on the left, a face I half recognize (?), a friend from my youth (?), nervous, talkative, who is here caught in one of those embarrassed silences, where conversation fails and one stares vacantly into space. But in speaking about it, in justifying my selection, I have already begun to draw it into the coded existence it is meant to refuse, into the design of the picture it is meant to fracture and subvert. I must hold my tongue. *Punctum* is the way in which, ironically, Barthes is able to salvage the visceral from the stranglehold of semiology.

But *punctum* is perhaps precisely the point at which muteness begins to weigh too heavily on us. Faced with the insignificant, the accidental, the arbitrary, which threaten to undo the aesthetic guarantees of the frame and to invalidate interpretation by branding it as too unifying, we want to talk this anarchic element into submission, to bring it into the corral of visual purpose. Critical talk is resourceful in explanation, in generating concepts, in making syntaxes, in constructing integrated wholes. Critical talk converts its obligation to the image into an obligation to its own hegemonic discourse. And we can often identify these processes as they occur, particularly in the interpretative portamenti and crescendi, in discreet relocations of critical position and in semantic amplifications.

I would like to demonstrate these processes of relocation and amplification, processes whereby the writer increases the significance of words without visibly increasing the significance of what they are describing, by considering Chris Killip's account of Doisneau's *La*

FIGURE 30 Robert Doisneau, *In the Strictest Intimacy* (1945)

Stricte Intimité (*In the Strictest Intimacy* or *A Private Wedding, rue Marcelin Berthelot, Montrouge*, 1945) (Figure 30):

You walk the street, a newly married couple cross, no guests, no fuss, so ordinary a scene you could call it mundane.

To Doisneau it could have been all of this, but he also discovered something else: a newly married couple walking to their destiny.

His understating in the photograph of what he had seen is accentuated by the sense of distance, and gives credibility to a truly

> perceived moment in time. It's simply and directly recorded, with no sense of imposition; the subject dominates, and the photographer seems secondary. All Doisneau's best pictures have these qualities, this sense of affection and awe. Respect for what Orwell called 'The heroic ordinary man'. (Haworth-Booth, 1983: 78)

Killip talks about the photographer's 'understating in the photograph of what he has seen' and this 'understating' is 'accentuated by the sense of distance'. Now we might for a moment assume that the virtue of Doisneau's photograph derives from its having the qualities of a photograph: photography understates because it cannot show more than it sees, though it may show less; photography is a perpetuator of the window aesthetic, of the distance created by framing, however close it may want to get. But as Killip proceeds, certain shifts and slippages take place which inflate this bottom line: 'and gives credibility to a truly perceived moment in time. It's simply and directly recorded, with no sense of imposition; the subject dominates, and the photographer seems secondary.' Understatement, it seems, guarantees 'credibility', and 'what he had seen' becomes 'a truly perceived moment in time'; the trouble is that 'credibility' is part of a transparent rhetorical strategy, while 'truly perceived moment in time' is an intensified, visionary equivalent of a fact – 'what he had seen' – in which the penetrative and insightful 'perceived', supported by 'truly', replaces the non-committal 'see', and the notion of fallible agency ('what *he* had seen') gives way to an impersonal agency located in the photographic moment itself ('perceived moment in time'). As we move further, 'understating', a stylistic and rhetorical choice, becomes an expression of *personal* moral characteristics in 'simply and directly', which, in turn, lead into praiseworthy *social* behaviour: 'with no sense of imposition', where 'imposition' presumably means 'self-imposition'.

 Then it begins to sound as if Doisneau's star is on the wane, as the subject dominates and the photographer becomes secondary. At first it had seemed that his understating was an index of suave control, of ironic restraint; now it sounds like a tactic of self-sacrifice, of self-effacement. But as we move into the next sentence – 'All Doisneau's

best pictures have these qualities, this sense of affection and awe' – we realise that we need not have worried: secondariness, or do I mean distance, or do I mean understating, derives from the impulse towards people ('affection') countered by the impulse to stand off from them ('awe'). What was once an uncomplicated, straightforward, honest (?) and egalitarian (?) relationship with the world – 'simply and directly' – has become an emotionally charged and pretty extreme and paradoxical response ('affection'/'awe'). This 'talking up' of the response requires a corresponding 'talking up' of the subject, to justify it. So Killip's final sentence – 'Respect for what Orwell called "The heroic, ordinary man"' – while resolving the potential conflict between 'affection' and 'awe' with the quieter, less disruptive, more unified 'respect', correspondingly juxtaposes 'heroic' and 'ordinary'. Orwell gives it the warrant to do so. Other writers' *obiter dicta* have an acquired authority which can be opportunistically appropriated.

It may seem that I am mocking this inflationary process. And, in one sense, I am. Language is very adept at raising the stakes and reading into situations and images a significance which seems increasingly disproportionate with the evidence. On the other hand, I am grateful to language for doing this, not only for giving shape to response, for compelling us to define and declare our position, but also for enhancing the banal, for insisting that we make our perceptual connection with the world as fruitful as we can. Reading Killip urges me to formulate, if only to myself, my own 'take' on the photograph. This married couple seek an entrance into their celebration of themselves, of their love, which is denied them: the café restaurant, with its teasing repetition of 'café' in the window, remains resolutely shut, uninhabited, funereal. The couple demand entrance to a life which is already dead, and their desire to celebrate their uniqueness – *what is* on the menu? – is undermined, set at nought, by the repetitions of windows and of paving stones, and by the monotonality which surrounds them. The nearer of the passers-by views them with amused unconcern (?): this couple still do not know what life is about. And yet the photo's title suggests that the couple have the wherewithal to withstand the cynicisms and

capitulations of their environment. Their black-and-white, their af-firmation of complementarity and contrast, defies the insidious and murky greyness of the street. In proposing these things, I have not availed myself of the suggestiveness of the date, 1945. With the war's end, this married couple are testing their homeland's capacity to hope, are expressing an irrepressible demand for renewed existence. Will those around them be equal to it?

When we move into the linguistic interpretation of the photographic image, two ways lie open to us. Either the significance of the image lies in the significance of the photographer's relation to his subject, or it lies in what the image, regardless of the photographer, says to us. One view implies that the image cannot be significant without a demonstration of the photographer's special skills, the other that any image must speak for itself or not all. But there is also the viewer to consider, not so much the one who 'translates' the photograph's intentions or meanings, but the one for whom the image is a pretext for speculation about human motives and behaviour.

Thus my final observations concern Harold Evans's commentary on Jacques-Henri Lartigue's *The Beach at Villerville* (c. 1901–04). For those who come to this image through the paintings of Eugène Boudin and thence through Manet, Monet and Degas, there is no difficulty in envisaging a street photography of the beach:

> Our hero, who is poised on what the old-fashioned would call a dividing third, looks like Edward VII, but what is he up to? Is he temporarily in disgrace with the ladies or cogitating on how he might remark to them that it is a very fine day and he wonders if he might share their [company?]?
>
> He is an immensely romantic figure, a head full of poetry and fine visions, the spirit of liberty by contrast with the dark conformity of the relentless troika on the right.
>
> Does the position of the lady's hand and that of our hero suggest that we are witness to an act of goosing? But this is France and not Italy. And the man in the white suit for me epitomises imagination and freedom. He is reflecting. The others in the picture are merely talking and walking or chatting. (Haworth-Booth, 1983: 48)

I assume that this commentary is not so much criticism as gossip; that is to say, Evans is not interested in trying to draw this photograph into a body of knowledge, to map it into a developing history of the medium; indeed, he is not really concerned to come to conclusions of any kind. Instead, he is happy to maintain his ignorance, so that the speculative impulse is left free to indulge itself unconstrained. While criticism has anxieties about ignorance, and feels a strong sense of responsibility to learning, gossip is justified by ignorance and can thus proceed irresponsibly, whimsically, because its guess will always be as good as another. Like criticism, gossip does not believe that anything is innocent; but while for criticism nothing is innocent of meaning, for gossip nothing is innocent of ulterior motive and interpersonal stratagem. Criticism and gossip have different epistemological objectives, and, on the whole, we are taught to value the former over the latter. But in the case of photography, we might argue not merely that both kinds of discourse are peculiarly appropriate to the medium, but that photography positively vindicates gossip.

In order to make this claim, one must insist that the language of photography is a language of appearances. Criticism advises us, warns us rather, that photographs are *representations* of reality, ideological and rhetorical constructs, activated by the very act of framing. Gossip retorts that photographs are fragments of existence, records of encounters with existence, which we read as we read the life around us. Criticism underlines the making of images, gossip the taking of likenesses; criticism accepts the photograph's inevitable drift towards the iconic and the symbolic, gossip continues steadfastly to affirm the photograph's indexicality. In short, the gossip lobby would argue that however much a photograph is subjected to interpretation, the element of the accidental, the incidental, the random, the anarchic, cannot be eradicated; and this margin of recalcitrance authorises an approach to photography which is anecdotal and fantasising. Photographs will never entirely surrender their facts; we, for our part, as viewers, will go on guessing and misapprehending and puzzling. Gossip, the dictionaries tell us, is conversation about the details of other people's behaviour

or private lives, *often including information which is either not true or has not been verified*. It is for this reason that gossip is often dubbed 'idle'.

It might at first sight seem curious that this language of gossip cannot be applied to paintings. But, in the end, it is not so surprising, for two reasons. First, we assume that the painter puts intention and semantic function into every object as he paints it, in a way that the photographer cannot: the photographer may have an intention, and indeed may will that intention into the components of his picture, but his task is not so much one of *embodying* intention as of transferring it to things that already have a life of their own. By definition, therefore, these things cannot exactly coincide with a function; their relative autonomy ensures that the door of free speculation is left ajar. Second, as we have already argued, the photograph's indexicality, even where referentiality has slipped, makes gossip worthwhile. The attribution of motive, the discussion of possible backgrounds, the evaluation of behaviour, even in photographs that are long past, still seem a *necessary* way to respond to an image which, as we have already pointed out, is evidence rather than proof. But we should also insist that gossip undoes the history of photography: gossip has nothing to gain from relating one photograph to another, from thinking about the image generically, from assessing its degree of photographicity. This begins to suggest that photography's being, the plausibility (or not) of its history, the significance of its intertextual connections, depend entirely on the discourse brought to them.

Let us retrace our steps a moment. We have proposed that muteness preserves the magic of photographic contact and have implied that contact is most indelibly established by the returned look. Looking at the camera is a resource peculiar to photography, if we subscribe to the distinction between film and photography made by Barthes, in his notes of 1977 for a collective volume on 'Le Regard' ['The Look']:

> As we have seen in relation to Avedon, it is by no means ruled out
> that a photographed subject should look at you – that is to say, look
> at the lens: the direction of the subject's look (we might call it his/her

'address') is not distinctive in photography. But it is in cinema, where the actor is forbidden to look at the camera, that is to say, at the spectator. I am almost tempted to look upon this prohibition as the distinguishing characteristic of cinema. (1982: 282)

Not looking at the camera in film spells 'integrity of illusion' and 'fictitiousness'. Not looking at the camera in photography spells 'candour' and 'authenticity'. A paradox, then, is already inscribed in this distinction: what endows a photograph with its honesty to the real – subjects caught unawares, not looking at the camera – is what gives it the potential to be seen as a photogram, that is as an ongoing narrative whose past and future are available to imagination (fiction). We might then argue, in a converse paradox, that the very documentariness of the documentary, its credibility as document, depends on its cultivating the pose, the composed and returned gaze, of its subject; the pose disqualifies the photogrammic, the process of fictionalisation and thinking out of the image into mobile time.

We have already had occasion briefly to consider posing in relation to the documentary photograph (Chapter 3, pp. 92–3). Clearly the objective of the documentary pose is a synthetic 'portrait', a subject whose multiplicity is fully gathered into the single, inclusive image. Benjamin thought that the length of early exposures made such portraits possible; he quotes Emil Orlik:

The synthetic character of the expression which was dictated by the length of time the subject had to remain still, ... is the main reason these photographs, apart from their simplicity, resemble well-drawn or well-painted pictures and produce a more vivid and lasting impression on the beholder than more recent photographs. (1999: 514)

It is as if the open lens were building a sequence of millisecond manifestations of the self into a composite being. Alexander Rodchenko's 1928 broadside 'Against the Synthetic Portrait, For the Snapshot' suggests that, with instantaneous photography, truth to the subject must become truth to the moment, or, rather, that the notion of (eternal) truth is outdated, since everything is moving forward in a process of continual experimentation. There is no work that can claim to depict

the real Lenin 'because there is a file of photographs, and this file of snapshots allows no one to idealize or falsify Lenin' (Bowlt, 1988: 252). Documentary photography's implicit, continuing allegiance to the idea of the synthetic portrait – the soliloquy of the face – relates to the minimisation of perspectivism, of multiplied point of view. Documentary photography, like naturalism, is prepared to live with a potential contradiction: it affirms that the relativity of conditions ('race, milieu, moment') acts deterministically on mankind, but does not allow a relativity of point of view which might release mankind from that determinism.

Barthes makes the assumption that looking at the lens is equivalent to looking at the spectator. He is, from the spectator's point of view, right to do so; this 'looking back at us' is, as we have seen, an essential part of the magic of photographic contact. But the subject's look is, in fact, a double or peculiarly divided look, because the subject, for his/her part, does not look at the photographer (a spectator-substitute), but at the lens, the enigmatic eye. The person who poses is adopting the behaviour known as 'being photographed'. This is an unstable behaviour made up of submission and self-declaration, in varying mixes. Many sitters try to please the lens, to produce an 'expected' photograph, to create the photogenic. But others look at the lens with a look that is disarmed, because there is nothing to *respond to* only to *look at*. This is what may indeed give the lens access to a truth not vouchsafed to a human counterpart. Alternatively, the inanimateness of the lens encourages a monologic, self-reflexive face, which, however, the subject promises to a viewer. As we look, for example, at Jim Rice's *Van Driver, Deptford Creek, 1993*, we realize that to look at a documentary portrait is as much to confront and disentangle these strategies of pose, as to read character or social type; or rather it is to read character or type through the strategies adopted. The van driver, further framed by the open window of his van, displays a lower-face smile which is belied by the searching distrustfulness of the eyes, the askanceness of the look. But he is in his own territory, his cab, and this, at the same time, allows him to relax a little into his habituality,

so that his smile, the lineaments of his face, begin to outline certain innate modes of behaviour: the nature of his kindness, the nature of his hard-heartedness, the nature of his self-protectiveness, and so on.

When we look at Lewis's *Charing Cross*, on the other hand, or at Lartigue's *Le Viaduc des Fades, on the Lower Footbridge* (1909), or at Cartier-Bresson's image of a flower market in Moscow, of 1954, we see, in the momentary look of a woman turned towards the camera, something encapsulative of the whole scene; the face is our channel of communication with the ensemble, and it is through this face that the ensemble looks at us; it is in the instantaneousness of the face's expression that this very thin slice of time is given to us. This look expresses the collective, a certain solidarity of purpose and activity, which barely has time to acknowledge the camera's intervention. If, therefore, the documentary portrait is driven by a desire to let the subject's gaze sink into itself, the better to sink into us, the street photographer shows a face snatched out of itself, the better to capture within it the energies by which it is surrounded. The camera isolates a look, individuates that look as the signature of a moment, but at the same time treats it as the scene's awareness of, and response to, the shutter's interruption of its duration. In other words, the street-photographic look does not characterise a being, or individualise a psyche, as much as capture, through a face, the psyche of a time and place, and of an ongoing urban dynamic. The indexical look is not to be confused with the iconic look. The indexical look is not a look to please, or to arouse sympathy, or to make a social point, or to reveal a character; it is, more than anything, the registration of the moment of contact, the often guarded look of Benjaminian shock (*Erlebnis*).

What the street photograph surprises, inevitably, is the returned look before its preparation, its composure. It is as if the returned look momentarily comes out to meet the camera, to anticipate the camera's enquiry, with something challenging about it, but equally something anxious or defensive. This inchoateness of features makes the street-photographic face less decipherable than the documentary

face; the street-photographic face is, after all, subject to its instant, is complicit with its environment, is being drawn off into the overall structure of the photograph. The look of the documentary photograph, on the other hand, may be intensified by the photographic structure (rhetoric), but is able to detach itself, to hold us, and is able to detach itself from the instant, too, entering its own duration. In this sense, even though we might say that the returned look enjoins muteness on us by enjoining us to meet the look, to establish a wordless dialogue with and of the look, we must recognise that different kinds of look give different inflections or modalities to that muteness, penetrative or puzzled, concentrated or dispersed, recognitional or exploratory.

What these reflections about the returned look suggest is that the spectatorial eye makes immediate and intuitive judgements about the generical leanings of the subject's 'address' to the camera, prior to any engagement with linguistic explanation or rationalisation. We may then go on to propose that the visual encounter with the photograph draws on a set of recognitions which plot the coordinates of the image's designs on the interpretative eye. But the photograph is not an inactive partner in this visual exchange. The photograph may as much inter-rogate the spectatorial eye as be interrogated by it. The photograph may compel upon the spectatorial eye adjustments, which, as they are made, produce a revelation, or a fruitful perceptual enigma, or simply a visual pun. But, as we shall see, such adjustments of vision may also find themselves activated or sustained by the linguistic imagination.

We have had cause on several occasions over the foregoing chapters to refer to the anamorphic drive which seems to lie at the heart of the street photographic. By anamorphosis I mean not so much 'an image or drawing distorted in such a way that it becomes recognizable only when viewed in a specified manner or through a special device' (*Collins English Dictionary*, 2000: 53), as with the skull in Holbein's *The Ambassadors*. I mean any optical experience which when viewed once, or from one angle, seems to be one thing, and when viewed again, or from another angle, seems to be something else. We should be careful not to make too great a claim for this particular kind of

perceptual adjustment: it might sound rather like the equivalent of some metaphorical operation, applying to one thing, if only momentarily, terms appropriate to quite another thing; it might sound as if it generates fruitful ambiguity, the tension of an either/or. But it is not usually either a metaphor or a perceptual ambiguity, both essentially figures of juxtaposition or superimposition. It is a moment of misidentification, quickly corrected. It is neither a *and* b, nor a *or* b, but rather a superseded by b, in such a way that the route back from b to a is very difficult to retrace and the trick is blown. In short, the kind of anamorphosis that concerns me is a close companion of the double take: look and misconceive, look again and correct.

There is reason to claim that the anamorphic is an optical experience built into the very ontology of photography. Our living environment, like a film, is full of photographs we never see, freeze frames lost in the confused inexorability of movement. In this sense, the time of life, as of the film, despite editing, is very ordinary, undifferentiated time, any-instant-whatevers. Violent and gripping events take place *within* time, but time itself is not a happening, an agent, a creator, of events or conjunctions of circumstance. A still camera can make time this architect. The moment fired, as it were, from the shutter, surprises a world in the midst of its continual making of itself; time becomes an event and ordinary, undifferentiated time stops to look into itself, to discover the momentous. The moment holds time up so that it has consequences. Not narrative consequences especially. If one photographs time in a single space, then the progression of time is a series of explosions, of different centrifugalities, of life constantly diverging from itself, making decisions.

Photography is peculiarly geared to anamorphosis because the taking of a photograph changes vision, and, in a sense, the meaning of every photograph lies in this first encounter with it, in this shock of arrestation, in the realisation that we are seeing something we did not particularly notice. At this primary level, as indeed at the secondary level – as a device *within* the photograph – anamorphosis lies in the very act of seeing, not in a posterior process of interpretation.

Photography chooses anamorphosis because it minimises the interferences of language, because it depends on an instant of visual recognition which is also an instant of visual discovery. This latter near-paradox is perhaps peculiar to street photography: whereas documentary photography, too, may be based on the assumption that we do not see sufficiently, the inadequacy of our seeing, for the documentarist, has no excuse in the greater perceptual capabilities of the camera; the instantaneousness of the photograph, or the intensity of its focus, are devices of confrontation rather than of revelation. The street photograph, on the other hand, accepts that the camera sees more than we do, that it is an instrument of privileged access. This acceptance comes with two understandings. First, while the camera sees more than we do, we have the capacity to intuit this 'more', even before the shutter is released. Cartier-Bresson's decisive moment is crucially to do with the photographer's ability to surprise, with the help of the camera's instantaneousness, the instant he had already anticipated: 'the intuitive capture through the camera of what is seen'; 'To take photographs means to recognize – simultaneously and within a fraction of a second – both the fact itself and the rigorous organization of visually perceived forms that give it meaning' (Hill and Cooper, 1992: 67). Second, even where the camera sees what the eye does not even anticipate, where the camera becomes the instrument of creative chance, or Surrealist 'objective chance', or of visual automatic writing, it still brings to the visual surface something towards which the human unconscious is striving, or urging us; the optical unconscious[1] is also previsualised, but that previsualisation – how can there be recognition without previsualisation? – is so repressed that it is only the random interferences of external reality which have the power to reveal it. Thus anamorphosis seems to have two principal modes: a look which desediments the familiar to uncover the strange; and a look which 'corrects' the strange in order to reinstall the familiar, conscious or unconscious.

There is another sense in which the photograph has peculiar affinities with anamorphosis and that is to do with its temporal ambiguity, an ambiguity we have already explored in our distinction between the

instant and the arrestation of duration. The instantaneous photograph presents us with perspectival space in planar time. What do we mean by planar time? As we pointed out in Chapter 1, there is, between the then and there of the photograph and the here and now, a crisis of continuity. The past is a past of moments without chronology (dates may, of course, be inscribed in the title/on the back of the photo, but this does not really chronologise our perception of them), which, because of this absence of chronology/continuity, relate to the present in a 'free' relationship. There is no sense in which we can 'perspectivalise' the photographic moment from our own position in time. And, conversely, if we make that moment part of a continuity, part of narrative, it will lose its imperious authenticity, its ability to mould visual circumstance, to be reality's very self-sufficiency. Instead, it becomes something that confirms a trajectory, something dominated by its actors, who take it out of reach of itself, leave it behind, reduce its time to ordinary time.

We hardly need to rehearse the juxtapositional opportunities that a city provides: we have already seen the way in which a poster or sign can comment on the lives being lived within its purview (Brassaï's prostitute and 'Changement de propriétaire' ['Change of Owner']); or the way in which spaces, contiguous but invisible to each other, create piquant contrasts (kissing couple and gent of the old school in René-Jacques's *Paris*, 1930–35). The very complexity of urban space and the opportunities to reconfigure it by the adoption of unusual angles make the city rich in suggestive visual equations. And so many of these spaces are already framed. In his *Quartier latin* (1968), Édouard Boubat simply takes the façade of the apartment block opposite, à la *Rear Window*, to juxtapose the lives in different apartments, in a formal counterpoint of shutters opened and closed. Arrested duration, on the other hand, relates photography more closely to filmic metamorphosis, to the generation of the film still (photogram) in the still photograph. In our treatment of René-Jacques's *Newsvendor, Paris* (1936), we began to imagine place itself as filmic continuity, propelling its occupants tirelessly into Heraclitian flux, refusing to let itself ever be the same,

retrievable. The camera that records the singular becomes the projector that compels multiplication, proliferation, evolution.

Anamorphosis takes its place on the cusp between juxtaposition and metamorphosis; it is a juxtaposition in sequence, a section of metamorphosis. And although photography plays with all three modes, anamorphosis might be said most perfectly to express photography's in-betweenness. But anamorphosis inevitably runs the risk of falling between two stools, between the suspended potentialities of juxtaposition and the infinitely resourceful modulation of metamorphosis. Anamorphosis too often seems like juxtaposition undermined by a process of supersession, or metamorphosis stalled by resolution.

We know that Barthes was not very impressed by Kertész's *A Window, Quai Voltaire* (1928). He begins his argument thus:

> I imagine ... that the essential gesture of the *Operator* is to surprise something or someone ..., and that this gesture is therefore perfect when it is performed unbeknownst to the subject being photographed. From this gesture derive all photographs whose principle (or better, whose alibi) is 'shock'; for the photographic 'shock' ... consists less in traumatizing than in revealing what was so well hidden that the actor himself was unaware or unconscious of it. Hence a whole gamut of 'surprises' (as they are for me, the *Spectator*, but for the Photographer, these are so many 'performances'). (1984: 32)

Barthes then goes on to enumerate five types of surprise; the final type relates to Kertész's photograph:

> Fifth type of surprise: the *trouvaille* or lucky find; Kertész photographs the window of a mansard roof; behind the pane, two classical busts look out into the street (I like Kertész, but I don't like whimsy, neither in music nor in photography); the scene can be arranged by the photographer, but in the world of illustrated media, it is a 'natural' scene which the good reporter has had the genius, i.e., the luck, to catch: an emir in native costume on skis. (1984: 33)

Barthes's final comment here reveals how prone we are to willing deception when the whole value of lucky chance is at stake. But perhaps we also begin to cultivate undecidable conjunctions of the guileful and the innocent, the cynically exploitative and wide-eyed wonderment.

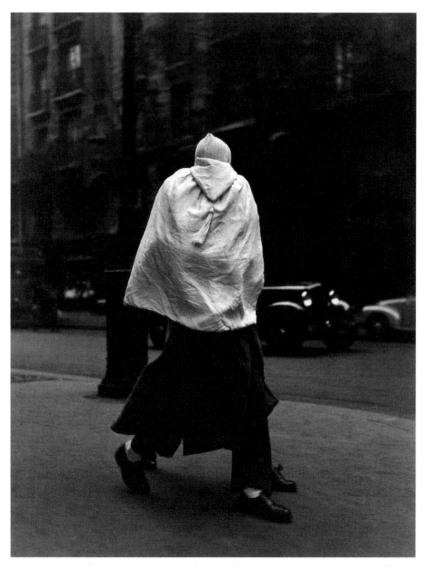

FIGURE 31 Louis Stettner, *Paris* (1949)

Perhaps this is one of the ways in which street photography negotiates between the visual gifts of the clairvoyant and the streetwise ruthlessness of the confidence trickster. But then the set-up – if that is what it is – of Kertész's photograph seems rather crude: the bust of the

philosopher-grandfather has been given a woollen skullcap to match the windswept wig of his 'granddaughter'. Does this help to 'consolidate' the double take? Is this a photograph one wants to look at twice?

Louis Stettner's image, *Paris, 1949* (Figure 31), works by related means. Who is this very tall, hooded, four-legged figure, with a 180 degree swivel at the waist? Oh, it is a father (invisible), carrying his child (invisible), and in step with his wife (invisible). Once solved, the enigma is not worth reassembling. Tom Hopkinson's closing comment on this image is: 'They are just a passing apparition, caught and made lasting by the camera' (Haworth-Booth, 1983: 70). But once we have solved the visual conundrum, the very tall monk, or small-headed contortionist, can never be recovered; the photograph has nothing to make lasting, other than our memory of having been initially mistaken.

Urban literature has its own version of street-photographic anamorphosis. The sounds of language play tricks on the ear, produce aural double takes, moments of creative mishearing. One of these is the subject of a prose poem in Jacques Réda's collection *Les Ruines de Paris* (*The Ruins of Paris*) (1977) (see Appendix 1a for the full French text, and 1b for Mark Treharne's English translation). Late at night the poet hears shouting in the street, as if someone were issuing a challenge or a taunt. The poet thinks of Homer, and this wilful auditory/imaginative self-delusion encourages the hearing of *brocanteur* (secondhand dealer), as a term of abuse:

> And once again these shouted challenges start up, like those in the *Iliad*. I grasp the word *brocanteur*. Perhaps this is how Hector humiliated Achilles before the latter literally hung up his arms like something from a fleamarket [*comme à Biron*]. (1996: 41)

Having opened up this imaginative space, having given himself this licence, the poet embroiders further, thinks in speculative gossip:

> Leaving these heights of epic poetry, it occurs to me that the secondhand dealer who sometimes comes on his rounds towards ten in the morning has temporarily struck it rich: in which case, like everyone else, he has treated himself to a trip to Bangkok and the jet-lag has played havoc with his sense of time. (1996: 41)

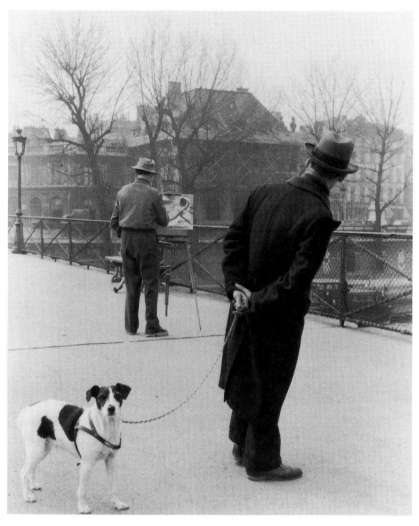

FIGURE 32 Robert Doisneau, *Fox Terrier on the Pont des Arts* (1953)

After the sallies into burlesque (epic heroes speaking like street traders) and mock epic (street trader as globe-trotting tycoon), reality is restored by a process of perceptual correction: what the poet actually heard was not *brocanteur*, but *pommes de terre* (potatoes). The poet buys a sack. The traders depart.

But as this anamorphic puzzle is solved, so we find ourselves more deeply embroiled in, rather than released from, the text. How has this occurred? The initial mishearing – *brocanteur* for *pommes de terre* – is based on hearing a voiced *b* for its unvoiced partner *p*, understandably, given that the street-vendors are shouting with gusto ('shouts ricocheting off the house fronts'; 'these shouted challenges'). But as the poem proceeds, we suspect that the *b* error is not created by the vendors so much as by a habit of tongue/mind, by the projection of a psychic tic, of the auditor. Why is it that all *imagined* place names begin with *b*: 'Biron', 'Bangkok', 'Bourg-Theroulde (Boutroude)', 'Bayeux'? Why is it that the 'as if' trader is the gun-running Rim*b*aud ('I am as moved as if it were Rimbaud flogging old rifles')? This *b* begins to take on the buccaneering carelessness of these potato-sellers from Normandy. The anamorphosis then becomes not so much the discovery of a truth as the loss of a dream, the sacrifice of a certain swagger, to the needs of daily livelihood.

Can photography map in thought processes of similar complexity? Can there occur a similar layered de-sedimentation of realisations and imaginative possibilities? Perhaps an obvious reason for suggesting 'yes' would be Doisneau's *Fox Terrier on the Pont des Arts* of 1953 (Figure 32). The photograph has this title apparently because the dog is in the foreground, posing for the camera. But, clearly, this is a decoy: the photograph has nothing to do with the dog, but rather with the painter – this is the Pont des Arts after all. His easel is set up as if for an architectural painting, of the Institut de France on the far bank. But, no, he is painting a nude. But why set up the easel with this orientation, why paint a nude in the street? Then we catch sight of a woman's lower leg and foot emerging from behind the painter's trousers. Ah! The easel is set up to face the bench on the bridge. Is the woman on the bench naked then? She is wearing shoes at least. Is it just the painter's gaze that has stripped her bare? But is that a coat immediately to the right of the painter's right hip? But the nude in the painting is leaning against something which is not obviously a bench-back. Yet the line of the woman's leg continues the diagonal of

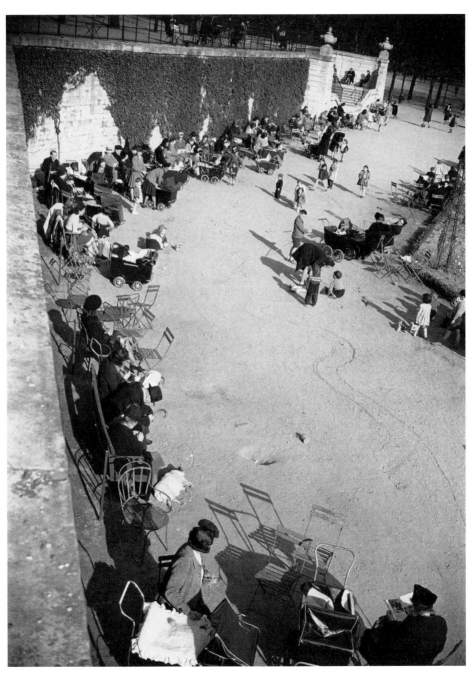

FIGURE 33 Marcel Bovis, *Jardin des Tuileries* (1947)

the nude's torso and head, which has been deliberately blacked out (to spare her blushes?). And is the strolling spectator trying to look round the painter at the painted nude, or round the easel at the (naked?) woman beyond? Layers of planes, layers of shifts of perception and speculation. The refreshingly unproblematic dog, no less posing than the unseen (naked?) woman, becomes a convenient excuse for stepping out of this insoluble enigma into visual comfort.[2]

This picture is not just a sequence of visual corrections, but a sequence which will not resolve itself. If we are held by this image, it is by the force of frustration and amusement; nothing is to be gained from further speculation; the problem will remain the same. The lack of resolution is not the lack that results from a work's having become a multicursal labyrinth progressively losing its centre, multiplying its options; Doisneau's photograph remains a unicursal labyrinth whose centre we have simply been unable to reach.

On this reckoning, the anamorphic photograph belongs to that class of photographs we have already encountered, in which the justification of the instantaneousness of the instant is too obvious, in which the instantaneousness of the shutter merely *coincides with* the instantaneous act. The instant is no longer an instrument of penetration, a moment of vision, a gravitational point; the moment is dictated by the fractional time that a visual arrangement takes to constitute itself. The anamorphosis which is temporally constructed is produced by time and taken away by time. The anamorphosis which is produced by space (in time), on the other hand, is not taken away by time, but is suspended in time, in the picture, by the dynamics of spatial disposition.

The power of Marcel Bovis's *Jardin des Tuileries* (1947) (Figure 33) lies in the way in which spatial perception and social perception interact. From one point of view, the image depicts a group of mothers and nannies, gathered in the late (?) afternoon to bask in the suntrap of the wall on a spring day which still has a chilly edge (?). The oblique-ness of the angle of vision, the wide-angle lens, makes the ground fall away towards the right, so that the assembly of mothers and nannies is reminiscent of shipwrecked passengers, or a colony of seals, sticking

to an area just below the cliffs, to avoid the suck of the sea on the down-sloping beach (the woman leaning back in her chair, on the right, focuses this feeling). At the same time, the mothers and nannies form an audience for the arena of the sandy path. The mood is desultory, unpurposeful, fag-endish like the afternoon; the performance is over. In the arena's foreground, there are the traces of an action: the tracks of a pram (why just one set? the pram prominent at top left?) which had a change of mind; a shallow hole in the ground, excavated with the bucket (?) now lying on its side, unclaimed. Whatever it was before, it is now an abstract bas-relief (one of those oil and sand pieces by André Masson?), requiring the onlookers to observe a respectful distance. Further up, other performers, children, are gradually quitting the stage. There are few men in this audience, but the alpha male is clearly the one posted at the apex of the angle created by the wall (am I thinking seals again?).

From the photographer's point of view, the whole of the picture's lower level (the path, the park) is a stage, on to which are strolling further performers, from the sinister, Hadean darkness of the wings at the upper-right-hand corner. And the photographer's view is relativised by other spectators on the same level or nearly, on the 'balcony' and at the top of the first flight of steps (but which level do these two women and half-hidden man really belong to?). As one passes backwards and forwards between these ways of making sense, so the eye is constantly deflected by stray visual information, things which because of their singularity resist visual assimilation: the girl with the bucket (?) and dolls (?) who catches the light on her back, mid-right; the sleeping dog also catching the light, on the left; the girl lying on her back on the path, right of centre, being addressed (coaxed? scolded?) by her mother or nanny; the shadows of the two chairs in the foreground, in line astern, shadows which turn other chairs into shadows; the one black woman (?) stooping over a pram, high and to the left. This is a photograph firmly set in time, in a specific instant; yet the photograph subjects its temporality to its spaces and angles, and in so doing transfers anamorphosis from sequence (look

once, see *A*; look again, see *B*) to simultaneity (see *A* in *B* and vice versa), the simultaneity not of juxtaposition but of superimposition. I can no longer distinguish between the rabbit and the duck; I can no longer stop seeing what my mind has set in motion; I can no longer extricate myself from the image's self-perpetuating, sense-suggesting interaction with itself. My view of the picture is peppered with ignorance, unverifiable supposition, whimsical association; this process of anamorphosis maps out not a shared visual joke or conundrum, but a personal itinerary of relationship; and it is activated not by an 'inserted' double take, but by what we have called 'primary-level' anamorphosis, the anamorphosis of the photographic act itself, the anamorphosis triggered by a frame.

When the double-take process works in this direction, not from enigma to solution, from bizarre to ordinary, but from what has no particular sense to what has, from chance to coincidence, from visibility to association, then anamorphism fills out the photograph and initiates a process of deepening which the photograph can fulfil but not solve. The double take as a habitual mode of perception is a thoroughly enriching mode of being. We look once, without engagement or penetration, and then we look again, with the lens of the camera as it were, with a frame, and make life mysterious for ourselves, activate our half-knowledge and our ignorance. Framed seeing is that kind of sharpened consciousness that the *flâneur* is master of. It is a kind of seeing which becomes increasingly dependent on the imagination that lies in language, on the literary rhetoric of intensified vision, seeing by analogy, seeing connotatively, seeing behind visibility. This is no bad thing, if language does indeed draw us into deeper seeing, into a seeing which is personally fruitful. And this language will be a form of monologic gossip, the gossip of visual autobiography, a gossip prevented from advancing too far into interpretation by its own fallibility, its ignorances and idiosyncrasies.

It is the anamorphosis constructed by time which threatens to leave unalleviated that crisis of attention described by Jonathan Crary in these terms:

there were two important conditions for the emergence of attention as a major problem in accounts of subjectivity. The first was the collapse of classical models of vision and of the stable punctual subjects those models presupposed. The second was the untenability of a priori solutions to epistemological problems. This entailed the loss of any permanent or unconditional guarantees of mental unity and synthesis. (2001: 19-20)

In many senses, it might be argued that photography merely perpetuated, anachronistically, the premodern confidence in an integrated, encompassable and assimilable field of vision, represented by Renaissance perspective and confirmed in the camera obscura. Alternatively, one might argue that photography became a weapon of defence against a field of vision that had reached sensory overload, that was fragmented, distractive, free-associative and that no shared socio-symbolic order was any longer available to process. The frame, focus and sensory specialisation in the optical became the instruments whereby the ordered was isolated from the disordered, the meaningful from the meaningless, the purposeful from the aimless. It is this power to exclude that makes photography a much more effective means than painting of addressing directly those crises outlined by Crary; painting continues to promote a deeply entrenched premodern notion that aesthetic contemplation is quite unlike any kind of 'worldly' looking and is impervious to that badgering of the eye that afflicts modernist vision.

But this view is clearly too convenient, since, for one thing, the photograph is powerless to guarantee the purposeful tenacity of attention. Indeed, our view of the photography of temporal anamorphosis would be that it sacrifices attentiveness for short-term gains, that it encourages attention quickly to exhaust itself. Such a process may be regarded as endemic to photography. This is certainly what Victor Burgin's account of the spectatorial look (1982b: 152) suggests:

To look at a photograph beyond a certain period of time is to court a frustration. ... To remain long with a single image is to risk the loss of our imaginary command of the look, to relinquish it to that absent

other to whom it belongs by right – the camera. The image then no longer receives *our* look, reassuring us of our founding centrality, it rather, as it were, avoids *our* gaze, confirming its allegiance to the other. As alienation intrudes into our captation by the image we can, by averting our gaze or turning a page, reinvest our looking with authority.

Attention, designed to stabilise and make meaningful our contact with the world,[3] is in fact a highly volatile state, liable by its own mercuriality to contribute to the amorphous flux of consciousness, subject to its own pathologies (psychic dissociation, agnosia, fetishisation, autohypnosis). It might even be said that Barthes's notion of *punctum* is itself a pathology of attention, deriving, paradoxically, from the free associationism to which we are all prone.

But underlying these particular predicaments – attention and visual ownership, attention and pathology – is that paradox common to the photographic arts, already adverted to: the photograph offers us a point of view on the world produced by a disembodied eye; the camera offers us acts of extreme attention which we cannot make our own. My argument about 'primary' and 'spatial' anamorphosis is designed to show that anamorphosis can, and should, be an assimilative process (Benjamin's *Erfahrung*), a process whereby we negotiate visual ownership of the image, whereby the disembodied eye engineers its embodiment. It can only do this by elaborating its own, inimitable set of anamorphic adjustments of vision, by engaging the psyche through its language, through language's ability to translate, transform, transpose, remember, imagine. And the more this language clings to its responsiveness, to the singularity of its perceptions (to intensify the singularity of the image's own moment), the more it will gravitate towards the gossip of autobiography. This is a language which still needs to discover its true mode and to establish its credentials. But it is a language which also needs to find the right path from the optical to the multisensory.

We have claimed that photography, more than the other visual arts, because it is machine-made and not hand-made, evacuates all senses

but the optical. This is the ground of its tendency to beautify: visual enhancement is endorsed by sensory sanitisation; even the beggar no longer smells. But maybe we need to consider another possibility: that the photograph releases the viewer's eye/look into its own synaesthesia:

> As the site of the making of meaning, the look generates a synaesthesia, where the (physiological) senses, pooling their impressions, enjoy joint-ownership, so that one can attribute to the one, poetically, what happens to the other ... : all the senses thus have the capacity to 'look', and, conversely, the look has the capacity to smell, to listen, to touch, etc. (Barthes, 1982: 280)

What this, then, might imply is that the eye reconstructs, wants to touch, smell, hear the photograph. Focus itself can be the magnetic point of this desire, and it is probably true to say that differential or shallow focus is more 'alluring' than overall or deep focus, merely because it intensifies the sense of a point of optical attention dissolving into more generalised sensory absorption; initial optical contact, encountering resistance, sensorily expands to fill out the scene. Another way of putting this transformation of the optical into the multisensory would be that an eye – the lens – which has no interest in the other senses (does not know them) hands over its evidence to an eye which is used to combining the evidence of all the senses.

We might then go on to propose that street photography favours subjects likely to invite or discharge synaesthetic experience. If we find a cultivation of images of streets in rain, for example, it may be partly because rain adds variety and vitality to surfaces, to the tonal range, to the play of reflections; but it may equally be because rain activates the synaesthesia of the eye, demands that we see those pungent smells that the rain brings out of the city's stone, see the rain's various rhythms and musics:

> I've always loved the rain. As a child, in beatific exaltation, I used to listen to it, rattling against the windowpanes of my bedroom, or pattering on the leaves in the garden. It filled me brimful with raptures, with guilty pleasures which acted on my senses and then

plunged me in endless reveries. The smell it had in Paris seemed to
have no kinship with those hoarded by my memory: I could pick out
in it the clinging pungency of prostitution and poverty. (René-Jacques
and Carco, 1988: 8)

Like darkness (see Chapter 5), the rain seems to draw out the city's
deep-sunken, seamier side, and leaves it as an obstinate persistence
in the air.

In the light of Carco's words, we might further propose that the
optical can only embrace the synaesthetic through the language of
autobiography. Autobiography like this is a language not of pondered
interpretation but of unavoidable response, a language made necessary
by the transformation of the informational image into the memory-
image (see Schaeffer, 1987: 134). If I consider François Kollar's *Rain
in Paris*, 1930), it will tell me very little I do not know already; the
knowledge I bring to the image makes redundant what it can tell me,
informationally. Two figures under umbrellas (both women?), seen from
behind, cross the road, in line astern, behind a man in a hat; between
the figures with umbrellas, in the background, a car passes. Signs in
the street are too obscured to be worth guessing at, and where more
of the letters are visible – as in 'ibles Vins' – my knowledge allows
me to fill it out – 'Comestibles Vins'. Faced with this informational
redundancy, my response to the image shifts from what it tells me
to what it recalls experientially: the chilly dankness of drizzle, the
way in which these conditions empty the street of noise, other than
the swish of rain under tyres, and the disembodied, moisture-laden
clip-clop of feet, people moving with unseemly haste across the open
spaces, preoccupied by the discomfort, the insidious smell. Schaeffer
argues that, in the memory-image, the iconic function preponder-
ates: indexical identification is, as it were, guaranteed in advance.
This makes sense, but the indexical continues to play an important
role; as the image latches on to memory, it does indeed generalise
itself, its indexicality is, in a sense, dispersed; but, in another sense,
the capacity of the optical to expand into a more sensorily inclusive
experience, at the behest of accumulated memories, depends on the

vividness of the image as trigger, on the ability of the image not merely to activate inner autobiography, but to challenge it, to *taunt* it into activity, by indexicality's lack of compromise, its demand to be, to be acknowledged, in contradistinction to the viewer.

Looking at a photograph would then entail a process of sensory expansion, in excess of the photograph, an inhabitation of the blind field, but the blind field of the self. What this suggests is that while the interpretation of photographs is a process of metaphorisation, of the translation of the mute into the speech of symbolism and semiology, the language of communal perception (presupposing the iconisation of the photograph), gossip and autobiography are metonymic languages, languages of association, extension, embroidery, the one with a social, the other with a personal, orientation. Just as in Proust's *À la recherche du temps perdu* the whole of the village of Combray emerges from Marcel's highly specified, originating, sensory experience of a madeleine dipped in lime tea, so the very insistence of a photograph's indexicality permits the radiating proliferation of accumulated remembering. It is often assumed that indexicality condemns photography to the role of aide-memoire for voluntary memory. But indexicality can be equally effective as the random trigger of involuntary memory, particularly where the image concerned has nothing directly to do with us. We remember ourselves better, more deeply, through the photographs of others, than through our own (our family's). Here, ignorance, paradoxically, restores us to knowledge of ourselves, and anamorphosis is the very process of involuntary memory. Our encounter with a photograph may well be the equivalent of Marcel's encounter with the three trees at Hudimesnil, on one of his drives from Balbec with Mme de Villeparisis, the double-take of déjà vu.[4] In these kinds of experience, it is not the *art* of the photograph that makes the difference, but its photographic-ness. We have already had cause to draw attention to the Proustianism, which, despite Barthes's asseverations, lies hidden in *punctum* (Chapter 1 n2). Barthes asserts that *punctum*, obtuse meaning, the third meaning, are beyond the reach of language. But what kind of language? Is there not a form of autobiographical writing which would teach us to

see what of ourselves photographs are capable of giving back to us? The photograph which restores Barthes's mother to him predates his birth; a photograph of rain taken in 1930, prior to my birth, allows me, *by its very indexicality*, to re-establish contact with my personal history of rain-filled days and passing showers.

This is a world of photographic meaning that documentary photography has nothing to do with. Documentary photography would become nonsensical if its indexicality were to become a-chronological, free to move through time and space. Documentary photography's efforts would be set at naught if the spectator were to treat its images as thresholds of access to his own inner life. The authority of the documentary derives not only from its authenticity, guaranteed by its indexicality, but also from the agreement it can produce in the spectatorial community. Street photographs, on the other hand, look to disperse authority by inviting a diversity of individual input, and by making indexicality more a value than a guarantee, a value whose expressive potentialities are not tied to any particular time or place.

By way of conclusion to this chapter, I would like to draw together the threads of synaesthesia and autobiographical anamorphosis, an anamorphosis instigated by the dialogue between the photographic and the linguistic, by briefly examining one of those examples of 'collaboration' between writer and photographer, in which the French street-photographic tradition is so rich, where others are peculiarly impoverished.

Mac Orlan's 'Les Balançoires' ('The Swings') appears in his *Fêtes foraines* (*Funfairs*) (1926), a sequence of prose poems which was published – with seven omitted – in an album, alongside photographs by Marcel Bovis, in 1990. The project had been ready in 1948, with the photographic work relating to the years both before and after the Second World War (1927-48); but no publisher could be found, and it was only after Mac Orlan's death that the album finally appeared. Bovis's preface is by way of being a collection of childhood memories of fairs, circuses, music-halls, but one sentence in particular stands out: 'You plunged into an ocean of noises and violent lights, you breathed all the smells

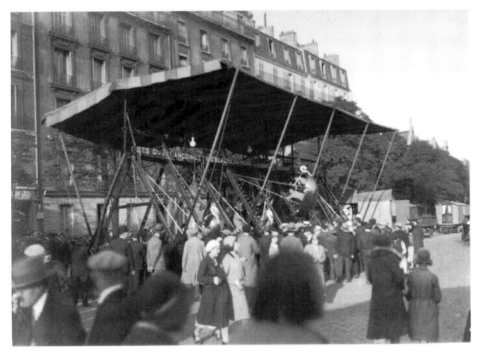

FIGURE 34 Marcel Bovis, *The Swings at Denfert-Rochereau* (1931)

mixed together, the smell of frites, of boiled-sweet twists, of marsh-mallow, of waffles, of crunchy Dutch biscuits, of gunpowder and the powder of magnesium flashes, all mixed with the dubious and pungent whiffs issuing from the menageries' (Bovis and MacOrlan, 1990: 9). The atmosphere of the fair, of the street photograph, is thick with sensory blends, a heady mix which crosses frontiers between foodstuffs, minor explosions and animals. The repetition of the word 'mixed' suggests that this is an unstoppable process, running across the fairground like wildfire, producing such an intoxicating blend that one can no longer isolate anything, that one has to surrender to the promiscuity and endless variation. We accuse photography of sanitising reality, of editing out all senses but the visual, of omitting most especially the olfactory, the most deeply embedded of the senses, the one that has the most to do with

memory, the one that works most insidiously. But, perhaps, photography, and street photography in particular, does not so much erase as deprive, expressly leaving a space for sensory reconstruction, using the eye as the trigger of a synaesthetic experience, which metonymically, as it were, opens out into the blind field. The blind field would then represent a desire for repossession, not just of the scene as lived, but of the sensory life of the self in the scene. Finally, we come to the inevitable pungency of 'menageries', about which we have already had suggestions to make in the previous chapter. Suffice it to say, for present purposes, that the piquant medley of smells is itself a menagerie, a principle of combination which seems to follow no principle, where the zebra might lie down with the goat, gunpowder with marshmallow. There is, in this menagerie, a madcap utopianism which potentially spells social revolution, but a disorganised and easily diverted revolution.

Bovis's photograph (Figure 34) comes from the south of Paris (Denfert-Rochereau, 1931). The whole crowd, apart from those few making their departure, is turned towards the spectacle of the swings – 'L'escadre du Nord' ('The Northern Squadron') we read from the cross-beam. Out of the mass breaks clear one swingboat, with two boys clinging to the rigging, breaking the rules – on the same cross-beam one can just make out 'Défense de se tenir debout' ('Do not stand up'). Warm jackets and overcoats are the dress code for this early spring day, but the sun catches the sky-bound boys and picks out, too, the swan-headed prows of two other gondolas, about to surge upwards.

But this is no easy moment of optimism. The sky that these swings rise up towards is the dark underside of the structure's awning, a night sky waiting to engulf this indulgence in unbridled pleasure. The dream remains imprisoned within the artificial world of the squadron of swings, a theatre which attracts spectators hungry for the resurrection of past illusions. The sensory blending, and the erasure of categorial distinctions, which we find in Bovis's brief description of smells at the fair, are acted out in the photograph's moments of indeterminate focus, as people shift about in varying degrees of dynamism. The sharpest focus, not surprisingly, is to be found in the Haussmannian

apartment block behind the swings, in the main frame of the swings, the cross-beam, the awning, the support struts, and among the stillest spectators. Focus is that clarity of vision which puts a scene in time, condemns it to the impatience of history. Absence of focus begins to make the moment unreal, possibly part of another timescale, begins to restore a certain visual potential; the slightly unfocused fairground shacks and wagons at the photograph's right, overseen protectively by the gables of a seemingly medieval building, belong to a tradition of carnivalesque nomadism, of improvised existence and bohemian spontaneity which can, however, do little to face down the settled, proprietorial surveillance of the apartment block. Focus is most absent in the cut-off heads of the foreground figures, the threshold we cross to enter what might have been a space of the imaginary, had not focus itself reminded us of our bearings in reality.

Bovis's photograph may be thought of as a comment on the iconography of the swing, to be judged in the light both of subsequent examples (e.g. Brassaï's *The Kiss*, 1935; Émeric Feher's *On the Grands Boulevards*, 1936; or Michel Fargette's *Swing-boat*, 1962) and of antecedents, which take us back into painting, to Renoir's *The Swing* (1876), and further back still, to Fragonard's canvas of the same name (1768). These latter images, along with Maupassant's description of Henriette Dufour on a swing in 'Une partie de campagne' ('A Country Excursion') (1881),[5] its realisation in Jean Renoir's film adaptation (made in 1936; released in 1946), remind us how important the swing is in the elicitation of the feminine, in the release of suppressed physical and emotional energies, of pleasure at its limits, perhaps coloured by fear. The male spectator is excited, even disturbed. Bovis is not interested in this sexual potentiality; his concern seems to lie more with the generation gap than with the division between sexes. His boys strike a sharp contrast with the surrounding spectators, among whom there seem to be no other children. As Bovis's own preface makes clear, fairs are lost paradises, the opportunity to recover selves long buried, and to participate again, if a trifle vicariously, in a world made of spontaneously expended energies and sensory surfeit.

Mac Orlan's prose poem, on the other hand, is in part concerned with the erotic undertow of the swing experience:

> Admiral North, as young and pink as a shepherd fed on edelweiss, wears on his hairless head Beatty's uniform cap in the Jutland mist. He puffs on the festivity which gracefully bends and rights itself again, and the good-natured squadron of swings sets off to conquer the sky over Robinson or Meudon.
>
> Blue, white, red, the sheltered harbour of departures and arrivals has stuck on the mast of its pavilion the tricolour cockades of the 14th July.
>
> In each caravel, or slung hammock, or swing, there is a young girl and a boy.
>
> The boy pulls on the cord and the girl spreads out her petticoats, uttering cries of high-spirited terror.
>
> When the swings stop, slow to come to a standstill, you can hear, distinctly, the tick-tock of the fairground clock, announcing the end of love. (Bovis and Mac Orlan, 1990: 73)

This is the people's voyage to Cythera, more high-spirited than Watteau's, but permeated by the same sense of a short-lived opportunity which went begging. The place of departure is the same as the place of arrival, for all its revolutionary decoration ('the tricolour cockades of the 14th July'). But these moments keep their magic because they are experiences of morphing, between Renaissance Portuguese ship ('caravel'), hammock and swing, because the feelings are taken to challenging emotional interfaces (joy and fear). Out of the misty north of the First World War (Beatty, Jutland) emerges the aeolian admiral puffing his boats to the south of Paris (Robinson, Meudon).

These are the added colours that the language of literature adds to the visual image. We encounter the same self-liberating impulse, and, likewise, the ability to cross different zones of affirmative experience, to hold choice in one's hands, is blocked by the sharp gesture of division and separation expressed in the word 'distinctly', that sudden coming into focus, which spells the intrusion of passing time and the immobilisation of the swings. The swings may resist for as long as they can ('slow to come to a standstill'), but the fancy dress of the fairground is not

sufficient protection against the dogged reminders of a banality always ready to reclaim its own.

But these verbal leavenings of the photograph, these invitations to elaborate a personal imaginary, to infuse Bovis's image with literary associations, with an autobiography of seeing and reading, do not supersede the originating visual encounter. The photograph retains its indexicality, its connection with vivid, first-hand seeing, the world of deixis, by constantly reasserting what Barthes might call its 'traumatic' force, which resists interpretative discourse and is a 'this-side of language' (1977: 30–31). Street photography is the trauma not of catastrophe but of the everyday. In Bovis's photograph, it may be the light reflected off the shiny surface of the boys' gondola, or an upturned fur collar, or two light bulbs (different shapes) suspended from the awning, or a clutched handbag, or simply the way in which the swing, suspended in mid-air, seems itself to have the power to suspend the life around it. The eye is selected by these things, surprised by them, although it was free to choose them. And suddenly they cannot be edited out, cannot be overridden by the prior claims of the picture's theme, but erupt in the eye like a series of small visual explosions, affirming the recalcitrance of their presence, their mereness, their apparent indispensability to this Parisian afternoon. What the addition of language, of connotation and association, allows is the coexistence of the instant and the moment; *Erlebnis* and *Erfahrung*, experience of the surface and experience of the depth, can simultaneously occupy two sides of the same coin. The swings re-enter the cruelty of passing time, of focus. But it is this very same focus which, paradoxically, preserves the fresh revisitability of the illusion.

One final aspect that relates to the issue of an appropriate language for, or the appropriateness of language to, street photography, is captions. But since, in street photography, these are so frequently of a geographical or topographical nature, it will be more fitting to consider them in the next chapter, which is devoted to the physical city, the city of buildings, of streetscapes and street furniture.

5

streets, buildings and the gendered city

Our final route into street photography takes us along the broad boulevards of Haussmann's new Paris. If we were briefly to summarise the changes wrought on Paris by the Prefect of the Seine, Georges Haussmann, then they might run something like this. Aesthetically, plaster gave way to stone, heterogeneity to a limited range of classicising models, the crooked and small-scale to the straight and amplified, the city as random accumulation to a planned city of 'settings' (for monuments, squares, parks, etc.). Economically, commerce was facilitated by the creation of cross-city arteries and the architectural enablement of large-scale business enterprise (department stores, hotels, railway stations, etc.), investment was encouraged, employment opportunities increased, tourism was fostered. Politically and militarily, the new wide streets and improved arterial access improved the speed with which police or troops could be deployed, opened up commanding fields of fire, prevented the construction of barricades and broke up the corporate solidarities, the tribalities, of the old *quartiers*. In terms of health and safety, open spaces were created for recreation, disease-harbouring houses demolished, water supplies and the sewerage system were overhauled and renovated, street lighting was radically extended and

modernised, and the width of the new pavements was capitalised upon with the provision of street furniture (urinals, advertising columns, kiosks, fountains). Socially and psychologically, the consequences are harder to judge: on the evidence of Impressionist paintings, we might suggest that the new articulations of space intensified or triggered the pathologies of space (agoraphobia, claustrophobia, vertigo), that they problematised the relation between native and cosmopolitan, private and public, that they generated new senses of irresponsibility, vulnerability, dispossession, exhilaration, distractedness.

The Haussmannisation of Paris is a masculinist enterprise of penetration, panoptic possession and universal visibility, the Thesean dream of a unicursal pattern of corridors whose centre might be reached and whose monster, fruit of an unnatural sexual union, might be destroyed. But however ambitious the scheme, time and the exhaustion of resource were bound to overtake it. The Haussmannian boulevard did not eradicate the narrow, winding alleyway, the sudden impasse, the unpredictable theatre of the inner courtyard. The remains of a multicursal labyrinth still continued to confirm the city's 'inner' femininity, the secrecy of its anatomy, its elusive fluidity, its unencompassable variousness:[1]

> Dans les plis sinueux des vieilles capitales,
> Où tout, même l'horreur, tourne aux enchantements.
>
> (In the sinuous folds of old capitals,
> Where everything, even horror, turns to enchantment.)

In these opening lines from 'Les Petites Vieilles' (The Little Old Women), we can sense Baudelaire's identification of the little old women with the old capitals themselves; whether mothers, courtesans or saints, their quoted ('cités') names are cities ('cités') (ll. 61-4), now left only as marginalised traces, suppressed but not erased.[2] Elsewhere, Baudelaire's commentary on the thyrsus[3] ('Le Thyrse', first published 1863) is just as apt a description of Haussmann's Paris, of the straight boulevard with its dancing, arabesquing accompaniment of sidestreets:

> The stick is your will-power, straight, firm, and unmovable; the flowers represent your fantasy wandering around your will; they are the feminine element executing around the masculine element its prestigious pirouettes. Straight line and arabesque, intention and expression, firmness of the will, sinuosity of the word, unity of the aim, variety in the means, an all-powerful and indivisible amalgam of genius, what analyst would have the odious courage to divide and separate you? (1991: 84-5)

The city of the multicursal labyrinth resists the teleologies of the masculinist boulevards converging on *étoiles*, or bridges, or bisecting the city in movements of unhindered traversal. The multicursal labyrinth also resists the continuities and teleologies of narrative; the corridors interrupt each other, lead nowhere, so that one is engaged in a sequence of temporary, short-lived excursions which achieve a peculiar autonomy without quite dispensing with the need to go on. While we might look upon the axial boulevards as the novel, or the main news, or the panoramic interpretation, the sidestreets and backstreets are anecdotes, the *fait divers* and gossipy speculation. Louis Chevalier, social historian of Paris and an outspoken opponent of the 'modernisers', insists: 'Anecdotes are not, as Voltaire insisted, "this small field where one gleans what is left from the vast harvest of history", but rather lovely bouquets of history, at least when it concerns Paris, where the anecdote is at a premium' (quoted in Merriman, 1994: ix). Haussmann's Paris is designed to uncover the city's simplified infrastructure, to make the panorama legible. In a symbolic act of optical possession, Brassaï begins *The Secret Paris of the 30's* with a climb to the top of Notre-Dame, but it is a climb designed to undo Haussmann, because it is a climb undertaken in the dark, an illicit climb in which a capacious and ageing concierge is the photographer's Ariadne, a climb that reveals not a vision of modern urban rationality, but a spectral cityscape floating free in time:

> Scarcely discernible, the Hôtel-Dieu, the Tour Saint-Jacques, the Quartier Latin, the Sorbonne, were luminous and somber shapes ... Paris was ageless, bodiless.... Present and past, history and legend intermingled. (1976: n.pag.)

Haussmann's reconstruction of Paris is another one of those enterprises described by Anthony Vidler as

> cutting out of the fabric of the real city the sequences and places that constituted their memory maps of the city, of turning the city into a memory theatre and making that theatre accessible both to the inhabitants and, equally importantly, to visitors. ... Urbanism, in this sense, might be defined as the instrumental theory and practice of constructing the city as memorial of itself. (1992: 179)

But this process equally involved a process of forgetting:[4] demolitions entailed the erasure from the Parisian mind of those social, economic and medical realities associated with a certain kind of building, or street, or drainage system – just as, under the Commune, the toppling of the Vendôme column (16 May 1871) was designed to efface the signs of Napoleonic militarism. But there was always a photograph. Photography was instantly a political instrument, if only because, subversively, it resisted this suppressive, *imposed* forgetting (involuntary forgetting will eventually lead to involuntary remembering). Between 1865 and 1868, Charles Marville was commissioned to photograph condemned Parisian streets and buildings prior to Haussmann's demolitions, by the 'commission municipale des Travaux historiques' (Thézy, 1994: 30); a second commission, in *c.* 1877, was devoted to recording the new urban fabric. Where Marville's own sympathies lie is difficult to say with certainty. Inevitably, the confined spaces of the old streets seem to force the photographer into relations of (uneasy?) proximity with them, which accentuate the fact that so many, with their ends blocked off, look like impasses, that we cannot see the sky above the roof line. Here, there is little evidence of pavements, and traces of water standing in the gutters or between paving stones add to the atmosphere of the dank and insalubrious (there had been cholera epidemics in 1848 and 1853). Lighting is limited to isolated wall lamps. These are images of a city in which entry into individual streets makes relations with other streets invisible, and obliterates any sense of a presiding urban plan. The 1877 photographs, on the other hand, taken from greater distances, seem positively to open up the buildings to the sky, show junctions and

unimpeded vistas, so that we have a vivid awareness of the communi-
cational network, regularly punctuated by protective, path-finding
streetlights. But this pro-Haussmannian reading of Marville does not
change the fact that demolition, if it leaves no trace of buildings, leaves
photographs which demand to be taken into account.

Demolition and its visual meanings deserve a history of their own.
There is space here only to suggest two paths of enquiry, paths that
can be traced out of the eight-week Commune of 1871. As Alisa Luxen-
berg points out (2000: 27-8), the depredations of the Commune must
have struck the Parisian public as powerfully ironic. The 1850s and
1860s had made people familiar with demolition as the instrument of
rational, progressive government, with the navvies on the building sites
depicted as pioneers, mastering a wilderness, engaged in architectural
deforestation. One thinks of Marville's sequence of photographs of the
driving through of the avenue de l'Opéra (c. 1877), and particularly of
the image taken towards the north-west, across the Buttes des Moulins,
where a Haussmannian pavement, complete with lamp post and sap-
lings with iron-grille surrounds, pushes out into the wasteland, cleared
by navvies presented as coordinated teams driven by a new unanimity.
Now, in the aftermath of the Commune, people were faced with acts
of destruction whose motives were varied and harder to plumb: some
of the damage was a result of the bombardments conducted by the
Versailles army; some a result of the need to set fire to houses close
to barricades or to slow down the advance of troops (e.g. rue du Bac,
rue de Rivoli, rue Vavin, rue de Lille) (Rougerie, 1995: 108-9); some
were acts of revenge (the Tuileries, the Palais de Justice, the Ministry
of Finance); some the refusal to let buildings fall into the hands of the
Versaillais: the decision to burn the Hôtel de Ville was taken in the
night of 23-24 May 1871.

As we look at Hippolyte-Auguste Collard's[5] view of the burnt-out
shell of the Hôtel de Ville (Frontispiece), with its scattering of spectators
across the square, in varying degrees of substance or spectrality, as if
dumbstruck, or reverent, or appalled, we can begin to see that, however
much a photograph like this might have been used by others to promote

post-war, anti-Communard propaganda, it had a larger, more concili-atory role to play, too (significantly, Jules/Jean Andrieu entitled his series of photographs of the Commune *Désastres de la guerre* [*Disasters of War*]). As with buildings that are hale and intact, ruins, too, are anthropomorphisable, as corpses, martyrs, scapegoats. These fatally wounded buildings acted as substitutes for a human loss which could not be photographically depicted other than by images of insurgents in their coffins (Disdéri?), or laid out on hospital beds, or by photomon-tages of executions (Eugène Appert). But ruins like the Hôtel de Ville also stood as memorials to other kinds of loss: national pride, social solidarity, self-belief. Although figures are visible in the sunlight of Collard's photograph, the majority stand contemplatively in the shade, as if beset by an acute and shaming awareness of human shortcomings, of the failure to live up to what the Hôtel de Ville represents.

The Hôtel de Ville, for its part, stands in the full sunlight, not quite transfigured, but radiant, as befits its transformation from building into monument, from product into work, from the functional into the commemorative. Standard monuments are designed to establish a collective memory, a consensus view, of the city's/nation's past. Like elegy, by burying the dead, the monument can work as an agent of pacification, can erase the violence of death and the fears associated with it, can seem to transcend death. As Lefebvre puts it: 'Thus the mortal "moment" (or component) of the sign is temporarily abolished in monumental space' (1991: 222). But with the monument which has been created by its very ruination as a building, things are markedly different. Unlike the Bastille column, with its 600 martyrs from the 1830 revolution and 200 from 1848, or indeed any cenotaph, the ruin-as-monument does not merely 'stand for' or record (and thus conceal) loss; it has loss inflicted on it, and thus can offer no promise of death transcended. And because, too, it makes manifest the temporality of loss, so it unravels consensus; it is never a point reached, but instead a constant going over of process. Its very irregularities of structure and outline are invitations to fantasy, to a deeply personal way of visually acquiring the building. Collard's photograph manages to suggest this

gradual visual acquisition of the monument by the transfixed spectators. Once restored, the Hôtel de Ville will become a building again, will return to use; it is now only photographs like Collard's which preserve it as a monument of traced, and constantly retraced, loss.

Edmond de Goncourt's account of the Commune in his *Journal* gives a vivid picture of the life of those inhabitants waiting for the repossession of the city by the Versailles army. But particularly important for our purpose is the entry for 28 May 1871. Out on the street he notes the burnt Palais-Royal, the much-damaged Tuileries, the large-scale damage of the Châtelet, and, across the river, the 'decapitation' of the Palais de Justice and the ruination of the Préfecture de Police. He finds his way back to the Hôtel de Ville and the encounter stimulates a self-contained paragraph/prose poem (see Appendix 2 for the French text):

> It is a splendid, a magnificent ruin. All pink and ash-green and the colour of white-hot steel, or turned to shining agate where the stone-work has been burnt by paraffin, it looks like the ruin of an Italian palace, tinted by the sunshine of several centuries, or better still like the ruin of a magic palace, bathed in the theatrical glow of electric light. With its empty niches, its shattered or truncated statues, its broken clock, its tall window-frames and chimneys still standing in mid-air by some miracle of equilibrium, and its jagged silhouette outlined against the blue sky, it is a picturesque wonder which ought to be preserved if the country were not irrevocably condemned to the restorations of M. Viollet-le-Duc. The irony of chance! In the utter ruin of the whole building there shines, on a marble plaque in its new gilt frame, the living inscription: *Liberty, Equality, Fraternity.*
> (Baldick, 1984: 193)

First, we might note that here the Hôtel de Ville has, by the intervention of fire, had its picturesqueness restored to it; its loss of function endows it with a new imaginative disposability. Goncourt puts the gutted building through its paces in a series of metamorphoses – construction of white-hot metal and agate, Italian palace, magical palace – in which each comparison is outreached by the comparison following; this description is a symphony of colours. The third sentence

takes us through a sequence of shattered structures which build a sculpture of fragility, a pattern of gaunt outlines, a miracle of just-survival, whose picturesqueness is threatened not by collapse, but by restoration (begun, in fact, in 1873), a restoration which will remove the building's ability to solicit the imagination and justify the flight of fancy. This is a characteristic insight of the street-photographic mind: so often adversity does not *tie us to* a condition, but releases us *from* a condition; the ruins of the city hall turn Parisian inhabitants into strangers, travellers, tourists in their own city, restoring, therefore, their access to the picturesque, generating a perceptual capacity to marvel. Buildings in ruins trace out the story of rags to riches, achieve a sumptuousness by accident. Street photography favours those who create their own kingdoms out of the least promising of occupations and territories.

But the close of the passage takes chance and the street-photographic in another direction, towards an ironic consciousness, alert to the slightest signs of the pretentious, the hypocritical, the bogus. Chance can make kings of us all; chance, too, can lay bare our gullibility. Goncourt, as an anti-Communard, has a political point to make: liberty as revolution begets fratricide not fraternity. Now he resorts to superlatives – 'in the utter ruin' (*dégradation*), 'of the whole building' – so that the insolence of this survival ('intact', 'new gilt frame') can achieve its full savour. And yet. And yet, even here, for those less embittered, the lie (*'Liberty, Equality, Fraternity'*) still might become an enchanted relic, the grail, some new beginning. This plaque, too, is part of the play of sunlight with which the early part of the passage is preoccupied.

The second kind of demolitional photograph I wish briefly to consider is that represented by the anonymous Commune photograph *Firemen Putting Out the Last of the Fire in the Bonded Warehouses at La Villette* (1871), but which might equally have been exemplified by the photographs of Haussmannian demolition by Marville and Henri Le Secq, or by Anneliese Kretschmer's *Dividing Wall, Paris, 1928*, or by George Rodger's photographs of the London Blitz. What

is left standing, or is revealed, is a wall with its interior still incrusted on it (wallpaper, fireplaces, lines left by piping, or by the division of storeys). In photographs like these, life is literally turned inside out, and, for the first time, we are promised, by violence, the penetration of appearances to being. And yet, as with the photograph itself, we discover that three dimensions have been collapsed into two, that the flat surface only bears the tantalising traces of the missing depth. This is merely another set of hieroglyphs to be deciphered, another case of having only *last impressions* as our evidence. This archaeology of everyday life reminds us that our access to knowledge of ourselves is both primitive (dismantle the building) and self-defeating (we are always too late; we scare away those we wish to know by wishing to know them).

One of the best-known literary accounts of an exposed inner wall is that by Rilke in *Die Aufzeichnungen des Malte Laurids Brigge* (*The Notebooks of Malte Laurids Brigge*) (1910) (see Appendix 3 for full text in English). This wall is both an anatomy, an *écorché*, whose digestive system is made distastefully public, and a face, whose outer layer has been ripped off.[6] As with Baudelaire, Malte's existential vulnerability has made him a prey to Paris – Rilke arrived in 1902 and subsequently became Rodin's secretary – not only in the sense of being consumed by its chaotic energies and force lines ('To think that I cannot give up the habit of sleeping with an open window! The electric street-cars rage through my room with ringing fury. Automobiles race over me.'), but also in being read by the city and allegorised by it: just as Baudelaire acknowledges, in his poem 'Le Cygne', 'tout pour moi devient allégorie' (everything becomes, for me, an allegory), so Malte admits 'I recognise everything here ...: it is quite at home in me'. This house wall enacts Malte's being laid bare.[7] Life clings on, but it is a life reduced to bodily functions, untransformed, a gathering of stale smells.

The 'modernist' writing that we find in the earlier pages of Rilke's *Malte* reveals the Expressionist and Futurist pressures which lurk just below the surface of the street-photographic. Malte's words about sleeping with the window open throw us forward two years, to Umberto

Boccioni's *The Street Enters the House* (1912): the 'dominating sensation' of the picture was described in the catalogue as 'that which one would experience on opening a window: all life and the noises of the street rush in at the same time as the movement and the reality of the objects outside' (Tisdall and Bozzola, 1977: 43). The city is a knot of chaotic forces, only just held in balance; it is the hiding place of the id, the place where relativism tends towards a maximum and multiplies parallel realities, sudden fragmentations of view; the city is a potentially explosive montage. The photography of demolition relates, if only distantly, to images of the city beset by seismic disorders, threatened by imminent collapse; and the distance lies in photography's difficulty in communicating the haunted sensibility, for, after all, what is at stake in urban collapse is the collapse of the individual psyche. The other face of apocalypse is entropy, a vision of declining energy accompanied by increasingly dispersed and erratic solitudes. Even in the conciliatory and assimilative world of the daytime street photograph, we are from time to time touched by this other city, dreamlike, menacing (e.g. Man Ray's *229 boulevard Raspail*, 1928; François Kollar's *Rain in Paris*, 1930; Cartier-Bresson's *Quai Saint-Bernard*, 1932; Brassaï's *Walkers in the Rain*, 1935). But it is only after dark that photography really establishes its contacts with the Expressionist city.

What date might we fix on as the beginning of a photography of the nocturnal city? We might do worse than pick 1896, when Paul Martin was awarded a gold medal by the Royal Photographic Society for his photographs of London by night. Night photography was not entirely new in 1896, but not only did Martin's achievement instigate the establishment of a Society of Night Photographers in London, but his experience provided some useful hints for future practice: the maximal use of residual twilight; exploitation of reflected light from water or wet surfaces; extension of the tonal range by use of lantern slide form; tinting the slides blue and yellow to match the visual sensation of gaslight (see Flukinger, Schaaf and Meacham, 1978: 54-9).

Some forty years later, Brassaï's article for *Arts et métiers graphiques* (15 January 1933), 'Technique de la photographie de nuit' (Technique

of Night Photography), a commentary on the preparation of *Paris by Night*, continues the discussion of ways of outwitting direct light, halo effects, overexposure, the over-immobilising effects of the pose. But just as instructive is what Brassaï has to say about the artificiality of the nocturnal decor, a 'décor de film':

> A city at night becomes its own décor, reconstituted in cardboard, as in the studio. The ceiling lights are turned off, the platform projectors are unplugged. A few lighting rigs and 'westerns' are all that is left. The former are the shop-windows and the cafés, and create the ambiance, the latter are streetlights, and produce the particular effect. (2000: 16)

Light itself becomes complex, competitive, multiform; the city is a stage in which different light sources vie for possession of the darkness, struggle to establish a security, act out different relationships with the darkness: the light of the lamp post, state surveillance; the shop-windows and signs for bars and *bals*, the festivals of commerce and sensual indulgence; domestic light, well-earned quietude. Light itself becomes the instrument of social organisation and the orchestrator of encounters; light dismantles the continuities of space, and of atmosphere, into discrete zones (Blühm and Lippincott, 2000: 196). This particular transformation of the city by night is endorsed by the close connections between the nocturnal city and the crime thriller, and more specifically by, for example, photographic illustrations of Georges Simenon's work (Krull, Bovis), or photographic contributions to the magazine *Détective* (first issue 1928).

In his preface to Brassaï's *Paris by Night*, Paul Morand quotes Julien Green's description, in *Épaves*, of the transformation that Paris undergoes as the gaslights are lit:

> The gaslight brings about this transformation. At the first ray of this sun, the nocturnal land decks itself out with shadows, and matter takes on sinister and fantastic new skins. The smooth, sensual trunks of the plane trees seem suddenly made of leprous stone, while the paving stones imitate the tones and rich marblings of drowned flesh; even the water is covered with metallic glints; everything abandons its

familiar daytime appearance to don the look of lifelessness. (Brassaï, 1987: n.pag.)

Day and night are two distinct realms, the one conservative, the other revolutionary,[8] the one masculine, the other feminine,[9] the one healthy, the other infected with a creeping sickness. The darkness, particularly in the interwar years, was where gathered, was itself a gathering of, that existential condition, hard to define with any exactitude, of anxiety, *inquiétude*:

> And one might even say that, at night, there comes into existence a dangerous Paris, like the sum of all Parisians' anxious souls, which have slipped from their sleeping mouths. (Morand, in Brassaï, 1987: n.pag.).

Part of this anxiety was the sense of being caught between a discredited old regime and a tentative, precarious new one; part the sense that the destructive forces set loose by the First World War had only been imperfectly dealt with and were ready to re-emerge; part the awareness of economic fragility and of employment under threat; part simply the lack of purpose. But, most important of all, anxiety was generated by a hyperactive imagination, set in motion by the stealth of shadows and whipped up by the suggestiveness of the animated dark.

Different writers developed their own versions of anxiety; Pierre Mac Orlan's version was part and parcel of his concept of *le fantastique social* (the social fantastic).[10] We have already seen Mac Orlan dubbing photography as 'the expressionist art of our time' (1965: 303), and the ingredients of *le fantastique social*, though manifold and not easy to fix, include the mysterious forces unleashed by modern technology (electricity, radio waves, the phonograph), the sense of imminent catastrophe which our own fears read into the environment, the eruptions of that optical unconscious that only the camera is fast enough to make visible: 'It is through the agency of photography that we are still able to capture the fantastic forms of life which require at least a second's immobility to be perceptible' (1965: 30). For our future investigation, it is important to note that Mac Orlan considers

prostitutes as one of the 'elements which are efficient conductors of the social fantastic' (1965: 32); they act as magnets, as rendezvous points, for all the phantoms of subterranean human activity that the order of daylight has suppressed:

> Day, which belongs to order, makes visible the traces of social anxiety only at the moment when it is too late to provide a cure. Night, which is favourable to disorders of thought, reveals images of the despair which each of us sketches out, as the fancy takes us and according to the imminence of our own disaster. (1965: 68)

The shadows[11] generated by day have a certain coherence, a unanimity of direction determined by the position of the sun, an easy explicability. These are the shadows cast by the public city, by, for example, its monuments, spreading their protective and proprietorial shade across the neighbourhood squares (e.g. Bovis's *Colonne de Juillet, place de la Bastille*, 1947; Doisneau's *Shadow of the Bastille*, 1949; Ronis's *Shadow of the Institut de France*, 1956). At night they become something different, an emanation of the soul, the Other that is present in the self, a double with an agenda of its own. Why did Brassaï photograph his *Prostitute, quartier Italie* (1932) from the front *and* the back (with the position slightly changed), if not because, from the back, against the light, she has become herself a shadow, the negative of her positive, recovering a latency, the darkness of her profession, a concentration of the menacing othernesses that inhabit her. Her three-dimensionality only just emerges in the band of light down her left side, and yet this small reassurance is bought at a cost: the more light that civilisation tries to throw on its streets, to elicit substantiality, the deeper its shadows become.

Anxiety stalks the pages of *Les Dernières Nuits de Paris* (*Last Nights of Paris*) (1928), a novel by one of the founding fathers, with André Breton, of Surrealism, Philippe Soupault. Catastrophe hangs over this work in a curious convergence of the apocalyptic and the entropic, of the pyromaniac impulses of Octave and the creeping lassitude of the narrator. Can the prostitute Georgette, Octave's sister, prevent this collapse? Her temporary disappearance produces, among those

around her, panic, angst, despair. The novel ends inconclusively. Day comes. Georgette comes. The nervous waiting is over. Life continues. But Georgette, standing on the threshold, is still waiting. Paris cannot be counted on, Paris is being counted down. Earlier, the narrator has mused: 'Like the earth, Paris was growing cold and becoming simply an idea. For how many more years would she keep that power of illusion, for how many years would she live still mistress of time?' (1992: 144). Soupault's work seems a long way from the street novels of his Surrealist contemporaries: 'The contrast is striking between *Le Paysan de Paris* (*Paris Peasant*) and *Nadja*, whose surrealism is triumphant and sure of its powers, and this book of farewells' (Claude Roy, in Soupault, 2001: v). But then Soupault's novel may be a *roman à clef* (novel portraying real individuals as fictitious characters), a cryptic revenge on the Surrealists from whose circle he had been banished in 1926.

Darkness, in *Last Nights of Paris*, is when Paris comes into its own, becomes itself, becomes Georgette, recovers its density of being: 'It was Paris which I thought I knew and of whose sex and mystery I was ignorant, it was Paris unrecognized and rediscovered, the breath and gestures of Paris, Paris and her supple and silent nights – Paris and her folds, Paris and her faces' (1992: 103). But darkness is a time of vulnerability to threat, a time when the disruptive forces of the periphery stir and insinuate themselves, when the edge comes to the centre. The daytime city seeks to put its edge under pressure, by assigning it to 'no place' (to the *terrain vague* of the *zone*, or beyond the fortifications, beyond the city's protective laws) or by suburbanising it. But if the edge is outlawed, or in need of rehabilitation, it is also a place of release, as Vidler insists, 'a potential for another order, whether of nostalgic remains, destructive forces, or difference' (1992: 185). It is no accident that Baudelaire's prose-poem of sado-masochistic eroticism, and contagious obsession, 'Mademoiselle Bistouri', begins 'As I came to the furthest reaches of the suburbs, under the gas lights...' (1991: 98). Photographic images of the suburbs, as we find them in Doisneau's work (see Ollier, 1996: 554-665), or in the album of Ronis

and Didier Daeninckx on *Belleville Ménilmontant* (1999) project the 'other order' of community, resilience in poverty, inventiveness in leisure, but still fired by a rebellious spirit: 'Annexed a few years later to the last two *arrondissements* of the Paris which had rejected them (thanks to Haussmann's renovations), the inhabitants had never abandoned their recalcitrant and rebellious character: their shadows, in the alleys, made something like a threat weigh on the strictly aligned facades of the favoured quarters' (Ronis and Daeninckx, 1999: 11). The complicity of night with the experiential edge presides over chapter 6 of *Last Nights of Paris* in altogether more sinister fashion, when the narrator follows Octave in his expedition to the suburbs. In these outer reaches, Paris can no longer hold its own, as the light is increasingly extinguished:

> Little by little we left Paris behind. Already the districts we were traversing had lost their Parisian color, just as the polar regions are shown faded out on geographic maps. ... In spite of the dark I detected the presence of that slimy, gigantic leper who seems ready to attack the city. ... Step by step we sank into the thickness of the night, lost as if forever. (1992: 79-80)

Here we have returned to the primeval mud, to pre-creational night, to the horror at the heart of darkness, to the formless and inchoate.

Georgette, like other noctambulist prostitutes, can be looked upon as the figure of photography. She is two women: 'I had learned that she could be Georgette of the day and Georgette of the night, that two women, as different from each other as darkness and light, dwelt in that pale and supple body, that shadow dressed in black' (1992: 82). She is the negative and the positive: by night, she is an image that lacks volumetric modelling, whose positive is difficult to predict, that floats in an indeterminate latency, in a dreamlike medium which reverses reality; by day, we believe that she is the Georgette we see, self-explanatory, the whole evidence, disempowered by the mereness of her being: 'Then I saw her, but she was no longer the same. Here was an uninspired woman, commonplace and hardy. ... She was lost in the crowd, a part of it' (1992: 58). This is perhaps to suggest, then,

that all street photographs are trying to recover a nocturnal value, the nocturnal value hidden in their negatives. Holding the positive print, we think we shall receive the reply, or the revelation, that our curiosity seeks. But photographs are only the beginning of curiosity, of an unknown safeguarded by its being the print not of a truth but of a virtuality.

Like Breton's *Nadja* (1928), *Last Nights of Paris* is full of signs; everything seems to signal to the narrator. These signs cannot be controlled. The photograph, by its multiple reproduction, its repetition of a singularity, has a tendency to turn innocent phenomena into signs, without, however, embedding them in a stable system of reference. This, too, is a source of anxiety. And so is the way that the photograph, the result of an instantaneous activity, of the immediate now, opens up dangerous paths to the past and future. But even though it is itself the product of cause, the photograph compels the viewer to gamble with chance, under pressure from the sign. Photographs cut bits of time out of causal chains, turn cause into chance, liberate chance from cause, ask us to reinvent causality out of that chance. Chance is peculiarly what is at stake in street photography, a gamble unknown to the documentary photograph, where the cause for taking must convey itself unequivocally to the viewer, and chance be outlawed.

Keeping a city's history intact is a sacred trust of street photography. But like photography, a city is not a continuous chronology. The visions of urbanists are, in the eyes of those of a street-photographic persuasion, the erasure of a past that is higgledy-piggledy, scattered with revolutionary incident, and the relaunching of history on the basis of an official understanding of it: Haussmann's reconstruction of Paris involves the rehabilitation (re-evaluation) of monuments – an organisation of the street that sets them off – a way of 'managing' the collective memory, whose unconscious is suppressed by the very visibility of the monument, and by a system of unmistakable hierarchisation (by size of building, dominant decoration, etc.).[12] Haussmann's architectural standardisations imply a corresponding standardisation of the city's temporality, time as a sequence of uniform spaces, the time of the clock,

the calendar, the working shift, the kept appointment, a time both arbitrary and tyrannical, the time of Muybridgean chronophotography. Haussmannisation, as an architectural and urban planning policy, has it in mind to evacuate the city of the heterogeneous, qualitative and elastic time of Bergsonian duration. In short, what Haussmann aspires to is the street life that blocks access to inner time.

But how can one not think that the photograph, standard (more or less) in its unitising of time, does not promote an externally measured and precisely calculated version of time's passage, an endless sequence of clicks, occurring at equal intervals, driven by the tyranny of the clock's ticks? Can the photograph have access to elastic inner duration? Barthes's notion of *punctum* is one way of answering 'yes'. And, periodically, throughout the preceding chapters, we have suggested other ways in which the ruthless segmentations of clock-time can be photographically outwitted. The strategy of the title now deserves further attention.

Soupault's Georgette lives in the rue de Seine, on the Left Bank, in the sixth arrondissement, Quartier Saint-Germain-des-Prés. Perhaps the most celebrated photograph of this street is the one that Atget took on an early May morning in 1924, a photo of the wedge-shaped building at the corner of the rue de Seine and the rue de l'Échaudé (Figure 35). In fact, Atget photographed this building on three occasions (Szarkowski and Hambourg, 1982: 179), and on this May morning he made two negatives, the one we have printed here, the other from the middle of the street, taking the building head-on. As Szarkowski points out: 'The oblique view shown here emphasizes the rapid foreshortening created by the wide-angle lens, and the island seems to have changed into a ship, moving at great speed' (2000: 170). The distortion produced by the lens also gives the building a marked precariousness: is this tilting to the right a consequence of intoxication or old age? Marooned on its small island, this building has open eyes (unshuttered windows) only on the third and fourth floors at the near end; everywhere else the building is sealed in somnolence, or death, or its own mystery. The slight mist increases the image's

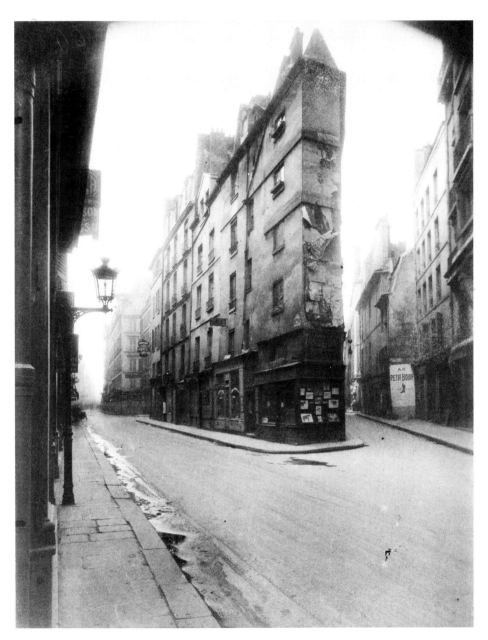

FIGURE 35 Eugène Atget, *A Corner, rue de Seine* (1924)

gothic potential, the two unshuttered windows are unnerving signs of a half-hidden consciousness. The roof is a jagged medley of chimneys, attic windows, dividing walls, pitched roofing, the disturbed mind, the lunatic metaphysics of an apparently sedate body; the skyline in the rue de l'Échaudé does nothing to allay these suspicions. This building has a knowledge that is becoming increasingly difficult to extract: on the boards over the corner-shop windows I can just make out 'Portraits' and what I take to be 'Encadrement'; above that I can only decipher the words 'd'Angleterre'. Peculiarly, in the window itself, images of draught horses predominate. Behind this shop, I can identify a coiffeur's and, beyond that, a hotel. What is this building trying to tell me? What of its multiple lives, of its past, of its prospective futures does it wish to confess? As photographs slip into the past, so they take their knowledge with them, without lessening the viewer's need to make sense of them. The enigma of the photograph, this irritation of visual clue combined with visual closure, drives our ignorance to a speculation in which the photograph reveals our own inwardness. The building's prow, or nose, which, in the past, has, it seems, been a convenient 'hoarding' for bill-sticking, speaks this loss of legibility: the information that this narrow wall might have communicated to us has been eroded by time and the weather, so that we are left with the tatters of a history, the unreconstructible, a history which can only be made from hearsay, quotation, deduction.[13] And it is as if the bareness of the title which is passed down to us (*A Corner, rue de Seine*, May 1924) were itself expressing an inability to say. This is a title of pure indexicality – place and time – which tells us only of the photograph's taking (where and when), but not what it purports to be as an icon or a symbol. This bareness of title is the acknowledgement of an ignorance, or rather a refusal to interfere with the ignorance/knowledge of the viewer. Language offers itself only to withdraw, to leave us to our own experiential and psychological resources.

But if we say that ignorance itself is what sanctions our dipping into our duration, which relieves us of our obligation to truths external to us, we need also to see how, as we proposed in our treatment of René-

Jacques's newsvendor, the street name itself is a source of inner duration. It is usual for linguists to propose that proper nouns designate or identify, but do not mean. But Lévi-Strauss (1952: 285) affirmed the opposite, and is eloquently supported by Barthes in these terms:

> The proper noun is a sign, too, and not of course a simple index which designates, without meaning, as the current conception, from Peirce to Russell, would have it. As a sign, the proper noun offers itself to an exploration, a decipherment: it is ... a habitat (in the biological sense of the word), into which one must plunge, bathing indefinitely in all the reveries it has within it. ... In other words, if the Name ... is a sign, it is a voluminous sign, a sign always heavy with a density packed with meaning which no usage can reduce, or make flat, unlike the common noun, which only ever produces one of its meanings per syntagm. (1967: 152-3)

The proper noun enjoys the condition of constantly being given meaning, and of being infinitely available to meaning. It is a superordinate signifier packed with subordinate signifiers; and these sub-signifiers will want to fend off signifieds, postpone signification, the better to interact and undertake journeys of mutual exploration. If the rue de Seine is a super-signifier, what are its sub-signifiers, the constellation of common nouns of which it is the synthesis and which it makes available for infinite relational permutation in the psyche of the individual *flâneur*/spectator? First and foremost, other images: Marville's photograph, looking towards the rue de Buci; or Atget's other images, including the corner where the rue de Seine meets the rue de Buci (*c.* 1900), the *cabaret du Petit Maure*, 26 rue de Seine (*c.* 1900) and the *Hôtel du maître des comptes Lafond*, 10 rue de Seine (1902). Each building, each historical fact, or anecdote, about the street is equally a sub-signifier: in May 1854, Baudelaire took up residence in the Hôtel du Maroc, 57 rue de Seine, leaving his room only twice a day, to take meals. But as early as 25 June he judges the hotel *dégoûtant* (disgusting), not least because, having invited Marie Daubrun to dine, he was compelled, by the poor quality of the hotel's cooking, to take her out to a *traiteur*. On July 21, he describes the hotel

as *la maison du désordre* (the disorderly house). Baudelaire vacated his room on 3 March 1855, but returned to the rue de Seine in July, to another address, no. 27, until the end of the year (Pichois and Avice, 1993: 103-9). The Hôtel de la Louisiane, also on the rue de Seine, played host to Cyril Connolly between the wars, and in the closing years of the Second World War to Sartre and Simone de Beauvoir, partly because the street was the home of many of the regulars of the Café de Flore (Littlewood, 2001: 144-5). Personal recollections and associations are no less sub-signifiers. And as we pass across all these photographs – rue de Venise, 1945; rue Xavier-Privas, *c.* 1932; boulevard de la Chapelle, 1947; rue du Viaduc, 1930; pont Marie, 1933; rue Piat, 1947; quai des Célestins, 1954, and so on (all photographs by Marcel Bovis) – we not only see a specific moment of a street's being; the very title invites us to conflate that specific moment with all other sub-signifiers within the viewer's ken, so that the moment of the photograph is indeed the access point to the blind field, the inner duration of the viewer, and the inner duration of the street itself. In short, the street photograph becomes the threshold of an expanding field of interwoven lives, events, histories – some factual, some fictional – memories, fantasies; this expanding field, which for the documentarist would be a perilous distraction, is triggered by the photograph and lies, like an Aladdin's cave, behind the photograph's impassive, apparently reliable, cut-and-dried exterior.

If we look across again at *Last Nights of Paris*, we find that streets do generate predominant atmospheres, are pulled into certain configurative modalities by the sum of their evidence:

> The rue de Medicis along which we were strolling at a fair pace is sad around ten-thirty at night. It is a street of everlasting rain. ... At its very start the rue de Vaugirard stinks of books. The odor comes from every side. Its friend and neighbour, the rue de Tournon, is more inviting. So much so that I was prepared for a proposal and the address of a comfortable hotel. (1992: 3-4)

What this begins to suggest is that street photography, and the literature associated with it, were investigating not only the ways in

which the realistic could tip over into the oneiric, both by anamorphic devices[14] and by the transformative force of hyper-attentiveness itself, but also, by anticipation, the psychogeography, the spatio-mentality, of the Situationists of the late 1950s. If we remember Pierre Borhan's description of Izis, as wandering 'à la dérive de ses humeurs enjôlées' (adrift on his bewitched moods) (1990: 174), it is the *dérive* (drifting) we should stop over, a way of installing inner duration and the haphazard, into the planned and purposeful, of mapping itineraries of memory and association into the spaces of organised communication. Each trajectory between two points becomes a series of unpredictable digressions, in which purposefulness and communicative efficiency are sacrificed to social and imaginative gambling, to maximising the opportunities for chance to declare itself. It seems peculiarly appropriate that the café, that port of call specially designed for urban drifting, should be the home of that literary gamble, that corporate automatic writing, namely the conversation-poem.

Marja Warehime appositely draws our attention to the comparability of Brassaï's 'Le Bistrot-Tabac' (The Café-Newsagent's) and Apollinaire's *poème-conversation* 'Lundi rue Christine' (Monday rue Christine) (see Appendix 4a and 4b for the full French text of Apollinaire's poem and its English translation), and the conclusions she draws are surely the right ones:

> Brassaï practices a similar kind of authorial anonymity, letting other voices speak in his stead and making his presence felt only in the rendering of a concert of voices. Yet where Apollinaire sacrificed the coherence of individual stories, deliberately fragmenting and dispersing the speaking subject, Brassaï attempted to re-create the subject's unity and coherence out of the murmur of conversations in which some voices and some words are lost or indistinguishable. (1996: 148)

But while Apollinaire's poem is different in ambition from Brassaï's 'Le Bistrot-Tabac', it is remarkably close to Brassaï's café photographs, particularly in its exploitation of perspectivism, of the relativisation of view.[15] Apollinaire's poem seems to start relatively coherently, with a planned break-in by small-time crooks:

The concierge's mother and the concierge will let everyone through
If you're a man you'll come with me tonight
All we need is one guy to watch the main entrance
While the other goes upstairs

Indeed, after the first two stanzas, the poet still seems to feel that things hang together: 'That almost rhymes.' But at lines 16-17:

Six mirrors are still staring at each other
I think that we're going to get even more muddled

the poet connects the play of mirrors with an increase in disorientation. And it is true that the deeper into the poem one ventures, the more one is likely to lose one's bearings, not merely about subject, but about the level of language (literal/metaphorical). In:

Ces crêpes étaient exquises
La fontaine coule
Robe noire comme ses ongles

(Those crêpes were delicious
The water flows
Dress as black as her nails) (ll. 25-7)

It is difficult to know what 'la fontaine' refers to, whether a water supply out in the street, or within the café (both Bernard [1965] and Chandler [2000] translate 'fontaine' as 'tap'). Remembering the phrase 'pleurer comme une fontaine' (to weep like a fountain), we might think that it has a human source. 'Robe noire comme ses ongles' might be a description of someone's dress and nail varnish, but because of 'fontaine' I have a black pool of water in mind, on the pavement perhaps, with a curvilinear hem.

If we then turn to Brassaï's framed picture of two lovers in a café, *place d'Italie* (*c.* 1932) (Figure 36), reflected three times in two mirrors, we see not only the way in which these mirrors fragment, separate the couple, but the way, too, in which they make us ask which is the true image, at what levels of the conscious or unconscious mind the different images take place, how these images comment on each other

FIGURE 36 Brassaï, *Lovers, place d'Italie* (*c.* 1932)

(one image as the metaphor of another). There is a sense, too, in which
the reflections shatter the third-personness of the couple and make
each of them, in the mirror, a second person, not merely observed
but *addressed* by our look, taking their place in our imagination.
Similarly, *A Happy Group at the Quatre Saisons* (*c.* 1932) shows us,

through the agency of a mirror, both shot and reverse shot, in such a way that the characters of the main protagonists change as they pass into their reflection (cf. Manet's *A Bar at the Folies-Bergère*), and the threesome in the mirror, because it so closely parallels the threesome in front of the mirror – trilby-hatted men sandwiched between two women, men's left hands on women's shoulders, similarity of directions of gaze – looks like a jeering imitation performed behind the backs of the forward three.

Mirrors multiply perspectives in cubist fashion and transform the single image into a montage of images; the mirror indulges in an act of *détournement*, diverting the image from what it would normally say about a moment that 'has been'. Montage asks us to question the assumptions we make about a photograph's (and reality's) visibility, its evidential value, its unchangeability; at the same time, it invites us to re-project the image, but now as the malleable 'document' of our own psyche. And the violence of montage, implied in the cutting out and forcible juxtaposition of images, the violence of the discontinuous, the violence of paradox, these violences make the image a scrapbook, like history itself, in the Benjaminian view, a temporary collocation of fragments and quotations, subject to chance and permutation.

The café itself is a form of social montage. In many ways the café is street photography's social utopia, at a time when, to use Michael Walzer's distinction between single-minded and open-minded spaces, urban planning seems to favour the former: single-minded spaces are those spaces which are uni-functional, specialised, purpose-driven (the industrial zone, the housing estate, the car, etc.) and have segregative tendencies; open-minded space, on the other hand,

> is conceived as multifunctional and has evolved or been designed for a variety of uses in which everyone can participate ... the busy square, the lively street, the market, the park, the pavement café are 'open-minded'. (Rogers, 1997: 9)

Certainly Doisneau insists, in an interview as late as November 1977, that

What is terrifying in a town now is that people tend to establish blocks of specialisation saying: Here there will be young executives, here there will be the miserably poor, etc. It makes towns *very* annoying. So the café was, for me, the reunion of people from different milieus, all of whom brought together their own ideal. With the excitement of a little wine, these people talked without holding back, without fear of being ridiculous. And what happened was that they really gave of themselves. (Hill and Cooper, 1992: 81)

And Doisneau's *Café noir et blanc* of 1948 makes the point visually: celebrating newly-weds stand at the bar alongside a grubby, morose-looking workman.

One might claim that graffiti are a signature of spaces that have lost their 'open-mindedness'. By 'graffiti' we need to understand any appropriation of the surfaces of buildings for graphic purposes. This is part process of defacement, of desecration, part attempt to increase the city's legibility, part need to imprint oneself on this fabric which seems neither to care nor know, which simply endures, indifferently. But as we have already seen (Atget's *A Corner, rue de Seine*), these acts of self-inscription usually have only precarious existences. It is another Atget photograph, *Rue St Jacques at the Corner of rue Saint-Séverin* (c. 1900) (Figure 37), which gives us an early taste of saturation bill-sticking and, at the same time, indicates some of the close affinities and underlying differences between bill-sticking and wall graffiti. Looking across this sea of adverts, one begins to see that where wall graffiti record the creation of a mythology in recurrent archetypal images (sun, death's head, genitals), the mythology of adverts is all in the authority and suggestiveness of established names (Fer-Kina, Mathusalem, Cardinal Quinquina). Both modes are a bringing to consciousness of appetites, desires, anxieties. It is just that bill-sticking tends to excess: these close-packed adverts seem to express the need of the consumer psyche to fill its spaces with a rich chaos of pulsions and fantasies, in order to banish psychic vacuums and to rebel against submission to an ordered existence. At the same time, read as a montage, a montage created by chance over a period of months, the bills bring us face to

FIGURE 37 Eugène Atget, *Rue St Jacques*
at the Corner of rue Saint-Séverin (c. 1900)

face with the Freudian slip, the subversive muse of the association of
ideas, the collisions and complicities of the political and commercial.
Bill-sticking and wall pursue different ends inasmuch as bill-sticking
is a papering over, a suppression, of the wall's spaces, whether those

spaces represent the vacuum of modern life or the constant social threat of the there-to-be-written-on. The wall has, in its very materials, close connections with the telluric, with the slow time of geological change; the advertisement offers liberation from the earth and its ties, its gravity, offers instant possession, the acceleration of self-betterment. And all this coincides, in this image, with the presence of Haussmannian street furniture, the Wallace fountain, the urinal with its fanciful, stepped architecture, surmounted by a lamp, the saplings.

But another truth is to be discovered in the crumbling of the wall where it is exposed, in the broken panes of glass: these posters will be undone by the earth's hidden chemistry (damp, fumes, frost, etc.) and by the erosive forces that society itself mobilises. And the old buildings which we see along the central vista, as if concealed in ambush, peer round the corner, biding their time, having survived their attempted suppression. This world of novelties is here on sufferance; the principle of entropic degeneration cannot be reversed by any quick fix of urban renewal. Atget may photograph the melancholy of loss (old Paris), but here he photographs, too, the melancholy of the inadequately and self-deludingly new.

Many photographers have made the most of the piquant incongruities and mixed messages generated by the confrontation of posters with the life around them. André Kertész, for example, beside his famous Dubonnet image (*On the Boulevards, Paris*, 1934), presents a tramp looking at posters as if, uncomprehendingly, into a shop window of the high life (*On the Boulevards, Paris*, 1926-1929, and *Boulevard de la Madeleine, Paris*, 1927), or a disconsolate-looking middle-aged man, sitting in front of an empty wine glass with a poster behind him urging that Ovomaltine '(re)donne des forces' (restores strength) (*On the Terrace of a Café, Paris*, 1928). Kertész accedes to the temptations of the visual joke, nowhere more so than in *Faubourg-Saint-Germain, Paris* (1936), where the perfect symmetry of the image only serves to further ironise the repeated 'graffiti' 'Défense d'afficher' (No bill-sticking); a lamp post in a corner-niche seems to have this appointed place expressly to enforce the prohibition.

But if posters were an almost unavoidable element in the street photographer's expressive arsenal, wall graffiti required more strenuous pursuit. Brassaï began photographing wall graffiti in 1930 and fruits of his labours were first published in the Surrealist journal *Minotaure* in December 1933, accompanied by his own text 'Du mur des cavernes au mur d'usine' (From Cave Wall to Factory Wall), a title suggested to him by Paul Éluard. This piece of writing establishes Brassaï's founding assumptions: that the very medium – wall (the clandestine) rather than paper (the regulated) – pushes graphism in the direction of the unconscious and archaic; that this pre-writing or proto-writing is myth-making in embryo, a poetry of the deep spring of the everyday. This is the stuff of ethnographic investigation, the city as prehistoric cave. These wall images are the memory of a civilisation in formation, or rather many possible civilisations: time is collapsed, in an experience of ecmnesia, made to seem as if it did not exist. As he writes later:

> Sometimes, in Ménilmontant I stumbled across Mexican art; at La Porte des Lilas, there was the art of the Steppes; in the fourteenth arrondissement, pre-Hellenic art; at La Chapelle, the art of the Iroquois Indians, and then, in some squalid little back-street, I was brought up short and returned to the art of our own time – by a Klee, a Miró, or a Picasso. ('Graffiti parisiens' (1958); Brassaï, 2002: 140)

For Brassaï, the graffiti artists belong to the privileged Surrealist[16] community: children, lunatics, the ill-adapted, the disinherited, but children above all. The wall is a place of exorcism and catharsis. But the wall is also full of its own thoughts, virtual images and utterances, in its scrapes, cracks, stains, and these the graffitist may draw out or use to elicit his own dream time.

So the photograph of graffiti celebrates the ecmnesic power of the photograph itself, the camera's ability to bring us face to face, in the present, with the past in the very process of its formation. But looking at these photographs, one is struck by another parallel. There are many ways in which photography 'naturally' serves Surrealism: the 'optical unconscious' (Benjamin); photography as 'automatic seeing' (its converse: 'automatic writing ... is a true photography of thought'

FIGURE 38 Brassaï, *Graffiti* (n.d.)

[Breton]); the isolation of chance in photographic instantaneousness (e.g. arbitrary juxtapositions, anamorphic transformations); the hyper-reality of photographic seeing (immobility, excess and precision of detail), which relate to Moholy-Nagy's New Vision (exact seeing, rapid

seeing, penetrative seeing). These factors variously connect with Surrealist notions such as *le merveilleux quotidien* (the miraculous in the everyday) and *hasard objectif* (objective chance), and to the Surrealists' pursuit of the metaphors embedded in random juxtapositions, as the revelation of elective affinities or of the nature of desire.

But in another powerful current within Surrealist photography, it is the photographic process itself which is asked to open up the passages between the conscious and the unconscious, reality and dream, the banal and the extraordinary. The darkroom is now the site where chance is solicited or gambled with, where chemistry and light are asked capriciously to interact: Man Ray's solarisations, Ubac's petrifications and burnings, the double exposures and superimposed negatives of Roger Parry and Maurice Tabard; and to these, by virtue of their visual effects, if not of their causes, can be added rayographs, photomontages, the use of screening devices (Man Ray) and mirrorings (Florence Henri). Brassaï's graffiti, with their low relief, and complex and dramatic textures, often look like negative prints, or solarised images, or petrified ones (Figure 38). As with rayographs, Brassaï's graffiti often seem to be humble objects re-created as shapes of thought, ghostly latencies, floating in a new kind of space. And his surface, too, the wall, is, as we have mentioned, itself subject to chemical processes: heat, damp, smoke, and so on.

The distinction that Brassaï makes between graphic work on masonry and that on paper is given an interesting twist by Denise Colomb's *Children Drawing in the Street, Paris* (1953) (Figure 39). This picture seems to grow directly out of Brassaï's observation that

> The most moving graffiti are perhaps those on the 'lower levels' – scarcely three feet above the ground – where childhood, in its early, quintessential period (between the ages of three and seven), first acts upon the world. Here are the human being's first rough drafts. (2002: 30)

But these children are using chalk as their medium, not the wall itself; for them, the wall is merely a support, like a piece of paper. Consequently, in the compelling logic of Brassaï's argument, the children

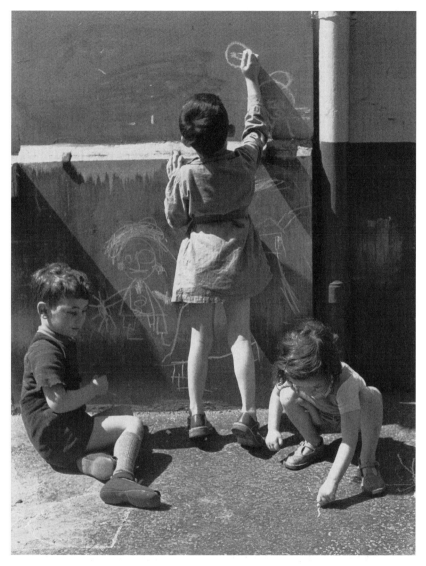

FIGURE 39 Denise Colomb, *Children Drawing in the Street, Paris* (1953)

are preconditioned, in drawing human figures, or features, to work not from gouged eyes, but from the 'primitive oval', to pursue the 'stick-man', to express themselves with less struggle, less gravity, free of the spell-binding presence of death; their drawings will gravitate away

from the tough and harsh towards the picturesque and charming and humorous. For the wall graffitist, because the wall is the medium, the faces depicted *on* the wall become the faces *of* the wall; for the wall-as-paper artists, the faces depicted *on* the wall can only be expected to be rubbed off. But in this photograph, it seems almost as if the children's drawing is a preparation for wall graffiti: the higher the drawings climb on the wall, the more they approach the condition of wall graffiti, the more primitive they become; the standing boy seems to be adding a second eye to a sunface or strange Redonesque homunculus or float-ing head, while in the shadow of his arm one can discern some sort of head-become-bird. But even the seated boy's depicted girl/woman is a being in transition: there are strange absences of correspondence between the left side and the right (as we look at it); the right side seems more unformed, more disrespectful of proportion and finish (large eye, scribbled ear, incongruous arm). All this seems to indicate not only that the wall can be bi-functional for a single graphic act, and can thus operate as a place of experiential and 'visionary' transition, but also that, as Brassaï claims, the mythical world of the wall is fluid, metamorphic, in flux.[17]

It is not difficult to think of the street photograph as itself a graffito, an image plastered on reality, what Barthes would call a madness, a scandal, an eruption in our habitual day-to-day commerce with the world. The photograph replaces and displaces reality in repeated acts of self-inscription and *détournement*. The photograph thrusts its else-where into the space in front of us, claims our attention, distracts us, reroutes our thought processes, is an agent of visual metamorphosis, opening up a field of unsuspected possibility in the everyday. The documentary image, on the other hand, does not seek creatively to deflect the eye, it does not wish us to believe that reality constantly reinvents itself by putting itself to new uses, almost unconsciously, as a matter of course; the documentary photograph seeks to lead us home to the self-repeating and inescapable. But through the agency of the street photograph, the banality of the everyday has access to a peculiar resourcefulness, almost despite itself, by chance, involuntarily.

conclusion

It is usual to assign the demise of French humanist street photography to the late 1950s and early 1960s and to locate the reasons for that demise in (i) the emergence of other street-photographic traditions (e.g. the American 'hard-boiled' trend of Robert Frank, William Klein,[1] etc.; street photography as a dimension of fashion photography; connections with surveillance photography; the street photography of the paparazzi); (ii) the contestation of French identity in a newly multi-ethnic capital; (iii) the dispersal of the working class; (iv) the increase in the volume of traffic and the consequent diminution of habitable public spaces; (v) the rise of television and the consequent demise of a certain kind of illustrated magazine; (vi) the Cold War and disillusionment with Communism; (vii) the rise in rents and property speculation; (viii) the increase in consumerism and consequent social homogenisation (see Hamilton, 1997: 143–8; Stallabrass, 2002: n.pag.). The tracing of street photography's diversification over the past sixty years is the task of another book. But Ferguson is probably right to surmise that, despite new visual emphases, 'Many photographers continue to search for the quiet revelations found in chance moments on the street' (Brougher and Ferguson, 2001: 20).

Within this span (1860-1960), one might pick out particular dates when Parisian life, and the street photography associated with it, took new directions and modalities. We have already quoted Pierre Mac Orlan's comment on the changes wrought by the First World War on the Montmartre nights of the early century: 'Parisian nights have gained in luxury what they have lost in picturesqueness' (1965: 74). For French historian Richard Cobb, the significant periods are 1935 (or 1934) to 1939, and 1944 to 1958 (constitution of de Gaulle's Fifth Republic); of 1934, with the financial scandal of the Stavisky affair (January) and the right-wing coup attempt of February 6, Cobb writes:

> It is not just a matter of public history; it is also the gap between a Republic that was still curiously light-hearted, even in its amiable cynicism and humorous, but shameless self-examination, and a Republic that was becoming sombre, divisive and increasingly frightened. (1998: 145-6)

But writing histories of street photography, or mapping the progress of street photography on to the shifts in socio-political history, runs the risk (a) of implying that, if one is patient, a definitive history of photography, as an autonomous and self-sustaining medium, will become possible and desirable; and (b) of giving the viewer obligations to this kind of history against other kinds of history, and, notably, perceptual history.

In this book, it is with perceptual history that I have been predominantly concerned, and not with a communal, myth-making history so much as with a history of the individual addressing the street-photographic photograph. We have, of course, had occasion to refer to the myth-making variety: the significance of street photography's historicity lies in the viewer's perception of it as the record of a lost paradise, of an arcadian time when we knew how to live, when straitened circumstances themselves became the source of a multitude of virtues – resourcefulness, interdependence, the ability to value the meagre, and to make a festival of scraps – and when communities thrived on that pre-industrial paradox, whereby the heteroclite, the

richly various, begets the tight-knit and the organic.[2] Nigel Henderson, in the draft of a prose poem written in 1949 for Eduardo Paolozzi, describes the street of the East Ender:

> A watch-repairer works in his window abutting the street in the medieval craftsman's way. The empirical articles of his trade are scattered around him in an organic order, obedient to the logic of his seeing fingers. One shop front crowds another in that bizarre interplay of trade and sign that contributes to the complex texture of the city. Funeral parlour and Ice Cream Parlour share the universal symbiosis and, from the window niche, the prurient headstone of an angel reassures us that in the midst of death we are in life. (quoted in Walsh, 2001: 49-50)

Henderson's East End photographs (1949-53) track the 'bizarre interplay', the 'complex texture', the 'universal symbiosis', in images which record the eloquent accumulations of graffiti, or newsagents' windows too small to accommodate their cornucopia of advertisements, new magazines, stationery, confectionery, tobacco products. In his streets, children play with indefatigable impudence and the street traders, as we have seen, enjoy the same multifariousness of existence. But this is urban pastoral, a world dreamed up by those outside it, those 'professional and administrative people in lands of maisonette, of mezzanine and mansard' who come home to their 'thick carpets in a world of hushed doors' (Walsh, 2001: 49). Urban pastoral depicts the land of lost content, where work always shades into play, where desires do not outstrip immediate needs, where the nagging demons of ambition and competition are unknown, where gossip is part of the vernacular poetry.

But the myth-making view is beset with obvious dangers: the socially overindulgent viewer, the loss of the interrogative as a street-photographic keynote, the homogenisation of street-photographic experience (in its very variety!), the easy equations of localisation and authenticity, localisation and folklore.[3] Like Louis Chevalier, Richard Cobb laments the attempts of urban planners and architects, from Le Corbusier to Georges Pompidou, to rid Paris of its jumble of streets,

whose very narrowness makes them, almost automatically, 'warmly human' (1998: 175). Gradually the suburbs, with their comfortable *pavillons* or barbarous *grands ensembles*, are sucking the life out of the centre. And this mass expulsion is an expulsion of the *esprit de quartier*, of the *flâneur*, of ethnic mix, of ordinary folk, of workshops, of intense sociability and insistent hubbub. Instead, tourists, discos, boutiques...

But my concern is more to do with the ways in which, as viewers, we each negotiate our individual perceptual relationships with the street photograph, and how a putative history of photography must, and to its own benefit, fray into personal histories of perception, into perceptual autobiography, and into photography's own peculiar way of undoing history and redefining history's availability.

Photography seemed to produce a revolution in perception. The image traced by the human hand enacts a transmutation of its raw materials. Art seemed to be dedicated to an appropriation of the world for human ends; indeed, there seemed to be some sense in which the world in and for itself did not matter, or could be denied. Even still lifes were either, literally, feasts for the human eye, or evidence of human pursuits. Suddenly, with the photograph, the human hand is no longer the artisan – light is. The world suddenly acquires the ability to present itself in its autonomy. Where image-making had been the expression of a power to change, to make sense of by changing, it was now a submission; it conveyed, instead, the enigma of untransformed reality. Among the many paradoxes which haunt photography, there-fore, there is this one: the machine around which has been built a whole vocabulary of colonisation, violation, intrusion, is a machine which also performs our dispossession of the world. Far from being a look at the world which allows us to do what we will with the world, the photograph, by its very opacity, blocks our desire to turn away and drags us by our lapels into a confrontation with the obstinately there. When we look at a photograph we look at a fait accompli, we are already too late to make a difference; while painting, for its part, seems to hold things open for the eye, indefinitely to invite the eye to exercise its own creative freedoms.

These reflections need to be undertaken, because we need to understand, too, the senses in which they are not quite true. One might argue, for example, that the photographic 'given', far from celebrating the resistant impenetrability of the merely there, is a process of making meaning possible. The frame of the photograph, we might argue, inevitably makes the photograph an image, a meta-reality, a comment on reality. A tramp sleeping on a bench becomes 'A tramp sleeping on a bench', a title as much as a subject, a challenge not just to see the image, but to construct it, to equate the autonomy of the image with the desire to claim its own semantic space.

And how is it that we can look at John Thomson's photograph of a 'Crawler' ('old women reduced by vice and poverty to that degree of wretchedness which destroys even the energy to beg') of 1877 and still feel pity? What is the point? How is it that a pornographic photo of 1855 can still arouse? In looking at old photographs, the eye does still have a freedom; it wishes, it seems, to generate a future in the past, a future that will make looking worthwhile. This strange tense of looking means that every photograph has a slight tendency to become a photogram (film still), to extend into a temporal rather than a spatial blind field.

Photography revolutionised history as well. It seemed to be a precious tool of authentication, something which would sharpen the facts and clinch the evidence. But there is a real sense in which photography also produced peculiar kinds of ahistorical experience. We can argue that although the photograph depicts a past event, it exists in our own time, in at least three senses: (i) it exists before us as a physical object occupying a visual space in our own environment (as might a still used antique candlestick) (this argument is helped by the fact that we can continue to take 'contemporary' prints from an old negative); (ii) we see the photograph in the way that we see the twinkling star already dead – the photographed subject is perceived as living, precisely because it is light years away; (iii) as in the Proustian experience of involuntary memory, the intensity of a past photograph's presence momentarily takes over the present moment (ecmnesia).

As we have already had occasion to observe, there is a crisis of continuity between the there and then and the here and now, which the photograph is powerless to solve. The photographic past is a past of unordered moments; there is no consecutiveness of time along which we can plot these images, all in their allotted temporal positions, and because of this absence of the consecutive, so photographs enjoy a peculiarly floating relationship with the present. In fact, one might claim that photography always tends to be more there than then, in another place rather than in another time. The momentariness of the photograph remains in place, but the historicity of the moment loses its certainty or applicability. Thus it is that, often, in looking at a photograph, we do not so much think of the image as being absent, but as being 'elsewhere'. Much photographic criticism has devoted itself to the melancholy of photographs, to the fact that the very release of the shutter assigns the subject to an irretrievable past, to a death which predicts the photographed subject's own death. Photographs, it seems to me, paradoxically, come back from this death as they age. The 'posthumous' life of a photograph, the story of the photograph's survival, is a varied and unpredictable one. Will it enter a museum? How many publications will it appear in? How will it be looked at? What arguments will it be called upon to back up or exemplify? Who will own it? How long will it survive in consciousness? How long will it physically survive?

We have also underlined the intrinsic part that ignorance plays in response to photographs. This condition one must regard positively, as an opportunity of relating, rather than as something regrettable and to be minimised or apologised for. All this is simply to say that photography is an extremely precarious medium, deeply informed by chance. This predicament does, however, have a positive side. Photographs populate the past. History itself seems to evacuate the past, leaving behind only famous figures, events, places, statistics. Photography has acted against this tendency: it puts in front of us figures we can no longer deny, coming as if to reclaim their memory, to reach forward from the past and interfere with our perception of things. Once the

photograph has established their presence, they can no longer be discounted. Walter Benjamin's description of David Octavius Hill's photograph of a Newhaven fishwife (Elizabeth Johnstone) eloquently acknowledges this moving demand to remain in consciousness:

> With photography, however, we encounter something new and strange: in Hill's Newhaven fishwife, her eyes cast down in such indolent, seductive modesty, there remains something that cannot be silenced, that fills you with an unruly desire to know what her name was, the woman who was alive there, who even now is still real and will never consent to be wholly absorbed in 'art'. (1999: 510)

We can see here what we might mean by the future in the past. Elizabeth Johnstone continues to trouble us, compels us quite simply to acknowledge her existence and to assume the responsibilities, to history and humanity, that this act of acknowledgement entails.

In our travels through street photographs and their literary, photographic and painterly partnerships and intertexts, we have been building up the different facets of the street photograph's temporal complexity: the time of the indexical (the instant, instantaneousness), the time of the iconic (iterative, durative), the time of the symbolic (atemporal), the time of looking (gaze, glance), the time of the viewer (intertext, involuntary memory, the imaginary), the interactions of clock-time and Bergsonian duration, the times of the eye-frame and the support-frame, the ways in which the instant can reach into past and future. In the end, we might say that this is where the fundamental difference between the documentary and the street-photographic lies. The documentary may share much with the street-photographic, but its temporality is unified at the level of the iconic (iterative, durative), with all other temporalities more or less evacuated. It would be a strangely perverse, or subversive, use of the documentary to open its implicit intentionality to the capricious temporalities which flit around the skirts of the street photograph.

appendix

1a Jacques Réda, from *Les Ruines de Paris* (1977)

Que se passe-t-il car des hurlements ricochent sur les façades, pas des cris de frayeur, mais c'est avec prudence que plusieurs fenêtres se rallument, et que des silhouettes en chemise font bouger les rideaux. Et de nouveau ces provocations hurlées comme dans *L'Iliade*: je saisis le mot *brocanteur*. Ainsi peut-être Hector a-t-il humilié Achille, avant que l'autre en effet n'accroche ses armes comme à Biron. Retombant des hauteurs de l'épopée, je songe que le brocanteur qui vient parfois vers dix heures du matin a fait provisoirement fortune: alors il s'est offert comme tout le monde un tourisme à Bangkok, et le décalage horaire l'a mis sens dessus dessous. Mais il ne s'agit pas de brocante ni de bagarre d'ivrognes ou de héros. J'ouvre, je me penche et, en bas sur la place, je vois ces deux types qui se démènent et je comprends enfin *pommes de terre*. Eux qui le nez au vent m'ont repéré tout de suite me prennent à partie aussitôt: *Quinze francs le sac de vingt-cinq kilos!* Je réponds que j'arrive. Ils se remettent à brailler et me citent en exemple à tout le quartier sourd, expectant. Je descendrais même si leur prix atteignait le double, ému comme si c'était Rimbaud fourguant de vieux remingtons. On traite vite, sans cérémonie. Il est jeune, maigre, avec

une moustache noire, la voracité de la fatigue dans ses yeux creux. A moitié dans l'agriculture, à moitié dans la mécanique; d'un lourd ciel usé qui dérive entre le trèfle et des moteurs.

–D'où venez-vous donc?

–De Normandie.

–Mais pourquoi de si loin, et ce tintouin, si tard, ce système?

–Parce qu'ils nous font tous chier.

On ne se regarde ensuite qu'une seconde, mais ça suffit. J'entends leur camion qui redémarre tandis que je hisse mon sac. Le matin les trouvera du côté de Bourg-Theroulde (qu'on prononce Boutroude) ou de Bayeux. Un peu de travers dans un fossé quand même ils s'assoupissent, la tête, cassée contre la vitre ou roulée dans les bras sur le volant, grise comme leurs patates, grise comme le point du jour et sa douceur d'anesthésie.

(1993: 48-9)

1b Jacques Réda, from *The Ruins of Paris* (1977)

What is going on? There are shouts ricocheting off the house fronts, not screams of terror, yet there is a wariness in the way that the lights go on in several windows and the outlines of people in nightclothes stir the curtains. And once again these shouted challenges start up, like those in *The Iliad*. I grasp the word *brocanteur*. Perhaps this how Hector humiliated Achilles before the latter literally hung up his arms like something from a flea market. Leaving these heights of epic poetry, it occurs to me that the secondhand dealer who sometimes comes on his rounds towards ten in the morning has temporarily struck it rich: in which case, like everyone else, he has treated himself to a trip to Bangkok and the jet-lag has played havoc with his sense of time. But what is going on out there has nothing to do with secondhand dealers nor with the brawls of drunks or heroes. I open the window, look out, and down below on the square I see these two fellows raising a racket and at last I grasp the words *pommes de terre*. With their eyes raised upwards, they spot me at once and set upon me immediately: 'Fifteen francs a 25 kilo sack!' I tell them I'm coming. They start bawling away

again and use my custom as an example to the entire silent, expectant neighbourhood. I would go down to them even if their potatoes were double the price. I am as moved as if it were Rimbaud flogging old rifles. Business is conducted at speed, without ado. He is a thin young man with a black moustache, hollow eyes drained with fatigue. Half farmworker, half garage mechanic. He comes from an exhausted, heavy sky that floats aimlessly between clover and car engines.

'So where are you from?'

'Normandy.'

'But why from so far away? Why this bother, and so late?'

'Because they treat us all like shit.'

Our eyes meet for a mere second, but it's enough. I hear their lorry start up as I hoist up my sack. By morning they will be near Bourg-Theroulde (pronounced Boutroude) or Bayeux. Parked askew in some ditch, they are able to doze at least, their heads flopped against the windows or wrapped in their arms over the steering-wheel, grey like their spuds, grey like daybreak with its anaesthetic softness.

(1996: 41-2)

2 Edmond de Goncourt, from *Journal: Mémoires de la vie littéraire II: 1866–1886*

La ruine est magnifique, splendide. La ruine aux tons couleur de rose, couleur cendre verte, couleur de fer rougi à blanc, la ruine brillante de l'agatisation, qu'a prise la pierre cuite par le pétrole, ressemble à la ruine d'un palais italien, coloré par le soleil de plusieurs siècles, ou mieux encore, à la ruine d'un palais magique, baigné dans un opéra de lueurs et de reflets électriques. Avec ses niches vides, ses statuettes fracassées ou tronçonnées, son restant d'horloge, ses découpures de hautes fenêtres et de cheminées, restées par je ne sais quelle puissance d'équilibre, debout dans le vide, avec sa déchiqueture effritée sur le ciel bleu, elle est une merveille de pittoresque, à garder, si le pays n'était pas condamné sans appel aux restaurations de M. Viollet-le-Duc. Ironie du hasard. Dans la dégradation de tout le monument brille, sur une

plaque de marbre intacte, dans la nouveauté de sa dorure, la légende menteuse: *Liberté, Égalité, Fraternité.*

(1956: 451)

3 Rainer Maria Rilke, from
The Notebook of Malte Laurids Brigge (1910)

Will anyone believe that such houses exist? No, they will say again that I am falsifying. But this time it is the truth, nothing omitted, and naturally nothing added. Where should I get it from? Everyone knows that I am poor. Everyone knows that. Houses? But, to be precise, they were houses that were no longer there. Houses that had been demolished from top to bottom. It was the other houses that were there, those that had stood alongside of them, tall neighbouring houses. Apparently these were in danger of falling down, since they had been deprived of all support from the adjoining structures; for a whole scaffolding of long, tarred poles had been rammed slantwise between the rubbish-strewn ground and the exposed wall. I do not know whether I have already said that it is this wall I mean. But it was, so to speak, not the first wall of the existing houses (as one would have supposed), but the last wall of the houses that were there no longer. One saw its inner side. One saw, at the different storeys, the walls of the rooms to which the paper still clung, and here and there marks of the beams of flooring or ceiling. Near the bedroom partitions there still remained, along the whole length of the wall, a greyish-white streak; across this there crept in worm-like spirals that seemed to serve some unspeakably disgusting digestive function, the gaping, rust-covered channel of the water-closet pipe. At the ceiling edges remained grey, dusty traces of the paths the gas-pipes had followed; they bent hither and thither, taking unexpected turns, and ran along the painted walls into a black hole that had been carelessly torn out. But the walls themselves were the most unforgettable. The stubborn life of these rooms had not allowed itself to be trampled out. It was still there; it clung to the nails that had been left in the walls; it found a resting-place on the remaining handsbreadth of floor; it squatted beneath the corner beams where a

little bit of space remained. One could see it in the colours which it had slowly changed, year by year: blue into mouldy green, green into grey, and yellow into a stale, drab, weary white. But it was also in the places that had kept fresher, behind the mirrors, the pictures, and the wardrobes; for it had outlined their contours over and over again, and had been with cobwebs and dust even in these hidden retreats that now lay uncovered. It was in every bare, flayed streak of surface, it was in the blisters the dampness had raised at the edges of the wallpapers; it floated in the torn-off shreds, and sweated out of the long-standing spots of filth. And from these walls once blue, and green and yellow, framed by the tracks of the disturbed partitions, the breath of these lives came forth – the clammy, sluggish, fusty breath, which no wind had yet scattered. There were the midday meals and the sicknesses and the exhalations and the smoke of years, and the sweat that breaks out under the armpits and makes the garments heavy, and the stale breath of mouths, and the oily odour of perspiring feet. There were the pungent tang of urine and the stench of burning soot and the grey reek of potatoes, and the heavy, sickly fumes of rancid grease. The sweetish, lingering smell of neglected infants was there, and the smell of frightened children who go to school, and the stuffiness of the beds of nubile youths. To these was added much that had risen from the pit of the reeking street below, and more that had oozed down from above with the rain, which over cities is not clean. And much the feeble, tamed, domestic winds, that always stay in the same street, had borne thither; and much more was there, the sources of which were not known. I said, did I not, that all the walls had been demolished except the last – ? It is of this wall I have been speaking all along. One would think that I had stood a long time before it; but I can swear that I began to run as soon as I had recognised it. For that is the terrible thing, that I did recognise it. I recognise everything here, and that is why it takes immediate possession of me: it is quite at home in me.

(1969: 43-5)

4a Guillaume Apollinaire, 'Lundi rue Christine',
Calligrammes (1918)

1. La mère de la concierge et la concierge laisseront tout passer
2. Si tu es un homme tu m'accompagneras ce soir
3. Il suffirait qu'un type maintînt la porte cochère
4. Pendant que l'autre monterait

5. Trois becs de gaz allumés
6. La patronne est poitrinaire
7. Quand tu auras fini nous jouerons une partie de jacquet
8. Un chef d'orchestre qui a mal à la gorge
9. Quand tu viendras à Tunis je te ferai fumer du kief

10. Ça a l'air de rimer

11. Des piles de soucoupes des fleurs un calendrier
12. Pim pam pim
13. Je dois fiche près de 300 francs à ma probloque
14. Je préférerais me couper le parfaitement que de les lui donner

15. Je partirai à 20 h. 27
16. Six glaces s'y dévisagent toujours
17. Je crois que nous allons nous embrouiller encore advantage
18. Cher monsieur
19. Vous êtes un mec à la mie de pain
20. Cette dame a le nez comme un ver solitaire
21. Louise a oublié sa fourrure
22. Moi je n'ai pas de fourrure et je n'ai pas de froid
23. Le Danois fume sa cigarette en consultant l'horaire
24. Le chat noir traverse la brasserie

25. Ces crêpes étaient exquises
26. La fontaine coule
27. Robe noire comme ses ongles
28. C'est complètement impossible
29. Voici monsieur

30. La bague en malachite
31. Le sol est semé de sciure
32. Alors c'est vrai
33. La serveuse rousse a été enlevée par un libraire
34. Un journaliste que je connais d'ailleurs très vaguement
35. Écoute Jacques c'est très sérieux ce que je vais te dire
36. Compagnie de navigation mixte
37. Il me dit monsieur voulez-vous voir ce que je peux faire d'eaux fortes et de tableaux
38. Je n'ai qu'une petite bonne
39. Après déjeuner café du Luxembourg
40. Une fois là il me présente un gros bonhomme
41. Qui me dit
42. Écoutez c'est charmant
43. A Smyrne à Naples en Tunisie
44. Mais nom de Dieu où est-ce
45. La dernière fois que j'ai été en Chine
46. C'est il y a huit ou neuf ans
47. L'Honneur tient souvent à l'heure que marque la pendule
48. La quinte major

(1966)

4b Guillaume Apollinaire, 'Monday in Christine Street', *Calligrammes* (1918)

1. The concierge's mother and the concierge will let everyone through
2. If you're a man you'll come with me tonight
3. All we need is one guy to watch the main entrance
4. While the other goes upstairs
5. Three gas burners lit

6. The proprietress is consumptive

7. When you've finished we'll play a game of backgammon

8. An orchestra leader who has a sore throat

9. When you come through Tunis we'll smoke some hashish

10. That almost rhymes

11. Piles of saucers flowers a calendar

12. Bing bang bong

13. I owe damn almost 300 francs to my landlady

14. I'd rather cut off you know what than give them to her

15. I'm leaving at 8:27 p.m.

16. Six mirrors keep staring at one another

17. I think we're going to get into an even worse mess

18. Dear sir

19. You are a crummy fellow

20. That dame has a nose like a tapeworm

21. Louise forgot her fur piece

22. Well I don't have a fur piece and I'm not cold

23. The Dane is smoking his cigarette while he consults the schedule

24. The black cat crosses the restaurant

25. Those pancakes were divine

26. The water's running

27. Dress black as her nails

28. It's absolutely impossible

29. Here sir

30. The malachite ring

31. The ground is covered with sawdust

32. Then it's true

33. The redheaded waitress eloped with a bookseller

34. A journalist whom I really hardly know

35. Look Jacques it's extremely serious what I'm going to tell you

36. Shipping company combine

37. He says to me sir would you care to see what I can do in etchings
 and pictures

38. All I have is a little maid

39. After lunch at the Café du Luxembourg

40. When we get there he introduces me to a big fellow
41. Who says to me
42. Look that's charming
43. In Smyrna in Naples in Tunisia
44. But in God's name where is it
45. The last time I was in China
46. That was eight or nine years ago
47. Honor often depends on the time of day
48. The winning hand

(1980: 53-7)

notes

introduction

1. It seems to be more than coincidence that Robert Doisneau photographed Diono the dog trainer in 1946. The transposition of letters (Diono > Donio) is surely more than a trick of the light.
2. Inevitably, there are several points at which my interests overlap with those of Walker – e.g. darkness, graffiti (Chapter 5) – but my approach places those concerns in a different context and consciously avoids trespassing on Walker's sensitive and revealing historical account of shifts in attitude and interpretative position.
3. Martha Rosler (1992: 334) has something equally varied to suggest for post-war trends in documentary: 'in the postwar era one finds documentarians locating themselves, actively or passively, as privatists (Dorothea Lange), aestheticians (Walker Evans, Helen Levitt), scientists (Berenice Abbott), surrealists (Henri Cartier-Bresson), social historians (just about everyone, but especially photojournalists like Alfred Eisenstadt), and just plain "lovers of life".'
4. Linda Grant is only too aware of this conflict. How can one do justice to both constituencies of the homeless? 'The difficulty about depicting homelessness is that, for the vast majority, living on the streets constitutes not a permanent condition, like disability, but a particular moment in their lives. They once had somewhere to live and, in all likelihood, they will again. To understand who a homeless person is, one has to view them through the medium of time, their story' (1996: 9).

one

1. When photographs serve voluntary memory, they become, for Marcel, meaningless fragments, increasing his feelings of spiritual barrenness: 'I tried next to draw from my memory other "snapshots", those in particular which it had taken in Venice, but the mere word "snapshot" made Venice seem to me as boring as an exhibition of photographs' (Proust, 1983: 897-8).

2. Barthes may boldly declare that 'The Photograph does not call up the past (nothing Proustian in a photograph)' (1984: 82), but elsewhere in *Camera Lucida* he concedes: 'I had just realized that however immediate and incisive it was, the *punctum* could accommodate a certain latency (but never any scrutiny)' (1984: 53), and, more unequivocally: 'For once, photography gave me a sentiment as certain as remembrance, just as Proust experienced it one day, when, leaning over to take off his boots, there suddenly came to him his grandmother's true face, "whose living reality I was experiencing for the first time, in an involuntary and complete memory"' (1984: 70).

3. 'Caillebotte has exhibited *The Floor-Scrapers* [1875] and *Young Man at his Window* [1876], each with an extraordinary sense of depth. However, this is painting of an absolutely anti-artistic kind, painting as squeaky-clean as glass, bourgeois painting, by virtue of the precision of its copying. Photographs of reality which do not bear the original stamp of the painter's talent – it's a poor show' (*The European Messenger*, St Petersburg, June 1876; 1970: 279). This attack echoes Baudelaire's in the Salon of 1859; given Zola's own commitment to photography in the latter years of his life (1894-1902), it is unlikely that his view would not have considerably softened, after his 'break' with Impressionism (1886).

4. The metro station in question is Concorde.

5. 'Above all, I craved to seize the whole essence, in the confines of one single photograph, of some situation that was in the process of unrolling itself before my eyes' (Cartier-Bresson, 1952: 42). 'There are thousands of ways to distill the essence that captivates us, let's not catalogue them' (1952: 45). Robert Doisneau has similar ambitions: 'There are pictures that may not only possess an astonishing graphic presence, due to some uncommon element or strange composition, but that may also radiate a unique atmosphere of their own, one that stays with you and leaves an important imprint in your mind. ... This, however, is what I'd like to aim for now: an isolated image whose contents possess the magic power of remembrance or memorialisation. ... The isolated image has an evocative power that is far greater than that of the series' (Hill and Cooper, 1992: 79).

6. Robert Doisneau has no doubt that photography has closer affinities with poetry than it does with painting: 'The poetic language of people, like Ronsard, is extraordinary. The choice of words, the bouquet of words without logical construction, is the same as that within a photo. Poetry and photography are much closer together than photography and painting. It is wonderful! You touch the exact thing, the unconscious side of this thing! And again, it is here that the poetry of Prévert was very close to photography. It is taking, within language, the used and worn-out expressions and setting them into a kind of ring so that they shine' (Hill and Cooper, 1992: 90).
7. Impressionist artists, too, approached the frame as a mobile, versatile generator of variations on an image. Of Degas's practice, Varnedoe (1989: 80) writes: 'Every time [the picture] could come out differently. When he put a violinist with a group of dancers he could decide to "pull back" and stress the openness of the room ... or simply by drawing a line around that composition, move in closer and isolate one part of the group. Or he could move in still tighter ... , with yet another cropping line imposed around the original conception.'
8. Michel Poivert (1992: 71) suggests that Bucquet's photograph derives more directly from Alfred Stieglitz's photograph with the same title, exhibited at the Salon du Photo-Club de Paris in 1895.

two

1. Brassaï, too, shared this distrust of colour, until some photographs of New York by night (1957) began to persuade him it was a viable resource. On his return to Paris, he resumed the challenge, working not from the subject (however colourful) to colour, but vice versa: in short, the subject might constitute no more than a support for colour (Brassaï, 2000: 14). Lartigue was of the view that black-and-white made it easier to marry what the lens saw with what the photographer carried within himself (Borhan, 1980: 20). But, essentially, he considered colour and black-and-white as two different visions: 'In the first case [colour], it is pleasure, poetry, the subtlety of colours. In the second [black-and-white], it is form, composition, the truth of what is caught (Borhan, 1980: 18).
2. 'Parisian life is rich in poetic and wonderful subjects. The marvellous envelops and saturates us like the atmosphere; but we fail to see it' (1972: 107).
3. The theory of spectres is explained by Nadar in relation to Balzac's well-known fear of the camera: 'Thus, according to Balzac, each body

in nature is composed of series of spectres, in an infinite number of superimposed layers, foliated in infinitesimally thin pellicles, in all the directions from which the body can be seen' (Nadar, 1998: 17-18).

4. For a history of the emergence of the Parisian department store in the nineteenth century, see Miller, 1981.

5. John Szarkowski accounts for the headlessness of mannequins in economic terms: 'Presumably, shops catering to working people sell their goods at a smaller markup, and it is therefore not surprising that they should find ways to save money in their display techniques. In Paris in the mid-twenties they did this by omitting the heads on working class mannequins, and substituting a kind of impersonal, abstract, unisex *tête*, suggesting something between a newel post and the spike on the top of a German soldier's helmet' (2000: 202). Plausible, but hardly likely to cover the majority of cases.

6. Barthes identifies three types of coincidence: (a) those that turn the axiom 'lightning never strikes twice in the same place' on its head; (b) those in which the diametrically opposed rub shoulders (e.g. a judge in a red-light district); (c) those which derive from mischievous and unexpected ironies (e.g. burglars frightened away by another burglar) (1964: 194-5).

7. This casual quality is evident not only in the awkward insertions of the socio-ethical disquisitions, but in the retrieval of characters: the Rougiers, for example, first mentioned in chapter 1, only re-appear in chapter 17, some 90 pages on, and another character from the first chapter, Roucoulle, reappears in chapter 23, some 120 pages further on, where the story of his death falls very incongruously in the narrative of Orwell's departure from Paris.

three

1. This hardly applies to Thomson, of course, whose tripod camera must have denied him any shred of surreptitiousness. The very publicness of the photographic act inevitably enjoins on the photographer a public role. Smith finishes his account of 'Caney' with the words: 'The biographical sketch I have given of Caney affords a good example of the circumstances which may bring a comparatively prosperous man down to the level where he will gladly avail himself of these easy methods of earning an occasional shilling' (Thomson and Smith, 1994: 38).

2. Doisneau's membership of the French Communist Party lasted only until 1947, but his childhood background, and his work for Renault (1934-39), in their advertising department at the Boulogne-Billancourt

factory, created strong bonds with the working class: 'Although it is clear that he was not happy as a *militant de base* – his *désobéissance* always got in the way of any attempt to involve him in disciplined political action – Doisneau felt a close affinity with the working class and *petite bourgeoisie*, whether or not he was a member of a political party or trade union. "I look like them, I speak their language, I share their conversation, I eat like them. I am completely integrated into that milieu. I have my own work which is a bit different from theirs, but perhaps I am a sort of representative of that class"' (Hamilton, 1992: 34).

3. Doisneau argues that there are significant parallels between street photographers and fairground folk: 'The framings selected by the exhibitor of images are perfectly comparable to the rectangles cut out of the public highway by the performers with their carpets and the fairground folk with their booths, to create what urbanists have called "ludic spaces". ... In the face of hostile appearances, we resort to the same artifices: false ingenuousness, bad faith, partial deafness and the sidelong look to detect the gendarme's kepi. Add inertia and the art of melting into the background and there you have our civil defence equipment' (1995: 79).

4. 'In humble life, different occupations, different localities, produce marked and *distinct hues* of character: these differences are made more apparent by the absence of those equalizing influences which a long-continued and uniform education, and social intercourse subject to invariable rules of etiquette, produce upon the cultivated classes. Original and picturesque characters are therefore much more common among the poorer orders' (anonymous review of *Hard Times*, *Westminster Review*; quoted by Armstrong, 1999: 96).

5. '[T]hey wished for nothing from life but a litre of red wine and a loaf of bread. They worked a few hours in Les Halles early in the morning as vegetable and meat porters. Then they set up on the banks of the Seine with their meal of wine and bread. If by chance they found no work, or in winter, they went to the Salvation Army for a bowl of hot soup. Each had a story, not always a pretty one. One had been director of a circus, another a banker. There were heads of families who left everything to live freely, *à la cloche*' (from 'La Vie mène la danse' (1980–81); quoted by Sichel, 1999: 107).

6. Marie is the cleaning lady in Brassaï's apartment building. Her trial relates to an action brought against her by the *Société* which owns the apartments and which is seeking to have her evicted on a variety of grounds (abusing the concierge, dumping her belongings obstructively in the corridor, letting her dog Jacqui foul the building, engaging in

noisy sexual trysts with a lover, etc.). We are led to suppose that Marie's lawyer's defence of her good name is successful.

7. It is the writtenness of transcribed speech which for Brassaï disqualifies those speech indicators to which I earlier referred (hesitations, fillers, false starts, etc.): 'Stripped of the quiver of the voice, of its physical vibration, it [writing] is also deprived of the *constant suspense* which the birth of a thought on the lips keeps in store for us, which, looking for its words and phrases in order to be made flesh in the word, hesitates, marks time, gets lost, recovers itself, repeats itself. This eruption of the word only keeps interest on tenterhooks because it unfolds *in time*. It no longer exists in writing, already formed and fixed *in space* which one can, before reading itself begins, take in, in a single glance' (1977: 19-20).

8. We refer to Cartier-Bresson's view in Chapter 1 (p. 48). Lartigue expresses himself in similar vein, in an interview with Pierre Borhan: 'It is not the camera which takes the photo, it is the eyes, the heart, the stomach, all that...' (Borhan, 1980: 16).

9. Bill Brandt's habits sound remarkably similar: 'Typically he would return to print the same negative many times, each print being slightly different, some substantially different. For him the process was intuitive, not formulaic' (Jay and Warburton, 1999: 316).

10. Nègre's other photographic nudes conform to painterly expectations and studio conventions (see Heilbrun, 1980: 49-53).

four

1. The 'optical unconscious' is a phrase which originates in Benjamin's 'Little History of Photography' (1999: 512). Benjamin writes: 'For it is another nature which speaks to the camera rather than to the eye: "other" above all in the sense that a space informed by human consciousness gives way to a space informed by the unconscious' (1999: 510).

2. Peter Hamilton (1995b: 250) reports: 'Creations such as *Fox-terrier sur le pont des Arts* ... are the result of a joke thought up in a nearby café by Doisneau, his painter friend Daniel Pipard, Jacques Prévert, and others. The monsieur with his fox terrier came along by chance to complete the picture'. Hamilton goes on to cite Doisneau: 'The picture of the pont des Arts, for example, is a completely staged photograph. There was a gang of us in a café on the rue de Seine, all a bit drunk. There was a girl with us. I suggested to her boyfriend, who was a painter and was going to work on a picture of the girl on the pont des

Arts, that he paint her as she if were naked, to see how people would react. So that gave me the idea of the picture of the guy with the fox terrier' (1995b: 251).

3. The manipulation of attention in programmes of social or capitalistic control cannot concern us here. But it is worth calling to mind the view that the cultivation of attention entails the dispersal of community and that the modern society of spectacle is not a society of the cohesive audience but of the isolated, scopophilic individual (theatre box, balcony, binoculars, stereoscope): 'Spectacle is not primarily concerned with *looking at* images but rather with the construction of conditions that individuate, immobilize, and separate subjects, even within a world in which mobility and circulation are ubiquitous' (Crary, 2001: 74).

4. 'I had just seen, standing a little way back from the hog's back road along which we were travelling, three trees which probably marked the entry to a covered driveway and formed a pattern which I was not seeing for the first time. I could not succeed in reconstructing the place from which they had been as it were detached, but I felt that it had been familiar to me once; ... I looked at the three trees; I could see them plainly, but my mind felt that they were concealing something which it could not grasp' (Proust, 1983: 770-71).

5. 'Her dress clearly outlined the firm fullnesses of her flesh, which were further emphasized by the efforts she was making with her back muscles to get the swing in motion. Her upstretched hands gripped the cords just above her head, so that her breasts were smoothly lifted at each thrust she gave. Her hat, blown off by a sudden gust of wind, had fallen behind her; and gradually the swing gathered momentum, each upward return revealing her slender legs up to the knee, and discharging into the face of the two men, who were watching her with amusement, the swish of air from her skirts, headier than wine fumes' (Maupassant, 1995: 19).

five

1. In his dedicatory letter to Arsène Houssaye, Baudelaire describes his inspiration for the prose poems of *Le Spleen de Paris* as follows: 'This obsessive ideal springs above all from frequent contact with enormous cities, *from the junction of their innumerable connections*' (1991: 30; my emphasis).

2. Burton (1988: 105-28) uncovers the varied masks assumed by Paris in Baudelaire's 'Les Sept Vieillards' (The Seven Old Men) and 'Les Petites Vieilles' (The Little Old Women), among which are the Paris-Prostitute

and Paris-Double of the former, and the Paris-Widow of the latter. Burton tellingly draws attention to a phrase Baudelaire uses in his assessment of Charles Méryon's engravings of Paris (*Salon de 1859*), where he speaks of 'the complex and deeply affecting charm of an aged city grown old in the glories and tribulations of life' (1976: 666).

3. The thyrsus is the attribute of Bacchus, a staff with flowers, or with leaves of ivy or vine, spiralling round it.

4. Among the crimes committed by 'modernisers' – after Georges Hauss-mann ('the Alsatian') come Eugène Hénard and Le Corbusier ('the Helvetian') (the Voisin plan, 1925), and the technocrats and *énarques* (graduates of the École Nationale de l'Administration) of the de Gaulle and Pompidou years – is this attempt to eradicate the folk memory: 'What virtually all architects and urbanists since Haussmann have had in common is a loathing for the past and an overriding desire to erase its visible presence. Like sociologists, they have little time for individuals and their trying, quirky, and unpredictable ways, tending to think only in terms of human destiny' (Cobb, 1998: 173).

5. Collard had taken up photography as an amateur in 1842. With the help of his brothers, he set up a studio in 1855 and specialised in the photography of public works. His photographs of the Commune relate particularly to barricades and ruins.

6. The motif of the face wrenched off first appears in *Malte* when, at the corner of the rue Notre-Dame-des-Champs, Malte sees a woman with her head in her hands: 'The woman took fright and was torn too quickly out of herself, too violently, so that her face remained in her two hands. I could see it lying in them, its hollow form' (1969: 7). The motif is picked up again in the story of Charles the Bold's death at the battle of Nancy (1477) (Rilke, 1969: 184-5).

7. The relevant terms in the German text are *bloßgelegt* and *bloßlagen*.

8. Morand: 'le Français est conservateur le jour et révolutionnaire dans ses songes' ('the Frenchman is conservative by day and revolutionary in his dreams') (Brassaï, 1987: n.pag.).

9. 'The night is feminine, just as the day is masculine, and like everything feminine, it holds both repose and terror' (Schivelbusch, 1988: 81).

10. For a full and searching account of 'inquiétude' in Mac Orlan's work, see Baines, 2000.

11. On shadows, see Baxandall, 1995; Gombrich, 1995; and Stoichita, 1997.

12. But in fact Haussmann was in the process of building a city which was itself monumental, and this, as François Loyer points out, required a different strategy for identifying the monument: 'When apartment buildings became huge, richly ornamented stone constructions, they

took on the characteristics of the monument and thus robbed the latter of its distinctive features. ... To define a monument, other criteria had to be invoked, such as isolation (as opposed to the contiguity of apartment buildings) and verdure (contrasting with the rest of the city's traditional mineral character)' (1988: 237). The very repetitiveness of the Haussmannian façade aided this task of isolation.

13. The narrator in *Last Nights of Paris* struggles to cope with the flotsam of clue-giving words which Paris tantalisingly offers and removes: a squall puts an abandoned newspaper in the hands of the statue of the Republic in front of the Institut de France, but she drops it; shortly afterwards, 'Following him [the dog] with my eyes, I happened upon a freshly posted ad. In the glimmer of the miserable lamp which lights the passageway after a fashion, I could make out words which seemed to flutter in the wind. I could not finish reading because an auto ... crossed the Pont-Neuf ... and pulled up before the railing of the Institute' (1992: 8–9).

14. *Last Nights of Paris* provides a particularly poignant example: 'At night, the Senate building looks like absolutely nothing. One sees only a great disc which roars in a bass voice: *Ralentir* – slow down – which, it is said, the nearsighted misread regularly, thinking it to be *Repentir*' (1992: 4).

15. Greet and Lockerbie's general comment on the language of the poem deserves quotation since it is equally suggestive for street photography: 'The affection that later innovators – the surrealists and others – had for the poem is understandable. In a lighthearted way it overthrows the concept of poetry as a special linguistic activity remote from ordinary uses of the language. It shows that poetry is potentially present in every manifestation of language, however inconsequential, if form and structure can bring the right quality of attention to bear on it' (Apollinaire, 1980: 378).

16. About his connections with Surrealism, Brassaï equivocated a little. In 1932–33, with the publication of *Paris by Night*, his collaborations for *Minotaure*, the beginnings of his friendship with Picasso, he was indeed closely involved with the Surrealists. Four of his photographs were later to appear in Breton's *L'Amour fou* (1937). But his abiding argument was that he had no specifically Surrealist ambitions: 'The "surrealism" of my images was in fact nothing other than the real made fantastic by vision. ... My ambition was always to reveal an aspect of everyday life as if we were discovering it for the first time. That is what separated me from the Surrealists' (2000: 52).

17. Brassaï's words are as follows: 'Primitive man did not erect the same immovable barriers between the animal and human as we do. For

him, men hardly differed from beasts and mutation was a common occurrence. ... On the wall, the fluidity of the mythical world is still apparent. Reality teeters over into fairy tale, myth and legend. Nothing is absurd. At any moment a snap of the fingers can alter a form, a being, or the course of an event. Everything is in a state of flux' (2002: 55).

conclusion

1. Russell Ferguson (Brougher and Ferguson, 2001: 13) quotes these words of Klein's: 'I was very consciously trying to do the opposite of what Cartier-Bresson was doing. He did pictures without intervening. He was the invisible camera. I wanted to be visible in the biggest way possible'. Pierre Borhan (1980: 99) provides another reason for Klein's refusal of the European way: 'Klein liked the American photographers of the 1930s, the F.S.A. photographers, such as Walker Evans, and Weegee, Lewis Hine. He didn't like the poetic, anecdotal photos he saw in Europe.'

2. This is one of the new trends in the metropolitan picturesque, 'the functional diversity of buildings which nonetheless seem to be organically connected' (Andrews, 1994: 293).

3. As Brassaï puts it: 'Rightly or wrongly, I felt at the time that this underground world represented Paris at its least cosmopolitan, at its most alive, its most authentic, that in these colourful faces of its underworld there had been preserved, from age to age, almost without alteration, the folklore of its most remote past' (1976: n.pag.).

references

Andrews, Malcolm, 1994. 'The Metropolitan Picturesque', in Stephen Copley and Peter Garside (eds), *The Politics of the Picturesque: Literature, Landscape and Aesthetics since 1770* (Cambridge: Cambridge University Press), 282-98.

Apollinaire, Guillaume, 1965. *Selected Poems*, trans. Oliver Bernard (Harmondsworth: Penguin).

———, 1966. *Calligrammes: Poèmes de la paix et de la guerre (1913–1916)* (Paris: Gallimard).

———, 1980. *Calligrammes: Poems of Peace and War (1913–1916)*, trans. and ed. Anne Hyde Greet and ed. S.I. Lockerbie (Berkeley: University of California Press).

———, 1996. *Le Flâneur des deux rives* (Paris: Gallimard).

———, 2000. *Apollinaire*, trans. and ed. Robert Chandler (London: J.M. Dent).

Armstrong, Nancy, 1999. *Fiction in the Age of Photography: The Legacy of British Realism* (Cambridge, MA: Harvard University Press).

Arrouye, Jean, n.d. [1985]. 'Le Temps d'une photographie', in *Henri Cartier Bresson*, special issue of *Les Cahiers de la Photographie*, 94-9.

Baines, Roger, 2000. *'Inquiétude' in the Work of Pierre Mac Orlan* (Amsterdam: Rodopi).

Baldick, Robert (trans.), 1984. *Pages from the Goncourt Journal* (Harmondsworth: Penguin Books).

Barthes, Roland, 1957. *Mythologies* (Paris: Éditions du Seuil).

———, 1964. *Essais critiques* (Paris: Éditions du Seuil).

————, 1967. 'Proust et les noms', in *To Honor Roman Jakobson: Essays on the Occasion of his Seventieth Birthday I* (The Hague: Mouton), 150–8.

————, 1970. *S/Z* (Paris: Éditions du Seuil).

————, 1974. *S/Z*, trans. Richard Miller (New York: Hill & Wang).

————, 1977. *Image–Music–Text*, ed. and trans. Stephen Heath (London: Fontana/Collins).

————, 1982. *L'Obvie et l'obtus: Essais critiques III* (Paris: Éditions du Seuil).

————, 1984. *Camera Lucida: Reflections on Photography* (London: Flamingo).

Baudelaire, Charles, 1972. *Selected Writings on Art and Literature*, trans. P.E. Charvet (London: Penguin Books).

————, 1976. *Œuvres complètes II*, ed. Claude Pichois (Paris: Gallimard).

————, 1991. *The Prose Poems and 'La Fanfarlo'*, ed. and trans. Rosemary Lloyd (Oxford: Oxford University Press).

Baxandall, Michael, 1995. *Shadows and Enlightenment* (New Haven: Yale University Press).

Benjamin, Walter, 1999. 'Little History of Photography', in *Selected Writings II: 1927–1934*, ed. Michael W. Jennings, Howard Eiland and Gary Smith, trans. Rodney Livingstone et al. (Cambridge, MA: Belknap Press), 507–30.

Berger, John, and Mohr, Jean, 1982. *Another Way of Telling* (London: Writers & Readers, 1982).

Blühm, Andreas, and Lippincott, Louise, 2000. *Light! The Industrial Age 1750–1900: Art and Science, Technology and Society* (London: Thames & Hudson).

Borhan, Pierre, 1980. *Voyons voir* (Paris: Créatis).

————, 1990. *La Photographie: À la croisée des chemins* (Paris: La Manufacture).

———— (ed.), 1994. *André Kertész: His Life and Work* (Boston: Bulfinch Press).

Bouissac, Paul, 1976. *Circus and Culture: A Semiotic Approach* (Bloomington, IN: Indiana University Press).

Bovis, Marcel, and Mac Orlan, Pierre, 1990. *Fêtes foraines* (Paris: Hoëbeke).

Bowlt, John E. (ed.), 1988. *Russian Art of the Avant Garde: Theory and Criticism 1902–1934*, revised and enlarged edn (London: Thames & Hudson).

Brassaï, 1949. *Histoire de Marie*, intro. Henry Miller (Paris: Les Éditions du Point du Jour).

————, 1976. *The Secret Paris of the 30's*, trans. Richard Miller (London: Thames & Hudson).

————, 1977. *Paroles en l'air* (Paris: Jean-Claude Simoën).

————, 1987. *Paris de nuit* [1933], text by Paul Morand (Paris: Flammarion).

————, 1997. *Marcel Proust sous l'emprise de la photographie* (Paris: Gallimard).

————, 2000. *Notes et propos sur la photographie* (Paris: Centre Pompidou).

————, 2002. *Graffiti*, trans. David Radzinowicz (Paris: Flammarion).

Brougher, Kerry, and Ferguson, Russell, 2001. *Open City: Street Photographs since 1950* (Oxford: Museum of Modern Arts, with Hatje Cantz Publishers).

Bryson, Norman, 1983. *Vision and Painting: The Logic of the Gaze* (London: Macmillan).

Buisine, Alain, 1994. *Eugène Atget ou la mélancolie en photographie* (Nîmes: Éditions Jacqueline Chambon).

Burgin, Victor, 1982a. 'Looking at Photographs', in Victor Burgin (ed.), *Thinking Photography* (London: Macmillan), 142–53.

————, 1982b. 'Photography, Phantasy, Function', in Victor Burgin (ed.), *Thinking Photography* (London: Macmillan), 177–216.

Burton, Richard, 1988. *Baudelaire in 1859: A Study in the Sources of Poetic Creativity* (Cambridge: Cambridge University Press).

Cartier-Bresson, Henri, 1952. *The Decisive Moment* (New York: Simon & Schuster).

————, 1968. *The World of Henri Cartier-Bresson* (New York: Viking).

Cobb, Richard, 1998. *Paris and Elsewhere*, ed. David Gilmour (London: John Murray).

Cowling, Mary, 1989. *The Artist as Anthropologist: The Representation of Type and Character in Victorian Art* (Cambridge: Cambridge University Press).

Crary, Jonathan, 2001. *Suspensions of Perception: Attention, Spectacle and Modern Culture* (Cambridge, MA: MIT Press).

Damisch, Hubert, 2001. *La Dénivelée: À l'épreuve de la photographie* (Paris: Éditions du Seuil).

Danziger, Nick, 1996. 'Street Cred or Exploitation [*sic*]', *The Big Issue* 201: 8.

Daval, Jean-Luc, 1982. *Photography: History of an Art* (New York: Rizzoli International/Geneva: Skira).

Davison, Peter, 1996. *George Orwell: A Literary Life* (London: Macmillan).

Deedes-Vincke, Patrick, 1992. *Paris: The City and Its Photographers* (Boston: Bulfinch Press).

Deleuze, Gilles, 1992. *Cinema 1: The Movement-Image*, trans. Hugh Tomlinson and Barbara Habberjam (London: Athlone Press).

Denvir, Bernard (ed.), 1987. *The Impressionists at First Hand* (London: Thames & Hudson).

Doisneau, Robert, 1995. *À l'imparfait de l'objectif: Souvenirs et portraits* (Arles: Babel).

Dujardin, Édouard, 1931. *Le Monologue intérieur* (Paris: Albert Messein).

———, 2001. *Les Lauriers sont coupés*, ed. Jean-Pierre Bertrand (Paris: Flammarion).

Florence, Penny, 1986. *Mallarmé, Manet and Redon: Visual and Aural Signs and the Generation of Meaning* (Cambridge: Cambridge University Press).

Flukinger, Roy, Schaaf, Larry, and Meacham, Standish, 1978. *Paul Martin: Victorian Photographer* (London: Gordon Fraser).

Friday, Jonathan, 2002. *Aesthetics and Photgraphy* (Aldershot: Ashgate).

Franck, Dan, and Jean Vautrin, 1987. *La Dame de Berlin* (Paris: Fayard & Balland).

Gombrich, E.H., 1995. *Shadows: The Depiction of Cast Shadows in Western Art* (London: National Gallery Publications).

Goncourt, Edmond and Jules de, 1956. *Journal: Mémoires de la vie littéraire II: 1866–1886* (Paris: Fasquelle & Flammarion).

Grant, Linda, 1996. 'Homeless Supermodels', *The Big Issue* 201: 8–9.

Hamilton, Peter, 1992. *Robert Doisneau: Retrospective* (London: Tauris Parke Books).

———, 1995a. *Willy Ronis: Photographs 1926–1995* (Oxford: Museum of Modern Art).

———, 1995b. *Robert Doisneau: A Photographer's Life* (New York: Abbeville Press).

———, 1997. 'Representing the Social: France and Frenchness in Post-War Humanist Photography', in Stuart Hall (ed.), *Representation: Cultural Representations and Signifying Practices* (London: Sage Publications in association with the Open University), 75–150.

Hammond, J.R., 1982. *A George Orwell Companion: A Guide to the Novels, Documentaries and Essays* (London: Macmillan).

Hanson, Anne Coffin, 1972. 'Popular Imagery and the Work of Édouard Manet', in Ulrich Finke (ed.), *French 19th Century Painting and Literature, with Special Reference to the Relevance of Literary Subject-Matter to French Painting* (Manchester: Manchester University Press), 133–63.

Harker, Margaret, 1979. *The Linked Ring: The Secession Movement in Photography in Britain 1892–1910* (London: Heinemann).

Haworth-Booth, Mark (ed.), 1983. *Personal Choice: A Celebration of Twentieth Century Photographs* (London: Victoria and Albert Museum).

Heilbrun, Françoise, with Philippe Neagu, 1980. *Charles Nègre Photographe 1820–1880* (Paris: Éditions des Musées Nationaux).

Hiley, Michael (ed.), 1982. *Nudes 1945-1980: Photgraphs by Bill Brandt* (London: Gordon Fraser).

Hill, Paul, and Cooper, Thomas (eds), 1992. *Dialogue with Photography* (Manchester: Cornerhouse Publications).

House, John, 1986. 'Camille Pissaro's Idea of Unity', in Christopher Lloyd (ed.), *Studies on Camille Pissarro* (London: Routledge & Kegan Paul), 15-34.

———, 1998. 'Curiosité', in Richard Hobbs (ed.), *Impressions of French Modernity: Art and Literature in France 1850-1900* (Manchester: Manchester University Press), 33-57.

Jay, Bill, and Warburton, Nigel, 1999. *Brandt: The Photography of Bill Brandt* (London: Thames & Hudson).

Lanavère, Alain, 1995. *Fête foraine* (Paris: Caisse Nationale des Monuments).

Ledger, Sally, and Luckhurst, Roger (eds), 2000. *The Fin de Siècle: A Reader in Cultural History c. 1880-1900* (Oxford: Oxford University Press).

Lefebvre, Henri, 1991. *The Production of Space*, trans. Donald Nicholson-Smith (Oxford: Blackwell).

Lévi-Strauss, Claude, 1952. *La Pensée sauvage* (Paris: Plon).

Littlewood, Ian, 2001. *A Literary Companion to Paris* (London: Penguin Books).

Loyer, François, 1988. *Paris Nineteenth Century: Architecture and Urbanism*, trans. Charles Lynn Clark (New York: Abbeville Press).

Lugon, Olivier, 2001. *Le Style documentaire: d'August Sander à Walker Evans 1920-1945* (Paris: Macula).

Luxenberg, Alisa, 2000. 'Le Spectacle des ruines', trans. Pierre-Emmanuel Dauzat, in Quentin Bajac (ed.), *La Commune photographiée* (Paris: Éditions de la Réunion des Musées Nationaux), 25-59.

Mac Orlan, Pierre, 1965. *Masques sur mesure: Essais* (Paris: Gallimard).

———, 1995. *Vive la publicité* (*Les Cahiers Pierre Mac Orlan* 8) (Paris: Prima Linea).

Maupassant, Guy de, 1995. *Une partie de campagne suivi de Une partie de campagne scénario et dossier du film de Jean Renoir* (Paris: Livre de Poche).

Merriman, John (ed.), 1994. *Louis Chevalier: 'The Assassination of Paris'*, trans. David Jordan (Chicago: University of Chicago Press).

Miller, Michael B., 1981. *The Bon Marché: Bourgeois Culture and the Department Store, 1869-1920* (Princeton, NJ: Princeton University Press).

Mora, Gilles, 1998. *Photo Speak: A Guide to the Ideas, Movements, and Techniques of Photography 1939 to the Present* (New York: Abbeville Press).

Nadar, 1998. *Quand j'étais photographe* [1900] (Arles: Babel).

Ollier, Brigitte, 1996. *Robert Doisneau* (Paris: Hazan).

Passuth, Krisztina, 1985. *Moholy-Nagy* (London: Thames & Hudson).

Phéline, Christian, n.d. [1985]. 'Meurtres dans un jardin français', in *Henri Cartier Bresson*, special issue of *Les Cahiers de la Photographie*, 21–33.

Pichois, Claude, and Avice, Jean-Paul, 1993. *Baudelaire/Paris* (Paris: Éditions Paris–Musées/Quai Voltaire).

Poivert, Michel, 1992. *Le Pictorialisme en France* (Paris: Éditions Hoëbeke/ Bibliothèque Nationale).

Pontremoli, Édouard, 1996. *L'Excès du visible: Une approche phénoménologique de la photogénie* (Grenoble: Jérôme Millon).

Pound, Ezra, 1960. *Literary Essays of Ezra Pound*, ed. T.S. Eliot (London: Faber & Faber).

Proust, Marcel, 1983. *Remembrance of Things Past I: Swann's Way, Within a Budding Grove*, trans. C.K. Scott Moncrieff and Terence Kilmartin (Harmondsworth: Penguin Books).

———, 1988. *À la recherche du temps perdu II*, ed. Jean-Yves Tadié et al. (Paris: Gallimard).

Réda, Jacques, 1993. *Les Ruines de Paris* (Paris: Gallimard).

———, 1996. *The Ruins of Paris*, trans. Mark Treharne (London: Reaktion Books).

René-Jacques, and Carco, Francis, 1988. *Envoûtement de Paris* (Paris: Nathan).

Rilke, Rainer Maria, 1969. *The Notebook of Malte Laurids Brigge*, trans. John Linton (London: Hogarth Press).

Rivière, Marc, 2000. *Up and Down* (New York: ipso facto).

Roche, Denis, 1999. *Le Boîtier de mélancolie: La Photographie en 100 photographies* (Paris: Hazan).

Roegiers, Patrick, 1990. *Bill Brandt: Essai* (Paris: Pierre Belfond).

Rogers, Richard, 1997. *Cities for a Small Planet*, ed. Philip Gumuchdjian (London: Faber & Faber).

Ronis, Willy, and Daeninckx, Didier, 1999. *Belleville Ménilmontant* (Paris: Hoëbeke).

Rosler, Martha, 1992. 'In, Around, and Afterthoughts (on Documentary Photography)', in Richard Bolton (ed.), *The Contest of Meaning: Critical Histories of Photography* (Cambridge, MA: MIT Press), 303–40.

Rougerie, Jacques, 1995. *Paris insurgé: La Commune de 1871* (Paris: Gallimard).

Ruthven, K.K., 1969. *A Guide to Ezra Pound's 'Personæ' (1926)* (Berkeley: University of California Press).

Sayag, Alain, and Lionel-Marie, Annick (eds), 2000. *Brassaï: 'No Ordinary Eyes'*, trans. J. Brenton and H. Mason (London: Hayward Gallery).

Schaeffer, Jean-Marie, 1987. *L'Image précaire: Du dispositif photographique* (Paris: Éditions du Seuil).

Scharf, Aaron, 1974. *Art and Photography* (Harmondsworth: Penguin).

Schivelbusch, Wolfgang, 1988. *Disenchanted Night: The Industrialization of Light in the Nineteenth Century*, trans. Angela Davies (Berkeley: University of California Press).

Scott, Clive, 1999. *The Spoken Image: Photography and Language* (London: Reaktion Books).

Seaborne, Mike, 1995. *Photographers' London 1839–1994* (London: Museum of London).

Sichel, Kim, 1999. *Germaine Krull: Photographer of Modernity* (Cambridge, MA: MIT Press).

Sieburth, Richard, 1985. 'Une idéologie du lisible: Le Phénomène des "Physiologies"', *Romantisme* 47: 39-60.

Soulages, François, 1998. *Esthétique de la photographie: La Perte et le reste* (Paris: Nathan).

Soupault, Philippe, 1992. *Last Nights of Paris*, trans. William Carlos Williams (Cambridge, MA: Exact Exchange).

———, 2001. *Les Dernières Nuits de Paris* (Paris: Gallimard).

Stallabrass, Julian, 2002. *Paris Pictured: Street Photography 1900–1968* (London: Royal Academy).

Stoichita, Victor I., 1997. *A Short History of the Shadow* (London: Reaktion Books).

Szarkowski, John, and Hambourg, Maria Morris, 1982. *The Work of Atget II: The Art of Old Paris* (New York: MOMA).

Szarkowski, John, 2000. *Atget* (New York: MOMA and Callaway).

Thézy, Marie de, with Nori, Claude, 1992. *La Photographie humaniste 1930–1960: Histoire d'un movement en France* (Paris: Contrejour).

———, 1994. *Marville: Paris* (Paris: Hazan).

Thomson, John, and Smith, Adolphe, 1994. *Victorian London Street Life in Historic Photographs* (New York: Dover Publications); republication of *Street Life in London* (London: Sampson Low, Marston, Searle & Rivington, 1877).

Thomson, Richard, 1990. *Camille Pissarro: Impressionism, Landscape and Rural Labour* (London: Herbert Press).

Tisdall, Caroline, and Bozzolla, Angelo, 1977. *Futurism* (London: Thames & Hudson).

Toussaint, Hélène, 1978. 'The Dossier on "The Studio" by Courbet', in *Gustave Courbet 1819–1877*, ed. Alan Bowness et al. (London: Arts Council), 249-80.

Varnedoe, Kirk, 1987. *Gustave Caillebotte* (New Haven: Yale University Press).

———, 1989. *A Fine Disregard: What Makes Modern Art Modern* (London: Thames & Hudson).

Vidler, Anthony, 1992. *The Architectural Uncanny: Essays in the Modern Unhomely* (Cambridge, MA: MIT Press).

Walker, Ian, 2002. *City Gorged with Dreams: Surrealism and Documentary Photography in Interwar Paris* (Manchester: Manchester University Press).

Walsh, Victoria, 2001. *Nigel Henderson: Parallel of Life and Art* (London: Thames & Hudson).

Warehime, Marja, 1996. *Brassaï: Images of Culture and the Surrealist Observer* (Baton Rouge, LA: Louisana State University Press).

Wechsler, Judith, 1982. *A Human Comedy: Physiognomy and Caricature in 19th Century Paris* (London: Thames & Hudson).

Westerbeck, Colin, and Meyerowitz, Joel, 1994. *Bystander: A History of Street Photography* (London: Thames & Hudson).

Zola, Émile, 1970. *Mon salon, Manet: Écrits sur l'art*, ed. Antoinette Ehrard (Paris: Garnier-Flammarion).

———, 1995. *The Ladies' Paradise*, trans. Brian Nelson (Oxford: Oxford University Press).

Zwerdling, Alex, 1974. *Orwell and the Left* (New Haven: Yale University Press).

index